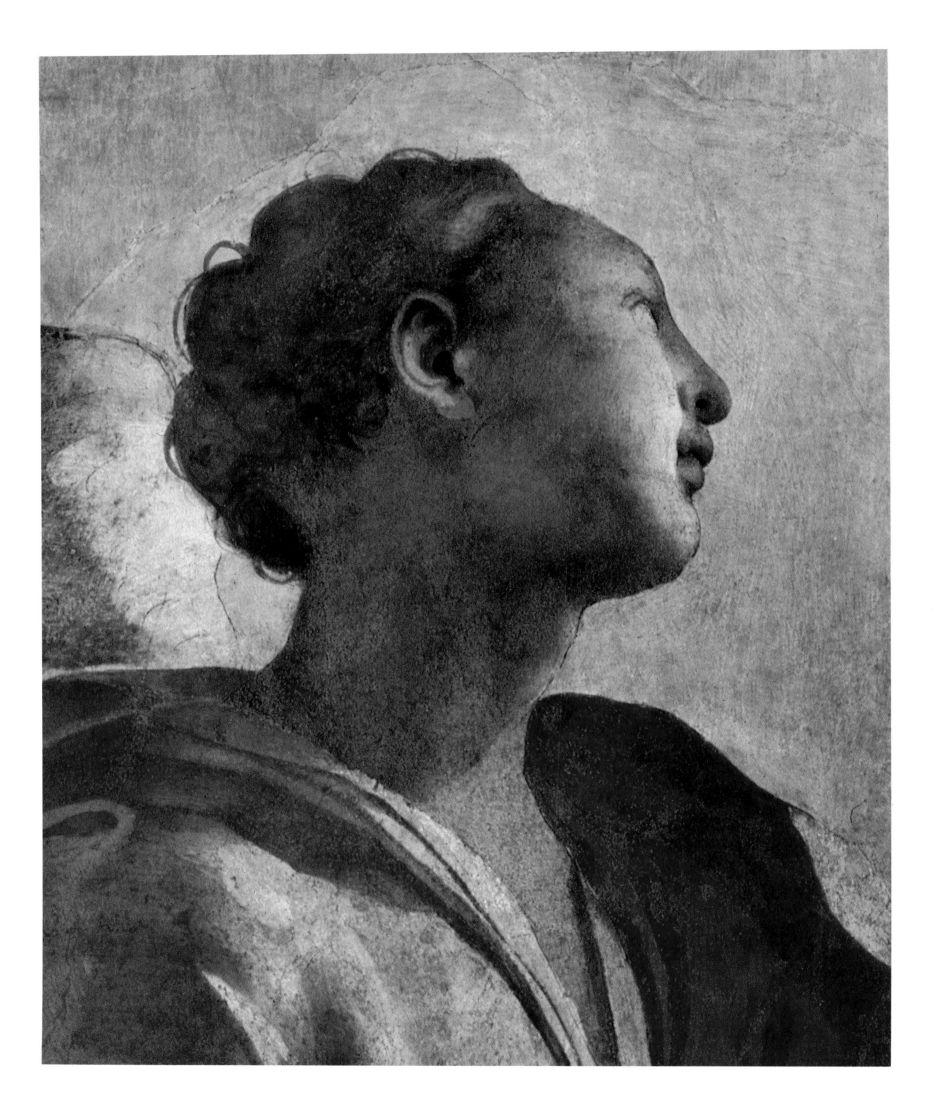

Doris Krystof

Jacopo Carrucci, known as

Pontormo

1494–1557

KÖNEMANN

1 (frontispiece)
Annunciation (detail ill. 88), 1527–1528
Fresco, 368 x 168 cm
Santa Felicità, Cappella Capponi, Florence

©1998 Könemann Verlagsgesellschaft mbH
Bonner Str. 126, D– 50968 Köln

Art Director: Peter Feierabend
Project Manager and Editor: Sally Bald
Assistant: Susanne Hergarden
German Editor: Ute E. Hammer
Assistant: Jeannette Fentroß
Translation from the German: Iain Macmillan
Contributing Editor: Chris Murray
Production Manager: Detlev Schaper
Layout: Sabine Vonderstein
Typesetting: Erill Vinzenz Fritz
Reproductions: Omniascanners, Milan
Printing and Binding: Neue Stalling, Oldenburg
Printed in Germany

ISBN 3-8290-0254-8

Contents

From Panel Painting to Video

It was this painting that in 1912 provided the stimulus for the seminal studies of Pontormo's work by the American art historian Frederick Mortimer Clapp. These studies played a decisive part in the rediscovery of the Florentine artist in the 20th century. In the preface to his monograph on Pontormo, published in 1916, Clapp recalls his reaction when faced with the altarpiece in the Cappella Capponi for the first time: "When early one morning, some years ago, I went into the church of Santa Felicità in Florence, I did not know that I was taking the first step in a task that has since then occupied all my leisure. It was in the autumn, and I imagined – it seems to come back to me – that on such a sunny day it might be possible to see an altarpiece at which I had often peered in vain in the darkness of the Capponi Chapel. I was not mistaken. The light, slanting through the upper windows of the nave, was falling even into that dimmest of corners and, in the fugitive splendor, for the first time I really saw Pontormo's *Deposition*. The moment was one of unexpected revelation. As I studied the picture with amazement and delight, I became conscious not only of its beauty but of the blindness with which I had accepted the prejudice of those for whom Andrea del Sarto is the last great Florentine artist and his younger contemporaries, one and all, mere facile eclectics …"

PONTORMO'S MODERNITY

The Florentine painter Jacopo Carrucci, named Pontormo after his birthplace in Tuscany, was forgotten by history for more than three centuries. Shortly after his death a cloak of silence descended over him; indeed, even the date of his death is uncertain. The 2nd of January 1557 is documented as the day of Pontormo's burial in the church of Santissima Annunziata in Florence. Born on 24 or 25 May 1494, he died either on the last day of the year 1556 or on the first day of the year 1557.

That such a skilled painter as Pontormo, who lived and worked in one of the most important centers of the Italian Renaissance, should have fallen into such obscurity seems strange. None of Pontormo's Florentine contemporaries suffered a similar fate. Pontormo's teacher, Andrea del Sarto (1486–1530), only eight years his senior, and the painters Franciabigio (1482–1525) and Fra Bartolommeo (1472–1517) have remained well-known throughout the centuries, to say nothing of the greats of the period – Leonardo (1452–1519), Raphael (1483–1520) and Michelangelo (1475–1564). Apart from a mention in the Florentine chronicle of Francesco Bocchi in the year 1591, there are hardly any references to Pontormo. He assumes no importance with any of the lovers of Italian art in the 17th and 18th centuries or with the Renaissance specialists of the 19th century, although most of his frescoes and paintings are even today still in their original locations in and around Florence.

Pontormo is a typical discovery of the early 20th century. It seems that only those who have been exposed to modern artistic movements such as Impressionism, Expressionism and Cubism can appreciate the outstanding significance of his painting. It was shortly after 1900 that a small number of essays heralded the awakening of interest in Pontormo. The actual hour of birth of his posthumous reception was in the autumn of 1912. The American art historian, Frederick Mortimer Clapp, during one of his study trips to Florence, paid a visit to the church of Santa Felicità, which lies on the south bank of the River Arno between the Ponte Vecchio and the Palazzo Pitti. There

he became so enraptured by a panel painting, the *Deposition of Christ* (ills. 2, 85), which had been in the church for almost four hundred years, that from that point on he became totally absorbed in the study of Pontormo. In 1916 he published his celebrated monograph on Pontormo, a work that, richly supported by documents and sources, was to become the key work for subsequent studies of this Florentine artist. Clapp's enthusiasm had repercussions. In the course of the 20th century Pontormo's exquisite art has won increasing recognition and admiration. Together with Rosso Fiorentino (1494–1540) he is now acknowledged as one of the two major representatives of early Florentine Mannerism.

The rediscovery of Pontormo was completed shortly before the First World War, at a time when the avant-garde art of the Modern Age was approaching its apogee. Pontormo is not alone in achieving recognition in the wake of the Expressionist movement. The reputation, for example, of El Greco (1541–1614), a Spanish painter of Greek origin whose visionary artistic creations had long been ignored, gained full appreciation only in the second decade of the 20th century (ill. 15). El Greco's art appeared to anticipate the modern artistic idiom and provided the impetus to a reappraisal of the phenomenon of Mannerism. The appreciation of Pontormo in the 20th century is closely bound up with the increasing interest in Mannerism. The abrupt break with the traditional concepts of art that occurred in a few short years after 1900 – the final liberation of art from the dictates of the representation of reality and the consequent striving for the autonomous picture – form the background to the new perception of Mannerism. In the bold artistic conceptions of the 16th century, which went radically beyond the Renaissance ideal of the harmonious imitation of nature, one can see a close relationship with the art of the modern age, an age perceived to be in crisis. Since their rediscovery, Pontormo's paintings have been seen as exceptionally modern, and he has attracted the oft-repeated and stereotyped label of "the artist of crisis". The daring perspectives and the strict formalism of his compositions; the stylized gestures, remote from any conceptions of naturalness; the

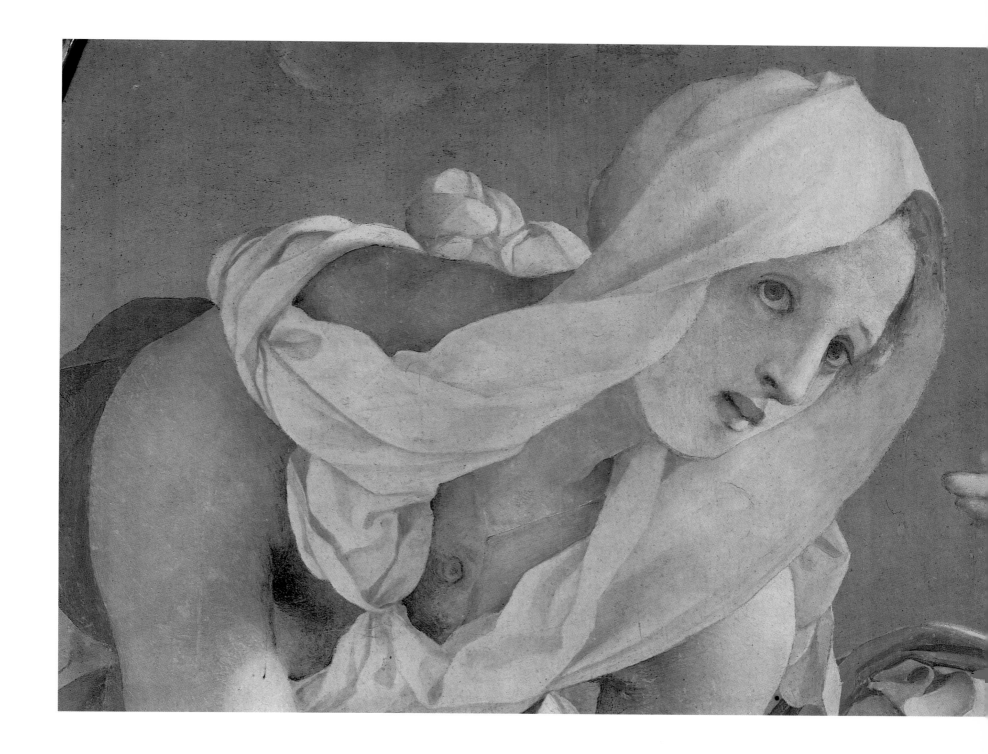

artificially bulging robes, which allow the free play of areas of color; the people in Pontormo's paintings, some with fearful expressions on their faces, or lost in thought – in the early 20th century all this made him the forerunner of an artistic freedom in which the painter's subject finds elegant expression. In Pontormo's works we seem to see an individual who is able to capture his existential doubts in paint.

If however we read the biography of Pontormo written by his contemporary Giorgio Vasari (1511–1574), one thing is obvious: those very paintings that appear so incredibly modern to 20th-century eyes, and now provide such keen aesthetic pleasure, were all more or less roundly condemned by Vasari. This is true of the *Deposition* in Santa Felicità (ill. 85) as well as the great fresco that Pontormo painted around 1520 for the Medici Villa in Poggio a

Caiano (ills. 8, 66). Vasari's biography of Pontormo splits his life as an artist into two very different halves. Vasari believed that Pontormo's extraordinary and very promising early work was followed in the second half of his life by a deplorable decline in quality. In Vasari's eyes Pontormo must have been some kind of artistic prodigy. Even Raphael and Michelangelo apparently recognized the extraordinary gifts of this young talent and forecast a great future for him. According to Vasari, Pontormo's restless and driven spirit was, unfortunately, always striving to devise something new and so he strayed shamefully from the well-trodden path of his great Italian forebears. Vasari does not pull his punches with his criticism, and several of Pontormo's works, subsequent to his early period, from about 1520 onwards, he condemns as bizarre, dissolute and excessive.

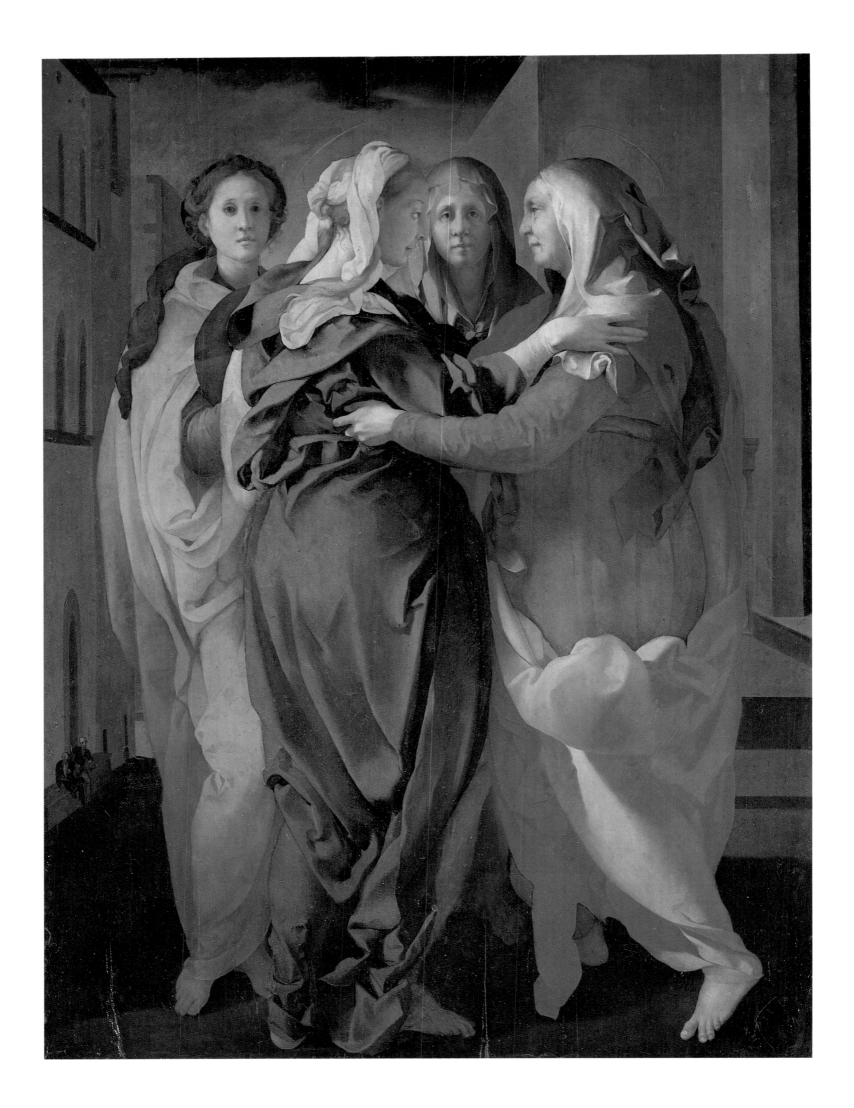

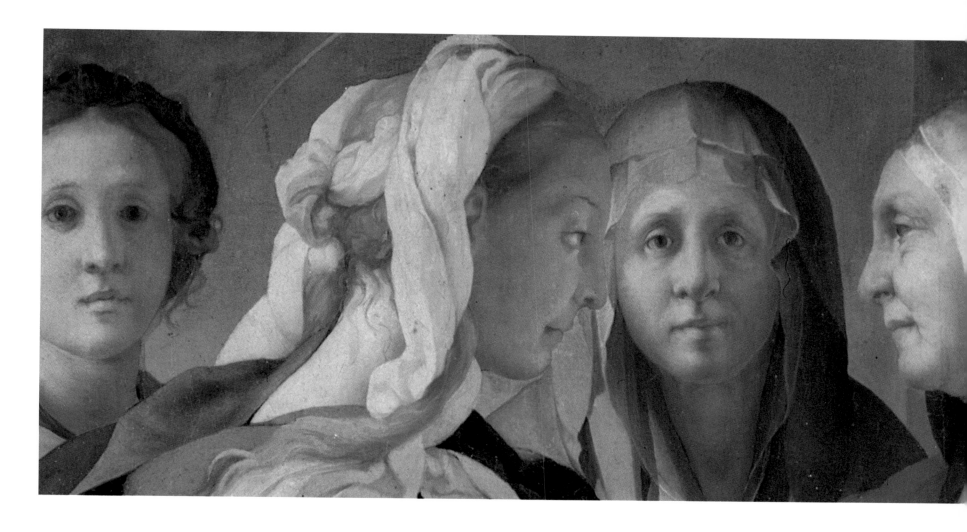

The painting has lost none of its evocative power, with its swirl of glorious colors, the captivating gestures, and the entreating glances exchanged by the protagonists. The visionary aspect of the scene is intensified by the magical, glowing quality of Pontormo's painting. Ever since the late Middle Ages, the Visitation has been considered one of the main events depicted in the Life of the Virgin. The Evangelist Luke describes the meeting of the two pregnant woman as follows (1, 41–42): "And it came to pass, that, when Elisabeth heard the salutation of Mary, the babe leaped in her womb; and Elisabeth was filled with the Holy Ghost: And she spake out with a loud voice, and said, Blessed art thou among women, and blessed is the fruit of thy womb." Originally painted for the Villa Pinadori in Carmignano, the painting has been in the local parish church since 1740.

During the 20th century Pontormo has retained his importance. Significantly it is not only art historians who have shown interest in the 16th century Florentine artist, as a growing literature on him clearly shows. This 16th century painter has, moreover, exercised a particular attraction to artists themselves. The list of admirers who have drawn inspiration for their own work from Pontormo's art is wide-ranging and includes Amedeo Modigliani (1884–1920), the film maker Pier Paolo Pasolini (1922–1975), and Georg Baselitz (born 1938). A further example may to serve to explain Pontormo's modernity: the American artist Bill Viola (born 1951) showed a large-format video work at the 1995 Venice Biennale that was inspired by the painting *The Visitation* (ill. 3), painted by Pontormo for the village church in Carmignano. Just as in Pontormo's work, Viola's *The Greeting* (ills. 5, 6) is dominated by richly robed female figures observed from a low viewpoint. By transferring the sacred panel picture into the medium of film, Viola highlights the fact that movement is the main element in Pontormo's composition. In *The Visitation* – which depicts the encounter between the two female biblical figures, Mary and Elizabeth – Pontormo finds an effective portrayal of the two women, both recognizably with child, as they approach and greet one another. The future significance of their sons, Jesus and John the Baptist, who are at this point in time still in their mothers' wombs, is translated into an exquisite and picturesque molding of the gowns. The dynamic

arrangement of the folds, the brilliant colors, and the impressive gestures of greeting all serve to capture our full attention. The correlation of colors and gestures formally binds the group of four together.

The two female figures behind Mary and Elizabeth in Pontormo's painting remain an enigma as there is no iconographical justification for them. These two women, shown frontally, may however be explained as the artistic doubles of the two protagonists shown in profile. As an echo on a second plane within the picture, they may embody a variation on the event taking place in the foreground. The simultaneous representation of the same figures in one picture is a technique frequently tried by Pontormo, even if this is a highly concentrated example of it.

The four female figures with their mutually and formally corresponding postures appear as if arranged around an imaginary symmetrical axis. Their changing positions embody a principle known in the artistic literature of the period under the Latin term *varietas* (variety), which was considered one of the main prerequisites for a successful composition. The distinctive aspect of Pontormo's *Visitation* is its extremely elaborate, almost artificial technique of representation, an aspect that fulfils modern expectations of a picture, and that may indeed have aroused Bill Viola's interest.

The artificial exaggeration in the representation of the figure not only lends the altar picture a spiritual character, possibly Pontormo's intention, but also

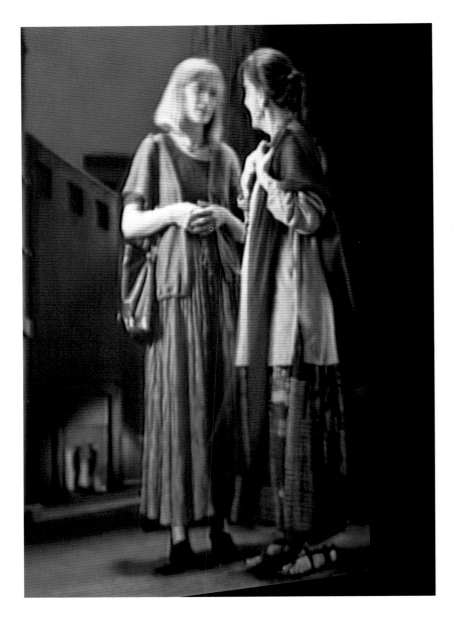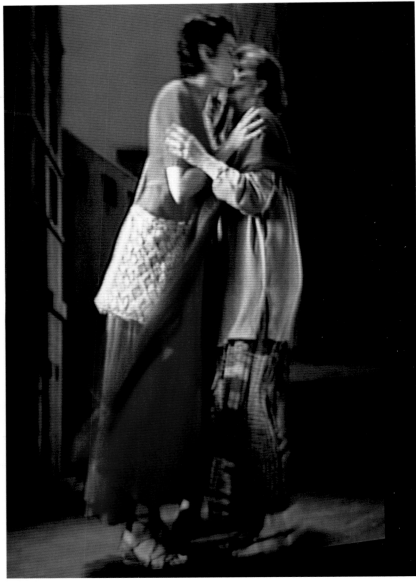

allows it to be broken down into post-modern categories such as fictionality, simultaneity, and immateriality. Other formal features which make the picture appear modern should also be mentioned: the serial nature of the figure arrangement; the parallels in the figures, both from left and right, as well as behind and in front, which combine to form a compact structure; the areas of color which appear independent from one another; the individual choice of colors and the elaborate interrelationship of the color tones; and finally the surrounding architecture, which resembles a stage set for a film and which was reproduced as such by Bill Viola for the production of his video *The Greeting* (ills. 5, 6).

The image of the modern applies not only to Pontormo's painting, but also to his personality, which clearly exemplifies that of the modern artist. Vasari describes Pontormo as a sensitive intellectual, a withdrawn outsider, a melancholic. References to his homosexuality underline the otherness of the artist. Like Michelangelo, Pontormo had little interest in elegant clothes. When he came into some money

around 1530, he did not commission a fine house, but instead a dwelling memorably described by Vasari as a tower-like refuge: "The room in which he slept and sometimes worked, was reached by a wooden ladder which he would pull up by means of a winding gear, in order that nobody could come up to see him against his will, or without his knowing." With such Bohemian traits in his character, it is not surprising that Pontormo should be such a lasting source of fascination to the 20th-century imagination. There is also an unconcealed erotic component in his art that should not be overlooked. It finds expression in works such as his drawing of *Christ seated as a nude figure* (ill. 9) and many others where there is particular focus on the body. The androgynous nature of some of the figures, and the mentally tortured expressions of a number of the faces in Pontormo's pictures, seem reflections of our own epoch, the 20th century, in which our outlook is largely freed of religious ties.

One final aspect that emphasizes Pontormo's modernity must be mentioned here. In the last years of his life Pontormo kept a sort of diary, entering brief

5, 6 Bill Viola
The Greeting, 1995
Video-sound-installation, 282 x 241.3 cm
(projection screen)
Sammlung Ludwig/Museum Ludwig, Cologne

The American artist Bill Viola produced a video as a tribute to mark the 500th anniversary of Pontormo's birth. It was first shown at the 1995 Venice Biennale and is an attempt to translate Pontormo's altarpiece into a "living picture", namely a film. The mysterious character of the original composition is conveyed by words whispered in a low voice and by somnambulistic movements.

7 *Study for The Visitation*, 1528/1530
Black chalk, white lead, traces of watercolor,
32.7 x 24 cm
Galleria degli Uffizi, Gabinetto dei Disegni e delle Stampe, Florence

This preparatory drawing for the *Visitation* has reached a stage fairly close to that of the final composition. The squares marked in red chalk helped to transfer the image accurately on to the large wood panel. For this process it was not necessary to fix every last detail of the four women depicted. The highlights on the gown of the Virgin Mary are heightened by white lead.

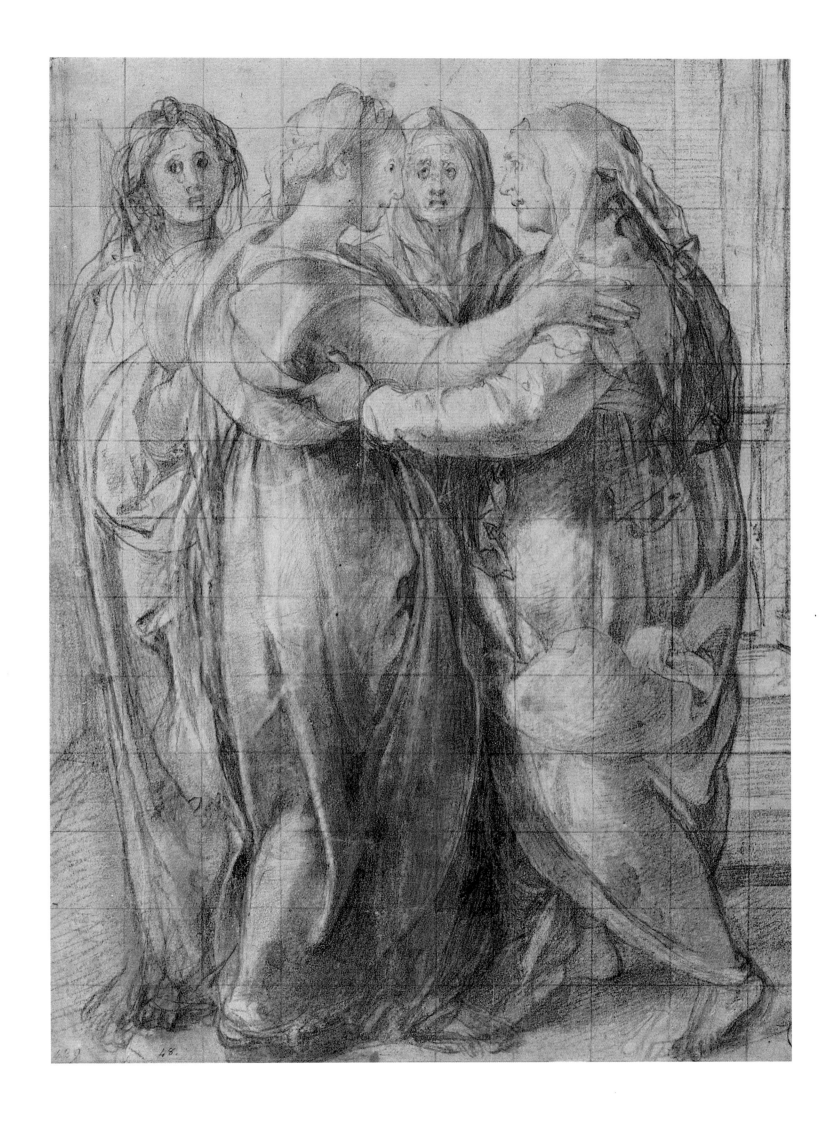

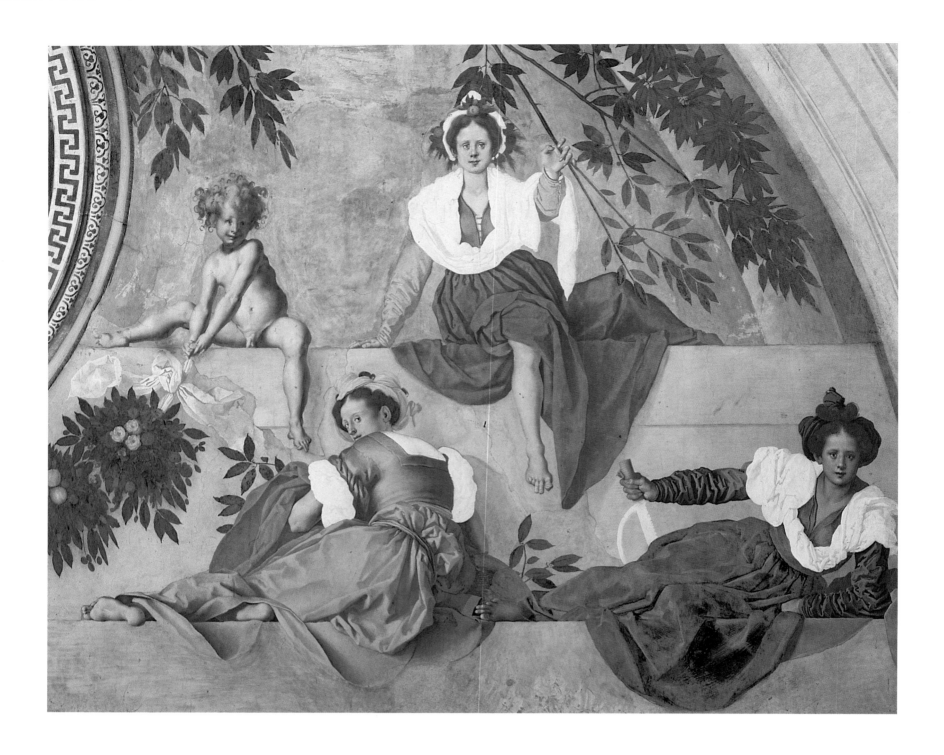

8 (above) *Vertumnus and Pomona* (detail ill. 66), 1519–1521

According to the commentator on a 1906 German edition of Vasari's "Lives", this is "Pontormo's most beautiful work". Dating from around 1520, the whole fresco measures nearly ten meters in width, of which the right-hand part is illustrated here. Pontormo's contemporary, Giorgio Vasari, however, found cause to criticize the fresco, despite his admiration for the artist's early work. He thought the female figures were "enveloped…perhaps too fully, with draperies"; and moreover, Pontormo had "set out to apply himself with such diligence that he overdid it: for destroying and doing again every day what he had done the day before, he racked his brains for ideas so hard that it was piteous". The fresco represents, in fact, a complex allegory of the rule of the Medici dynasty.

9 (opposite) *Christ seated, as a nude figure*, ca. 1526 Study for the *Deposition of Christ* in the Cappella Capponi Santa Felicità, Florence Red chalk, 35.3 x 28 cm Galleria degli Uffizi, Gabinetto dei Disegni e delle Stampe, Florence

This is a detailed study for the figure of the dead Christ in the *Deposition of Christ* (ill. 85). Using red chalk crayon, Pontormo achieved a very fine modelling of the body that he toned down on the pale corpse in the final painting. Pontormo was an excellent draftsman who did numerous preparatory studies for most of his paintings. His graphic works comprise nearly 400 sheets.

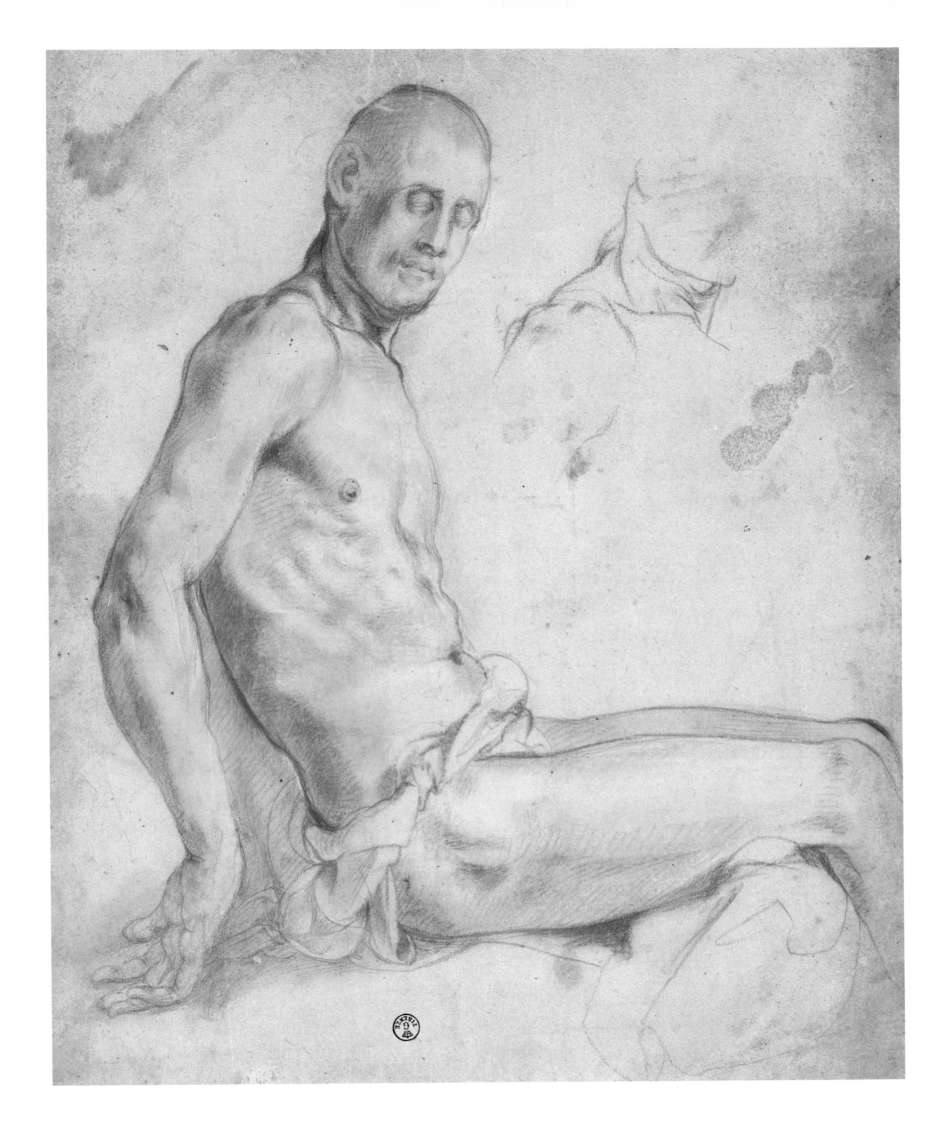

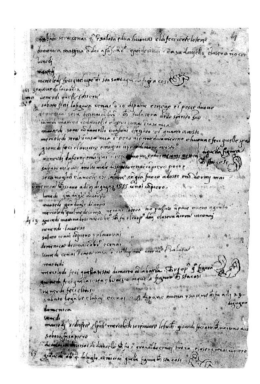

10 (above) Page 11 from Pontormo's so-called
"Il libro mio," 1554–1556
Biblioteca Nazionale, Florence

In February 1556 Pontormo noted in his diary: "On
Wednesday Bastiano purchased back of pork from me for
28 Kreuzers; in the evening two eggs, 10 ounces of bread.
Thursday, Shrovetide, evening meal at Bronzino's house,
did the trunk of the figure in this position." At this point
follows the small sketch at top right. A little further down
again he talks about the draft plans for the frescoes in the
choir of San Lorenzo: "Thursday: did the shouting head,
veal for dinner and by the 29th I had finished everything
from the head down to the ground. March 3rd, did the
head of the figure noted here. March 4th: did the part of
the trunk down to the breast, suffered from cold and
wind, to such an extent that during the night I was
overcome by weakness and could not work the next day."

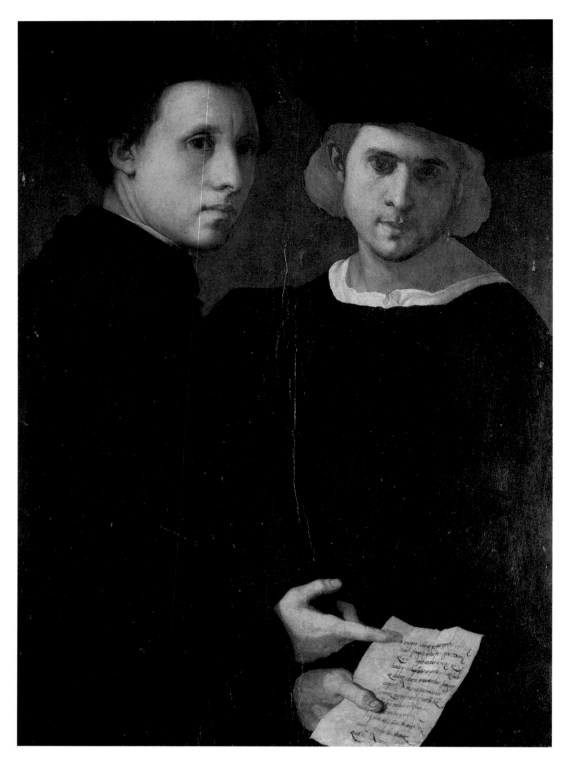

notes daily into a simple rough notebook from
January 1554 to October 1556. It is known today
under the title "Il libro mio" (ill. 10). This should not
be imagined as a diary in the modern post-romantic
sense. It is quite the opposite. Bald remarks on the
difficult progress of the work on the frescoes in the
choir of San Lorenzo in Florence; the repetitive
listing of meals eaten; the brief related entries about
his physical condition, his bowel movements, the
weather, and astronomical constellations – all reveal
disappointingly little about the person of the writer.
Pontormo's writings serve only to highlight the
differences between the 16th and 20th century minds.

An understanding of Pontormo's "diary" as an account
of a life lived can only be gained if one is prepared to
reconstruct the text on the basis of the thinking of the
time. In the commentaries to the most recent editions
of the text there are references to the early modern
understanding of an integrated concept of life – a
concept that, inspired by classical sources, makes a link
between the microcosm of the human and the
macrocosm of the universe, and recommends self-
observation as part of a way of life that integrates the
spirit and diet.

To form an impression of the artist himself we must
take into account the circumstances and character of

the period in which Pontormo's diary originates, an approach that is also valuable when considering Pontormo's paintings. There are nevertheless limitations to this approach, since the information on the development of his work and on the course of his life is highly fragmentary. Pontormo spent most of his 62 years in Florence and undertook only a few journeys, none of which took him beyond Tuscany. His early work, all of it executed in Florence, dates back to the second decade of the 16th century. Pontormo's most important works belong to following decade: the fresco in the Villa Medicea in Poggio a Caiano (ill. 66) was completed in 1521; the frescoes in the charterhouse

of Galluzzo (ills. 49–52, 54) were executed between 1523 and 1525; Pontormo then worked until 1528 on the decor of the Capponi chapel in Santa Felicità (ills. 85, 88, 89).

Little is known of the time between 1530 and his death. The large décor works of the 1530s and 1540s in the Medici villas in Careggi and Castello deteriorated as did the masterly late work in the choir of San Lorenzo, on which Pontormo worked for over ten years. If these works had not been lost, Pontormo's achievement as an artist would surely now be much more evident than it is.

11, 12 *Portrait of Two Men* (and detail), ca. 1522
Oil on wood, 95 x 97 cm
Collection Cini, Venice

According to Vasari, the men shown in this double portrait were friends of Pontormo's. Friendship is also the theme of the piece of writing depicted – we can recognize a passage from Cicero's dialogue "De amicitia" (44 BC). "In this book I have written, as a good friend, for a friend, about friendship" – Cicero's introductory sentence can be adopted as the motto for Pontormo's double portrait.

13 Rosso Fiorentino
Moses Defending the Daughters of Jethro, 1523
Oil on wood, 160 x 117 cm
Galleria degli Uffizi, Florence

In this painting, Fiorentino's main aim is to heighten the dramatic intensity of the story depicted. He achieves this by the movement of the figures and by a composition arranged in sharply defined layers, an idea that was new at the time. The features of the scene he chose to emphasize bring the scene vividly to life. In the center of the picture we see the figure of Moses, defending Jethro's daughters against the attack by the Midianite shepherds in a sweeping movement. The tumultuous chaos of the nude figures beaten to the ground is reminiscent of Michelangelo's famous cartoon of the *Battle of Cascina*, executed in 1505. An exact contemporary of Pontormo, Rosso Fiorentino is regarded as one of the co-founders of the early Florentine Mannerism.

The term "Mannerism" dates back to the late eighteenth century. In the 19th century the famous cultural historian Jakob Burckhardt used it as a pejorative expression to describe the period of Italian art between the high Renaissance and the Baroque (approximately 1530–1580). It is derived from the highly variable Italian word maniera, a widely used and complex label employed in the literature of art in the 16th century to describe the stylistic characteristics of works of art and their creators. The word maniera thus represented the first use in the early modern age of a concept that reflected artistic practice. An artist's handling of style and the nature of artistic forms became the object of observation and description. Vasari, for example, recommended the *buona maniera* of Michelangelo as the model that all artists should emulate. The demand that the artist should "have style" however did not refer only to artistic skill; of equal importance were

a universal education and matters of conduct in society. To "have style", to adopt a particular manner, can quickly lead to preciosity and affectation, and indeed Mannerism owes its original negative connotation to this tendency. Until the beginning of the 20th century, Mannerist art was considered a symptom of decline. The turning away from the imitation of nature was judged to be "anti-classical", a betrayal of the Renaissance ideals of harmony and balance in art. The art of Pontormo, Rosso Fiorentino (ill. 13), Parmigianino (ill. 14), or El Greco (ill. 15) appeared to be merely a transitional phase anticipating the Baroque art of the 17th century. The emotional accentuation of movement and expressions of the body, the eccentric composition of space with distorted perspective, anatomical exaggeration, restless variations of the light, and artificial colors – all these have been interpreted in a wider context as the expression of the social, religious and scientific upheavals of the time. The uncertainties of an age with all its contradictions appeared to be mirrored in Mannerism.

It was only in the second and third decades of the 20th century that there was a rehabilitation of the artists who were seen as part of the Mannerist tradition. The heightened expression in their works betrayed doubts about the ideal of imitating reality. This feature now appeared to be a positive sign of free artistic creativity, a view reinforced by Expressionism and Surrealism. Historical studies have also recognized the strong intellectual character of Mannerism. Concealed beneath the surface of these daring and inventive pictures are the influences of neoplatonic philosophy, and above all the ancient disciplines of rhetoric, poetics, and music theory. Of fundamental importance here is the idea that art draws primarily on art and not exclusively on nature. The Mannerist work of art does not conceal its artificial character, it boldly highlights it. Art itself becomes art's theme, an idea reflected in the burgeoning quantity of art literature written in the 16th century.

The age of Mannerism ushered in a new concept of the artist. Freed from the status of a craftsman, and now on a par with poets and philosophers, artists and sculptors could through their creations make their own distinctive contribution to knowledge. An interest in the exact portrayal of the world thus fades into the background. The idea of a neat separation between classical high Renaissance and anti-classical Mannerism has proved to be a false one. Indeed Michelangelo, Raphael, and Leonardo, in stimulating a climate of competition with one another, were themselves creating experimental works that served as inspirational models for succeeding generations of artists.

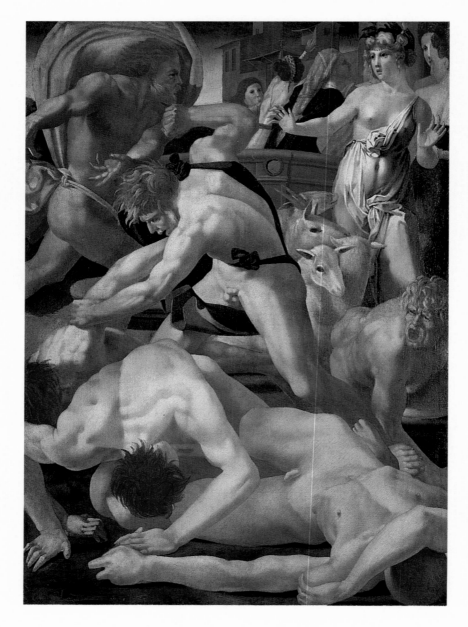

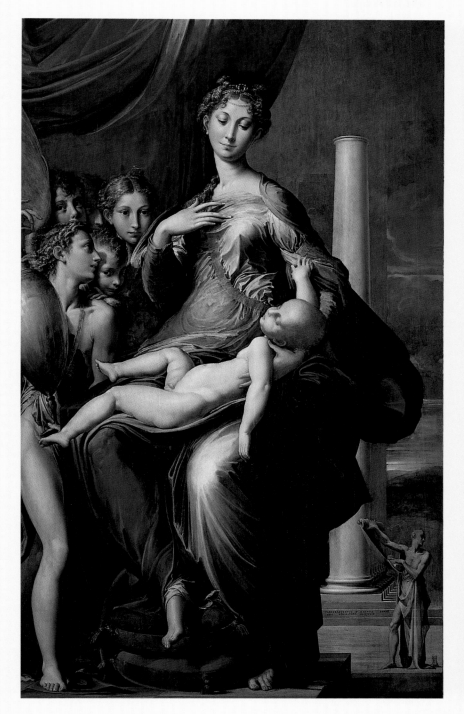

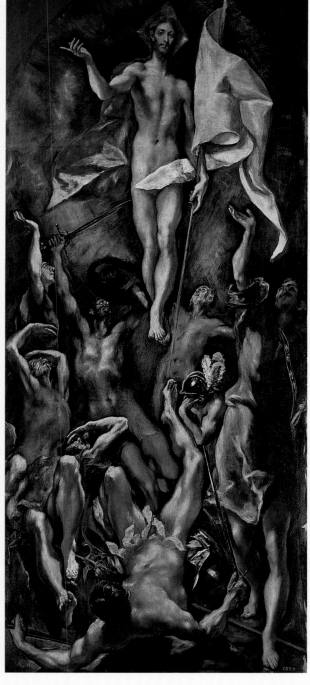

14 Parmigianino
Madonna and Child with Angels (Madonna with the Long Neck), ca. 1534
Oil on wood, 219 x 135 cm
Galleria degli Uffizi, Florence

The exquisite shapes of Mannerist art correspond in high degree to the subject depicted. Here Parmigianino (1503–1540) represents the delicate Madonna in an artfully arranged pose, holding the pale, sleeping Christ Child on her lap. Approaching from the left, some extremely slim angels pay their tribute. The exquisite preciousness and the elegant affectation of the gestures impart to the painting a supernatural radiance that, in effect, venerates Mary as the Queen of Heaven and a supernatural being. The Christ Child's limp, sleeping body is a reference to Christ's sacrificial death and redemption.

15 El Greco
Resurrection of Christ, 1605–1610
Oil on linen, 275 x 127 cm
Museo Nacional del Prado, Madrid

The steep composition of this Resurrection is comparable to flames leaping upwards, its dynamic force being enhanced by the narrow shape of the picture. The impassioned gestures of the horrified guards in response to the rising Christ further contribute to the feeling of unrest. El Greco's work is imbued with the religious fervor of the Counter-Reformation and characterized by an expressive vocabulary of form. This intensity of feeling and expression in Mannerist art underlie its rediscovery and re-evaluation in the early 20th century.

ELEVATING PAINTING TO A HEAVENLY PLANE

THE EARLY WORKS AND THE FLORENTINE COMPETITION

Pontormo was born into an eventful age of upheavals, innovations, and discoveries. In the year of Pontormo's birth, 1494, Charles VIII of France embarked on his Italian wars with the aim of realizing the claims of the House of Anjou to Naples. In Florence this led in the very same year to the expulsion of the Medici, the banking family who had ruled the city like monarchs. For the next few years the theocratic monk Savonarola determined the fate of the city, until, accused of heresy, he was executed in 1498.

The year of Pontormo's birth also marked a turning point in the city state of Florence, a change linked with political upheavals occurring in the power structures throughout early modern Europe. It was not only Florence, but also the whole of Italy that now became a hostage in the conflict between France and the Habsburgs, which lasted into the 18th century. During the whole of Pontormo's lifetime there were wars taking place on Italian soil, wars that involved not only the struggle for political power, but also, since the Reformation, fanatical religious conflicts. In the first half of the 16th century the face of Europe – and the entire world – was changing. With the coming of the age of discovery and with the profound split in the Church, the Middle Ages were finally over. Pontormo belongs to the first generation of the epoch historians describe as the early modern era.

In Florence the year 1494 also marked the end of a golden era. Under the patronage of the Medici, above all in the last third of the Quattrocento during the reign of Lorenzo de' Medici, the Magnificent (who died in 1492), the city on the Arno had risen to become a center of the fine arts and architecture, unique in Europe. Generously endowed commissions from families and institutions with an interest in the arts, as well as the lively competition among the artists living in Florence, had raised standards to a very high level. Names such as Donatello (1386–1466), Botticelli (1444/1445–1510), Signorelli (1441–1523) and Filippino Lippi (ca. 1457–1504) bear witness to this. The dynamic brilliance of the city continued even into

the times of political turmoil under Savonarola and beyond. In the first decade of the 16th century Michelangelo, Leonardo and Raphael were resident in the city and left behind works that were to shape the history of European art.

Pontormo's father, Bartolommeo di Jacopo di Martino Carrucci, had also belonged to the Florentine artists of the Quattrocento. Like Michelangelo, he had learnt his craft in the studios of Domenico Ghirlandaio (1449–1494), but unfortunately not a single work of his has survived. Bartolommeo Carrucci and his wife Alessandra di Pasquale di Zanobi had only been living a short time in Pontormo near Empoli, when their first son, Jacopo, was born at the end of May 1494. His father died in 1499, and on his mother's death in 1504 Jacopo became an orphan at the age of ten. As Vasari reports, Jacopo's grandmother, Mona Brigida, took on the responsibility for him, and had him taught "in reading and writing and the basics of Latin grammar". When he was 13 she sent him to live with a distant uncle in Florence. From January to June 1508, according to the city archives in Florence, Jacopo Carrucci from Pontormo was made a ward of court. For the beginnings of his artistic career, we are reliant on the partially contradictory information in Vasari's biography. Pontormo is said to have changed his apprenticeship studio several times, and even Leonardo da Vinci is alleged to have given him instruction. In the early summer of 1508, however, Leonardo was once again employed at the court of the Sforza in Milan, from which we may conclude that the contact between Pontormo and the great master from Vinci was confined to a number of sporadic encounters and did not amount to a regular teacher-pupil relationship. Around 1512/1513, Pontormo, together with Rosso Fiorentino, was undoubtedly an apprentice and employee of Andrea del Sarto. Once Leonardo, Michelangelo and Raphael had left the city, del Sarto's studio was the most progressive in Florence.

Andrea del Sarto, who together with Fra Bartolommeo is considered the most important painter of the Florentine High Renaissance, certainly exercised the greatest influence on the young Pontormo. The glowing colors in del Sarto's paintings, the

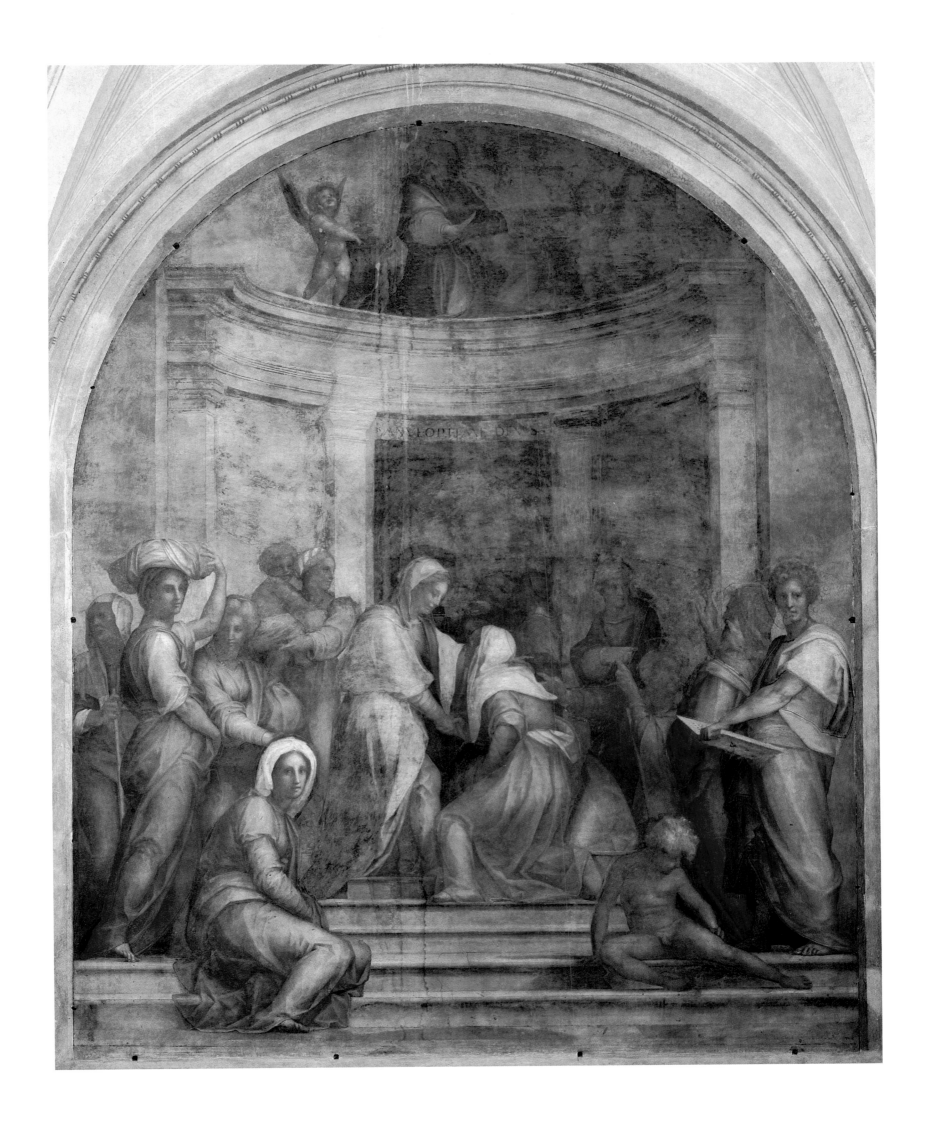

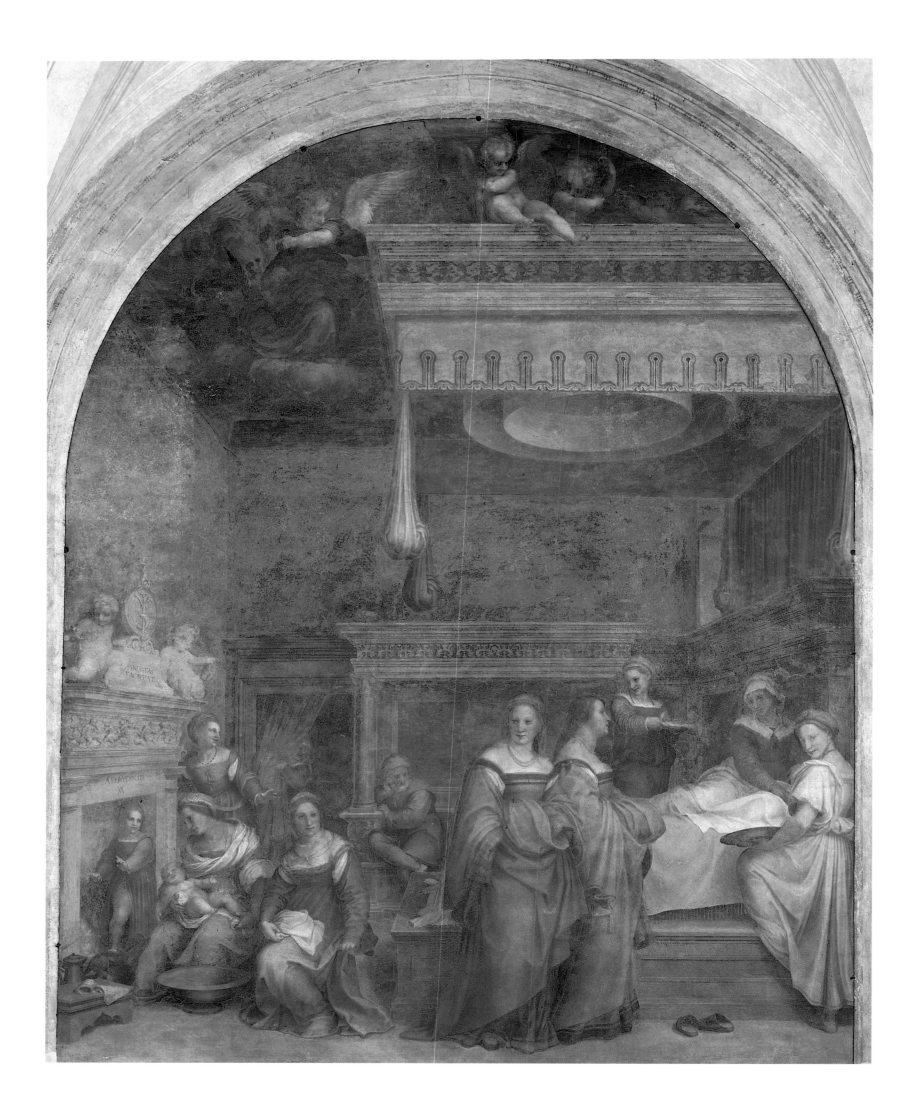

monumentality of the figures, and the clarity of the composition all form the basis for Pontormo's first works. That can be clearly seen in his large fresco *The Visitation*, which Pontormo painted for the atrium of the Florentine church Santissima Annunziata between 1514 and 1516 (ill. 16). References to Andrea del Sarto can be clearly seen in two features: color and the conception of the figure. But it is not just in these formal features that we can discern a reference to del Sarto in Pontormo's early masterpiece. The fresco was executed with the declared intention of measuring himself against the achievements of del Sarto, and the location of the fresco itself contributed considerably to this. In just a few years a whole cycle of frescoes depicting the life of Mary was executed in the cloister-like atrium of the church, each wall segment being painted by a different Florentine artist. According to Vasari, the Servite monks commissioning the work even exploited Pontormo's ambition and "competition with the other masters" in order to "produce something quite special".

If we are fully to judge Pontormo's achievement in this early work, we have to see his fresco in the context of the whole cycle. Thus *The Visitation*, which is to be found in the eastern corner of the atrium between Franciabigio's *Wedding of Mary* and Rosso's *Ascension*, is clearly more monumental in its pictorial structure that these other works. In terms of color, however, Pontormo has harmonized his picture with those of the adjoining frescoes. In the opposite corner Andrea del Sarto had painted a fresco in 1513/1514, the *Birth of the Virgin*, in which he experimented with asymmetrical groupings (ill. 17). In Pontormo's rhythmically flowing group composition it is also asymmetry that lends tension to the picture. A non-isosceles triangle forms the basis of the arrangement of the two protagonists, Mary and Elizabeth. The two figures, portrayed on a step, are viewed from slightly below. By placing St. Elisabeth in a kneeling position below the standing Mary, Pontormo transfers the motif of the steps into the composition of the figures. This automatically brings about an ascending and descending line that ensures a formal coherence in the disposition of the many figures in the composition. Pontormo is therefore able to portray the pre-eminent position of Mary without resorting to the customary pyramidal scheme. This is particularly apposite given the location of the painting in the church of the Santissima Annunziata, which is dedicated to Mary, the Queen of Heaven. Pontormo's fresco is thus a work that tells its story in harmony with its location and the inspiration of its environment. One further detail makes the reference to the fresco's location very clear: the lighting within the picture corresponds precisely to the lighting in the monastery atrium, so that what natural light there is serves further to heighten the effect of the picture.

Pontormo's art in this early stage demonstrates both extreme complexity and carefully calculated design. The inclusion of features outside the painting – such as the surrounding architecture and light, or the dialogue

with another work of art close by – are qualities frequently to be found in Pontormo. Since these can scarcely be conveyed in book illustrations, it is necessary to take a view of the whole situation for which a work of art is created. Some of his compositions otherwise remain incomprehensible, as is illustrated by this next example of his early work. In 1514 Pontormo painted a fresco for an altar in the Florentine church of San Ruffilo that shows Mary and Jesus together with the Archangel Michael and three saints, a *Sacra Conversazione* (ill. 18). When San Ruffilo was destroyed in 1823 the fresco was transferred into the so-called Painters' Chapel of the church of Santissima Annunziata, where it is still to be found today. In this early picture we can study Pontormo's interest in the investigation of a wide variety of movements and visual relationships. In 1932 the Italian art historian Adolfo Venturi described it vividly in these words: "The naked infant Jesus, whose arms and legs are twisting around, provide the impetus for an ornamental development of curves around the spindle-shaped central group". It was particularly the figure kneeling down to the left of Mary, possibly St. Agnes, that attracted the attention of the famous Italian art historian: "... seized by a mystic agony, and appearing almost to be collapsing in a state of rapture, the convulsed pose of the figure is an early example of Jacopo Pontormo's sharply developed sense of line." The extraordinary posture of this figure does however have an explanation that is to be found outside the picture. The Swiss art historian Kurt W. Forster writes in his Pontormo monograph that Agnes' gaze towards heaven forms a link with an image of God the Father situated in a lunette above Pontormo's fresco. The composition of the Pontormo *Sacra Conversazione* thus builds on the idea of guiding the observer's eyes in an arc up towards God. St. Lucia on the left edge of the picture attracts the gaze of the observer and leads it over to the Madonna, who is turning towards the Archangel Michael. He provides the link with the kneeling Zacharias, whose eyes alight on the lively infant Jesus, whose dramatic arm movement in turn leads the observer back to the upward gaze of St. Agnes.

A further early work demonstrates Pontormo's wealth of ideas in the invention of visual forms of expression. On the occasion of the visit of the Medici Pope Leo X to his home city of Florence, Pontormo received the commission to participate in the celebratory decoration of the Papal chapel in Santa Maria Novella. For this occasion he painted the fresco *Saint Veronica* (ill. 20), which shows the saint in an iridescent robe kneeling on a cloud under a baldachin. With raised arms Veronica presents the shroud portraying the face of Christ; a symbol of the Catholic Church, this shroud is held up towards Heaven. This sense is clearly conveyed visually by the shape given to the hanging cloth, which is vaguely reminiscent of a church building.

Already at the age of twenty Pontormo was gaining a reputation as a painter who could make his mark with his own independent contributions. If we are to believe Vasari, the career of the young painter made an

17 Andrea del Sarto
Birth of the Virgin, 1513/1514
Fresco, 413 x 345 cm
Santissima Annunziata, Chiostrino dei Voti, Florence

Pontormo's teacher, Andrea del Sarto, was also involved in the creation of the cycle illustrating the Life of the Virgin in the outer court of the monastery church Santissima Annunziata. His depiction of the birth of Mary in an elegant interior is characterized by a great wealth of detail, something not found in the work of Pontormo. What both master and pupil share, however, is the use of elaborately dressed female figures that are placed in an irregular pattern throughout the scene and dominate the pictorial space.

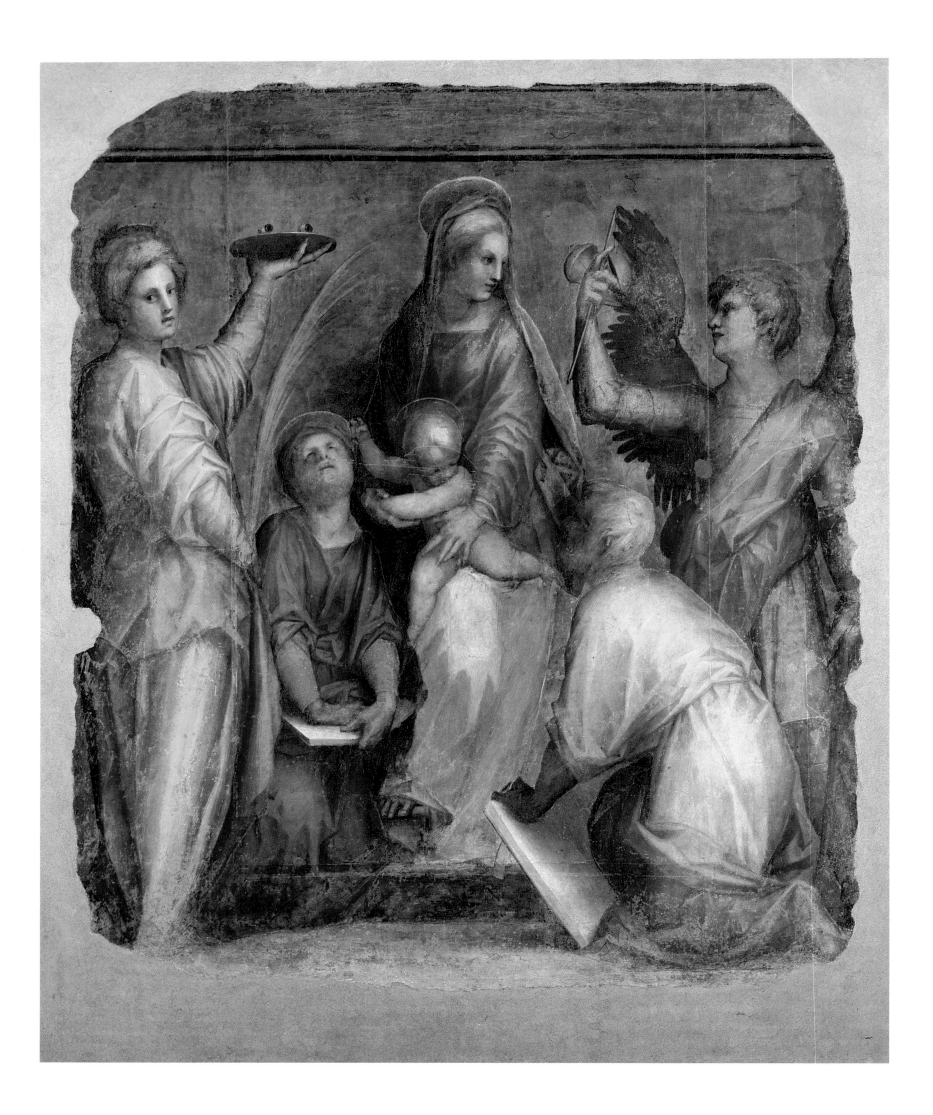

18, 19 *Sacra Conversazione* (and detail), 1514
Fresco, 223 x 196 cm
Santissima Annunziata, Cappella di San Luca, Florence

The "holy conversation" (sacra conversazione) between
the Virgin and Child and a number of saints was one of
the most popular subjects in Italian Renaissance art. On
the left-hand side of the fresco we can see St. Lucy with
her attributes, the palm frond and the shallow bowl
containing a pair of eyes. According to legend, St. Lucy
plucked out her beautiful eyes and received even more
beautiful ones from the Madonna. Therefore, St. Lucy is
often represented in Italian art as a helper against eye
complaints. The kneeling figure next to her may possibly
be St. Agnes. On the right-hand side, next to Mary, we
see Elisabeth's husband, Zacharias, and the Archangel
Michael, represented here as the weigher of the souls.

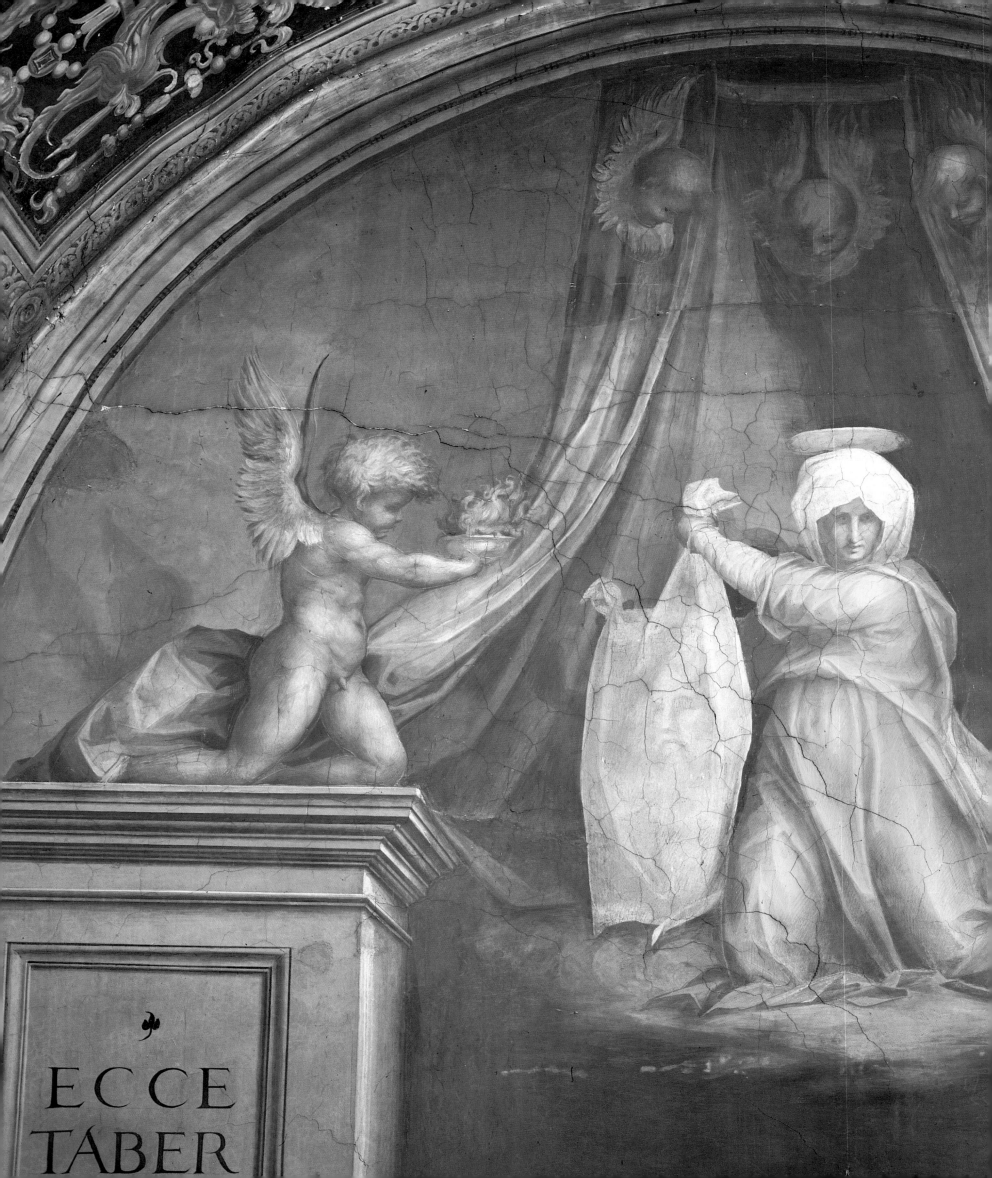

ECCE
TABER

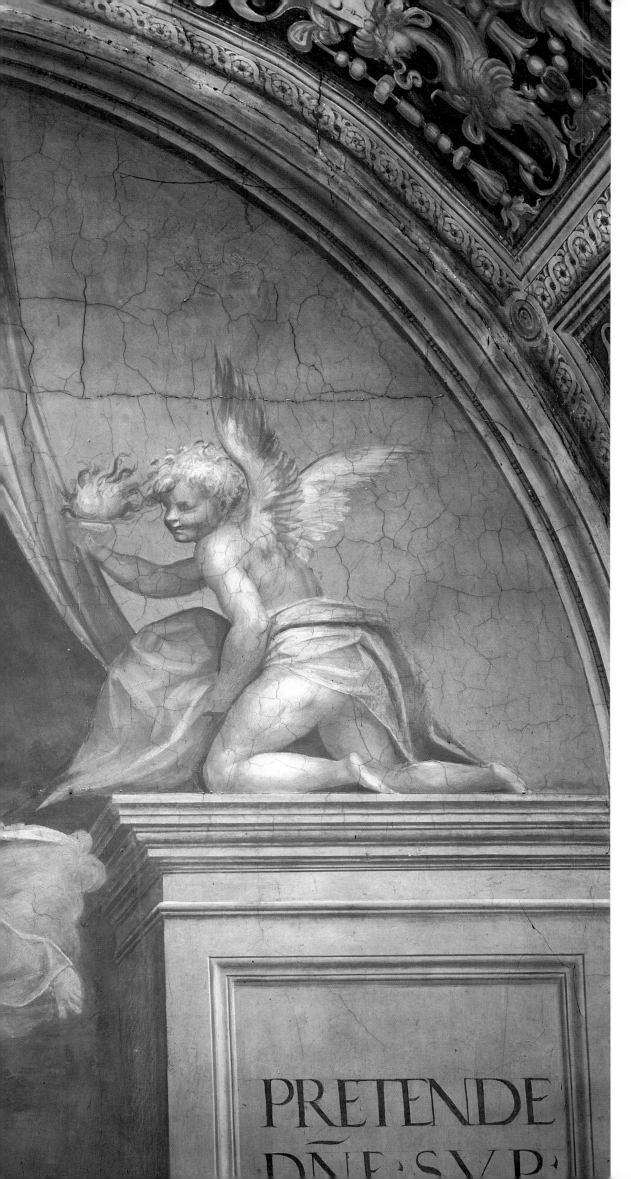

PRETENDE

DÑE·SVP

20 *Saint Veronica*, 1515
Fresco, 307 x 413 cm
Santa Maria Novella, Cappella pontificale, Florence

The blazing color of Veronica's gown is in sharp contrast
to the pale violet of the canopy, which refers to the
subject of the Passion. The story goes that Veronica met
Christ as he carried His Cross to Calvary and handed
Him a cloth with which to wipe the blood and sweat
from His face. The impression of His features were
preserved on the cloth (St. Veronica's veil) which was then
revered as a devotional image. According to mediaeval
legend, Veronica was named after the "true picture"
(Latin *vera icon*) of the face of Christ.

enormous impact in Florence. Many of the early, sensational works, however, have either not survived or are in a poor condition. An example is the fresco depicting two allegorical figures representing Faith and Charity painted 1513/1514. This fresco, located in the Santissima Annunziata with the large Visitation scene, is now so badly faded that it can hardly be reproduced. It is nevertheless worthy of mention because it is the first work that can be proven to be by Pontormo (by payment documents). It is, moreover, a work that had the honor of attracting the attention of Michelangelo: "If this young man continues his pursuit of such rare coloring, he will elevate his painting to a heavenly plane", were the words of Michelangelo according to Vasari. Even Vasari himself emphasizes Pontormo's early gifts several times. His great astonishment that so young an artist should already have executed such accomplished works makes Vasari's regrets over the decline of the older Pontormo appear even more marked.

For the time being, however, we will remain with Pontormo's highly acclaimed early works (or, at least, to those reliably attributed to him). As well as the works lost or only preserved in a fragmentary state, there are several whose dates are not reliably known and which render the task of producing a chronological catalogue very difficult. Pontormo dated only a few of his works, and generally omitted to sign them – to such an extent, in fact, that there are large differences in opinion as to the correct attribution of his works. It is above all over portraits that views diverge so greatly. In the Uffizi Gallery in Florence, where most of Pontormo's paintings are now hung, there is a wonderfully preserved *Portrait of a Lady with a Spindle Basket* (ill. 23). It portrays the half-figure of a woman in front of a dark foreground: her gaze is at once friendly and distant. With a slightly mannered pose, she is reaching into a basket filled with spindles. Particular attention is shown to the shaping of the voluminous sleeve, whose warm color tones determine the overall impression of the portrait. In its harmonious appearance the painting is reminiscent of Raphael's portrait painting, but above

21 (above) *Episode from Hospital Life*, 1514
Fresco, 91 x 150 cm
Galleria dell'Accademia, Florence

Following the example of his teacher, Andrea del Sarto, Pontormo painted several grisaille frescoes, originally executed on an interior wall of the Hospital of San Matteo in Florence. The depiction of nuns tending the sick refers to Christian virtues such as brotherly love, charity and compassion. The small-scale fresco might well have been a votive picture from a patient as a mark of gratitude for his recovery.

22 (opposite) *St. Quentin*, 1517
Oil on wood, 163 x 103 cm
Pinacoteca Comunale, Sansepolcro

The main aim of this painting, which shows the saint's body cruelly pierced by a huge nail, appears to be to establish the contrast between the process of torture and the yet unblemished body of the martyr. Imbued with his faith, St. Quentin rises above all earthly pain. The wayfarers depicted in the very detailed hilly landscape in the background of the picture are witnesses of St. Quentin's martyrdom. According to Vasari, the panel showing this Christian martyr was originally painted by one of Pontormo's young assistants named Giovanmaria Pichi. Gradually, however, Pontormo is said to have repainted the whole picture.

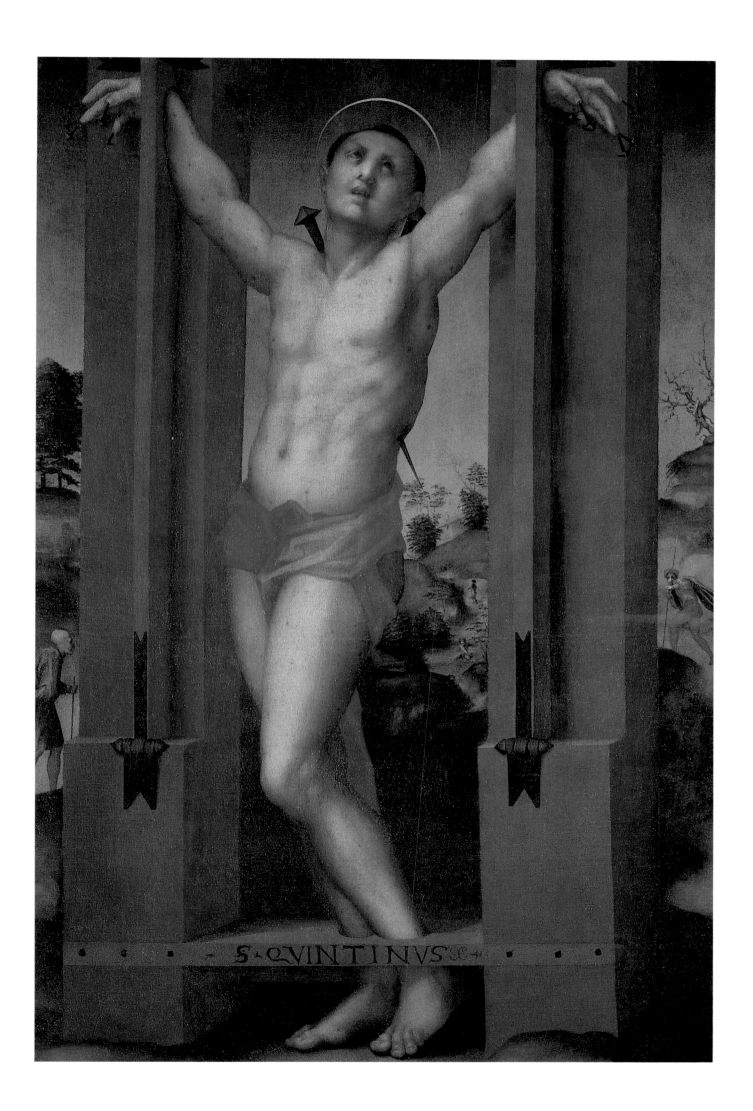

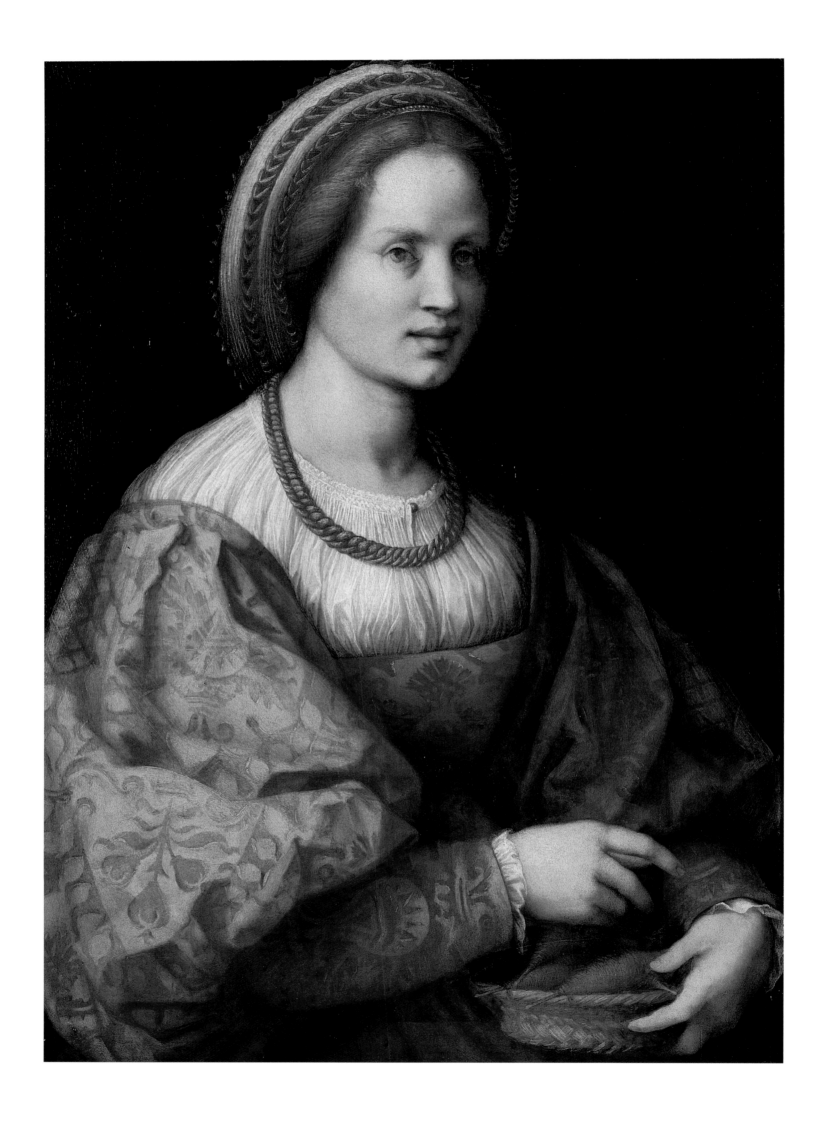

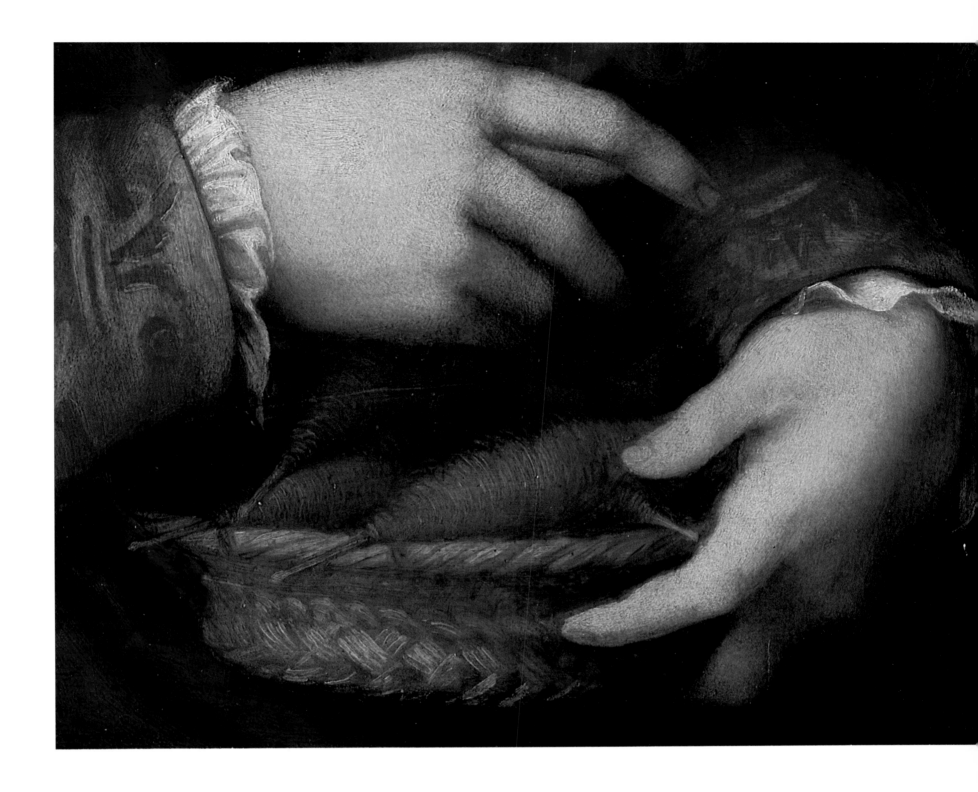

23, 24 *Portrait of a Lady with a Spindle Basket*
(and detail), ca. 1516/1517
Oil on wood, 76 x 54 cm
Galleria degli Uffizi, Florence

The richly dressed lady is placed in front of a dark
background, a device that shows off the harmoniously
balanced color tones to their best advantage. Judging
by the jewelry and the dress, the sitter was probably a
member of Florence's rich upper class. There is as much
doubt about the identity of the lady depicted as there is
about the attribution of the picture to Pontormo. The
painting has been dated early as a result of its great
stylistic similarity with portraits painted by Andrea del
Sarto. As Pontormo's teacher, del Sarto obviously exerted
a considerable influence on the early work of the artist.

all it is close to portraits by Andrea del Sarto, to whom
it was once attributed. The "Pontormesque traits" of
the lady's face, however, suggest that the young
Pontormo painted it in the style of his teacher. For this
reason it is dated to around 1516/1517 when
Pontormo was still clearly under the influence of del
Sarto. Other works that for similar reasons are said to
originate from this early period are the *Portrait of a
Jeweler* (ill. 25) and the *Portrait of a Musician* (ill. 26).
Present also in these pictures is the light slanting in
from behind and casting a semi-shadow on the faces of
the subjects. Once again we can see the forceful glances
of the portrait sitters, who appear strangely cold and
impenetrable, even if, as is the case with the musician,
they are looking out at us.

Forceful glances assume a prominent position in
Pontormo's painting, and a true masterpiece in their
skillful use is the large altarpiece *Sacra Conversazione,*
also named *Pala Pucci* after its patron (ill. 28). This is
one of the few works that bear a date on the picture, for
the year 1518 can be seen in the opened book of St.
John the Evangelist. Nine figures are portrayed in the
painting in an ingenious composition. The group
around Mary appears full of life and seems to be placed
loosely together wholly without any underlying
scheme. By ingeniously orchestrating the exchange of
glances between the subjects, Pontormo heightens the
impact of his highly varied composition. He thereby
achieves a maximum of *varietas*. Despite the demand
for multiplicity and variety, however, it was important

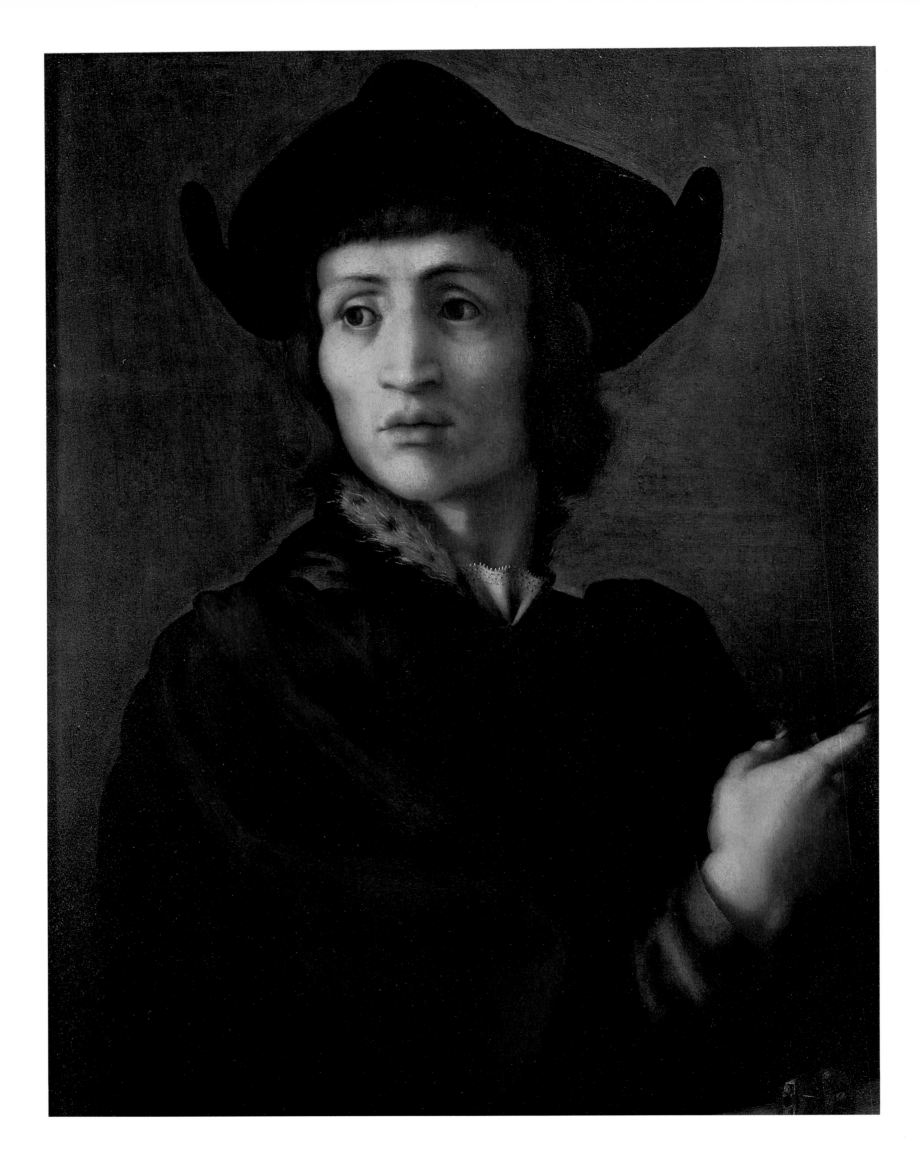

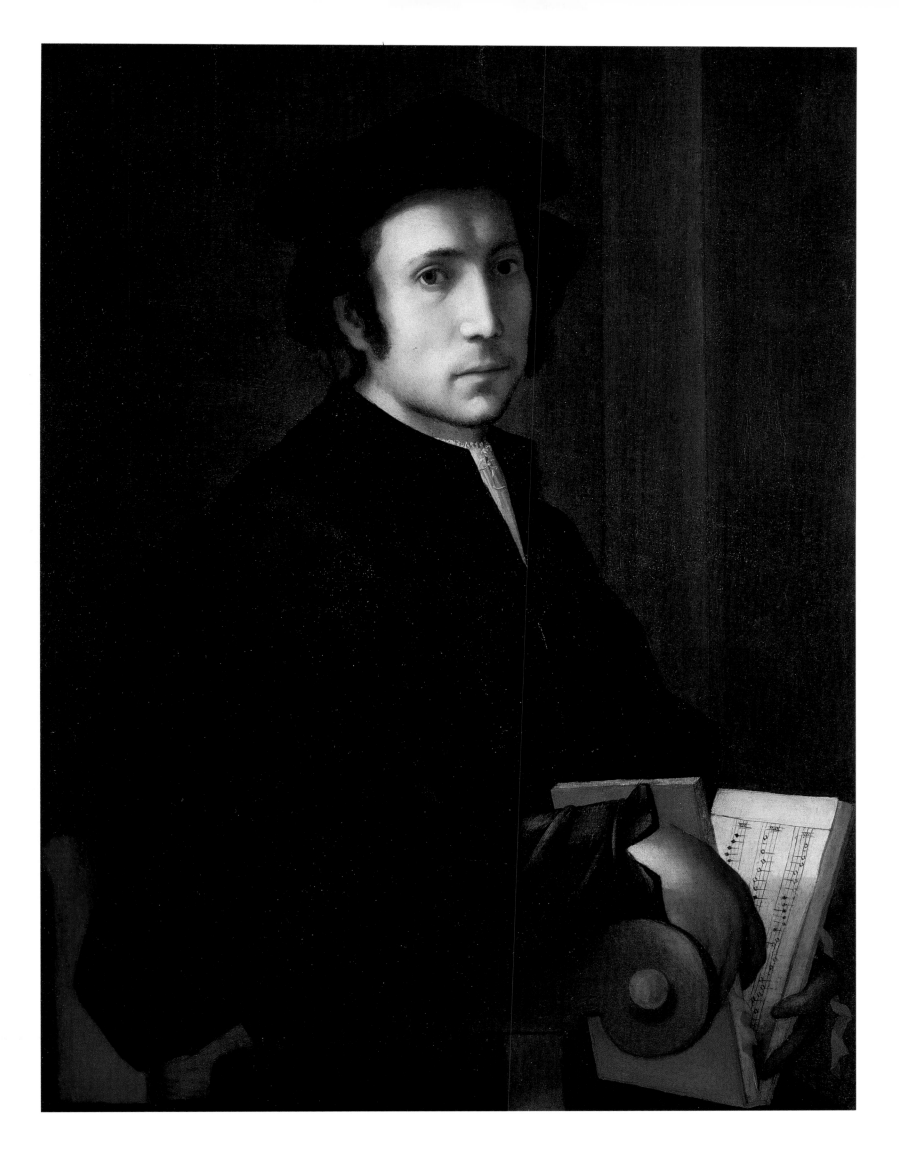

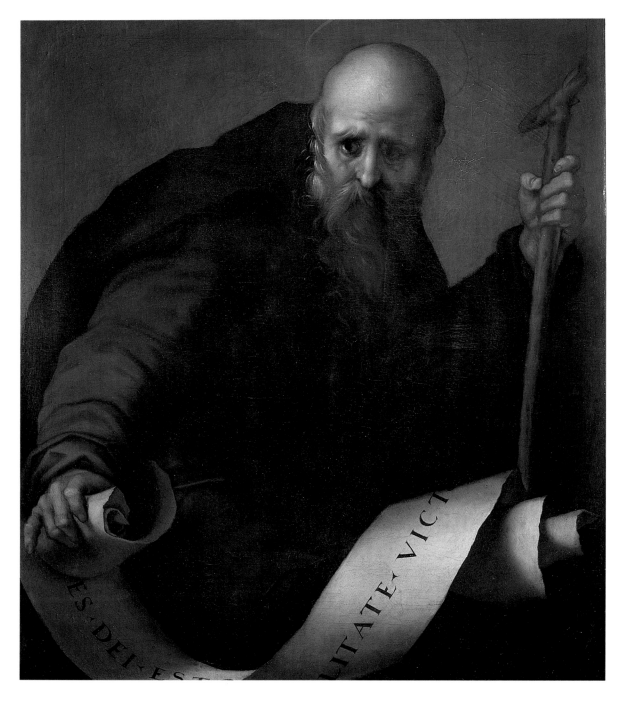

27 (left) *St. Anthony Abbot*, ca. 1519
Oil on wood, 78 x 66 cm
Galleria degli Uffizi, Florence

The hermit St. Anthony (ca. 251–355) renounced all
worldly goods and went to live in the desert in Central
Egypt. His ascetic lifestyle later became the model on
which Christian monasticism was based. Foregoing any
narrative moments, Pontormo concentrates on the facial
expression and posture of the bearded St. Anthony, who
is identified here by his T-shaped cross. In spite of the
saint's great age, his right arm, stretched out in front of
him, conveys an impression of vitality and energy.

28 (opposite) *Sacra Conversazione (Pala Pucci)*, 1518
Oil on paper, 214 x 185 cm
San Michele Visdomini, Florence

"The panel shows Our Lady seated and holding out the
Christ Child to St. Joseph, whose face is smiling with so
much vivacity and alertness that it is stunning." This is
how Vasari describes this panel painting, which he also
rates as the "best picture ever produced by the artist". The
Pala Pucci was Pontormo's first major commission for an
altar painting. It was commissioned by Francesco di
Giovanni Pucci, a former gonfalonier of the Florentine
Republic, for his family altar in the church of San
Michele Visdomini near the cathedral.

25 (previous double page, left) *Portrait of a Jeweler*,
ca. 1517/1518
Oil on wood, 69 x 50 cm
Musée du Louvre, Paris

The model for this portrait was probably a well-to-do
Florentine artisan. Pontormo has achieved an animated
pose by means of the directional opposition of the arm
and the head of the sitter. This moment of tension is
further heightened by the direction of the light in the
painting. This work was already part of the collection of
the French King Louis XIV in the 17th century, and was
placed in the Louvre during the reign of Napoleon.

26 (previous double page, right) *Portrait of a Musician*,
ca. 1518/1519
Oil on wood, 86 x 67 cm
Galleria degli Uffizi, Florence

The main protagonist in this dramatically conceived
painting is the light that enters sideways and at an angle,
plunging the right side of the man's face into mysterious
semi-shadow. Selected areas in the painting are also
highlighted. In his characterization of the painting's
subject, Pontormo has concentrated on the essential: on
the delicate features of the sitter, on the right hand, and
on the book of music in which it is possible to make out
parts of a composition for three voices in the tenor clef.

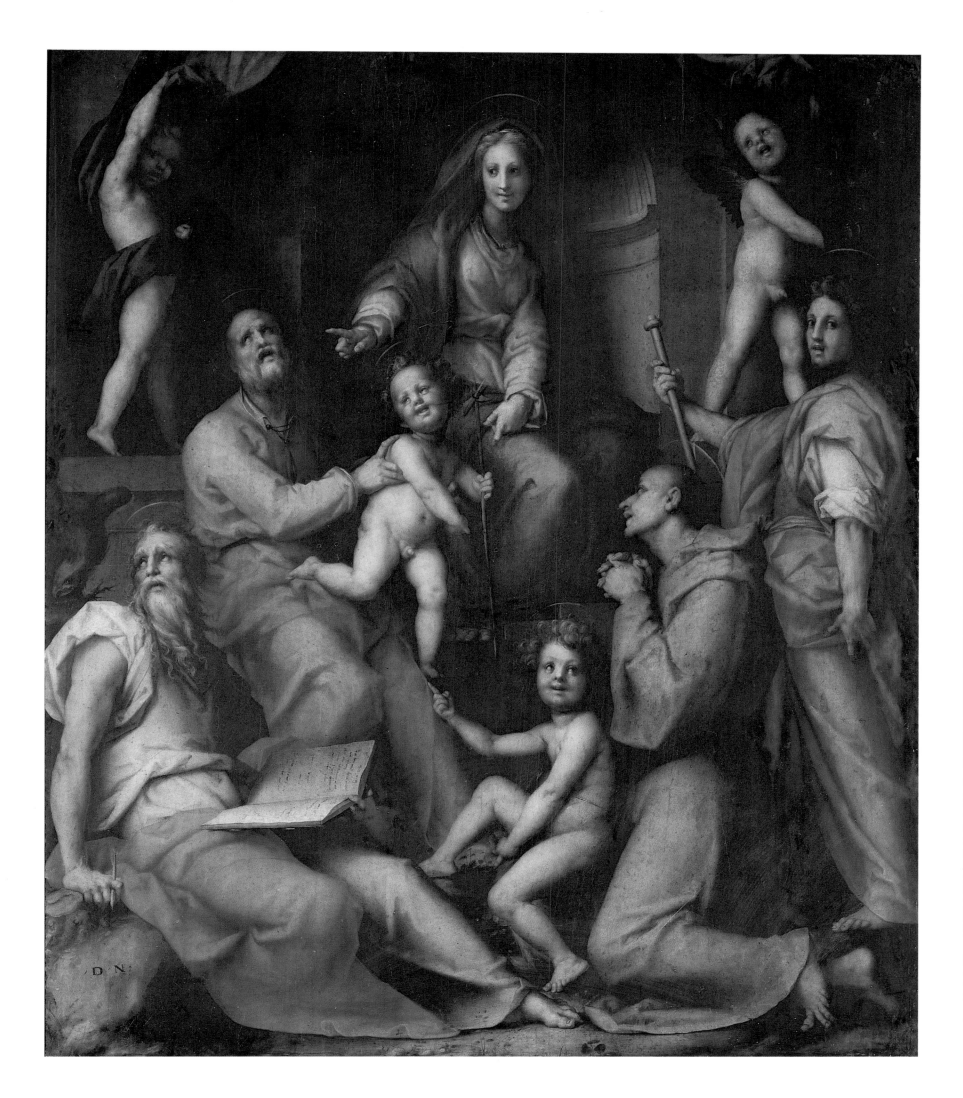

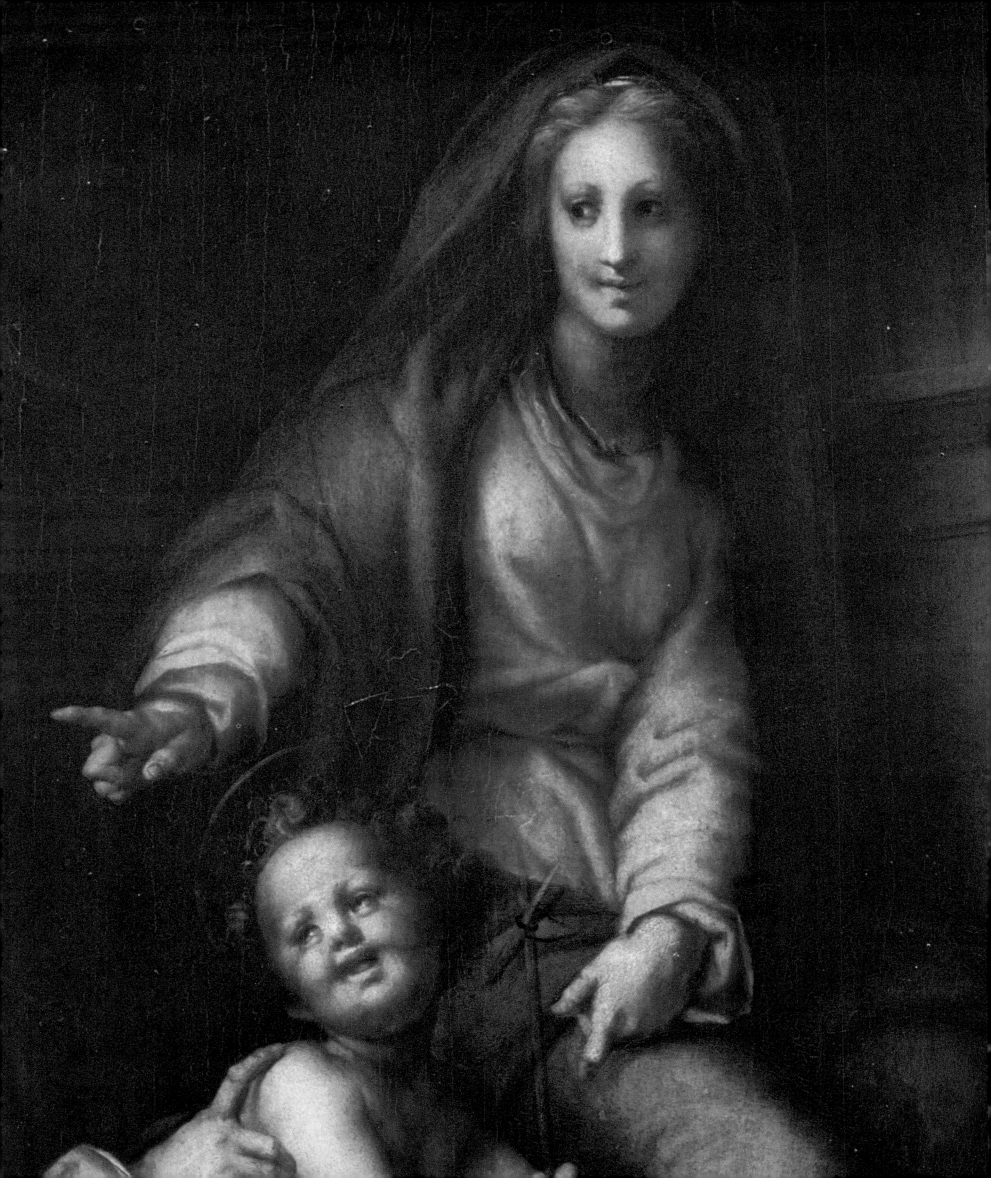

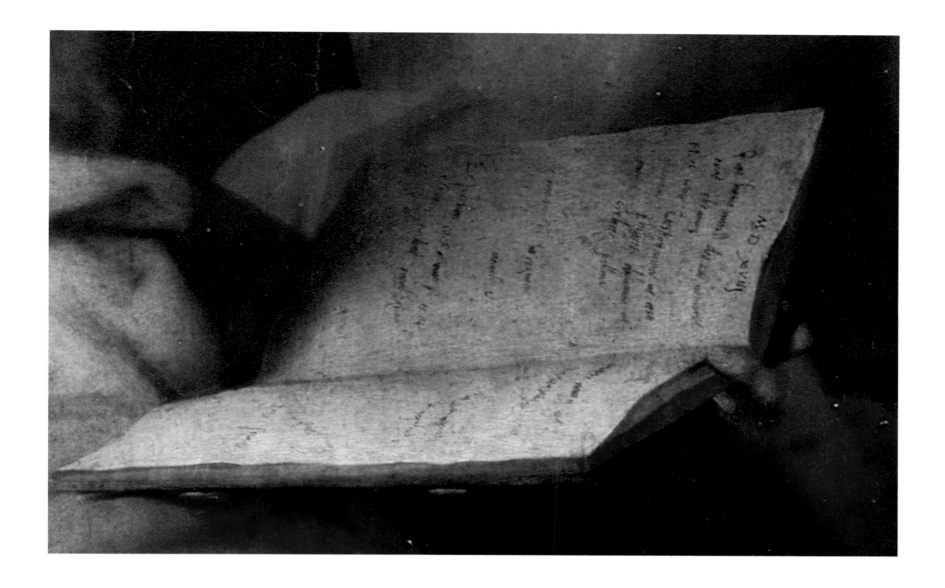

29, 30 *Sacra Conversazione (Pala Pucci)* (details ill. 28), 1518

Above the group of four figures the Madonna sits enthroned. Full of grace, she looks towards the left, whilst her sitting position towards the right of the picture restores a balance to the picture. From an artistic point of view the slightly twisted figure of the Queen of Heaven is the key element of the composition, which is developed from a wide variety of different view points. The dark toning of Pontormo's "Pala Pucci" betrays a conscious imitation of Leonardo's "tenebroso painting". Moreover, the soft smile of the Madonna is reminiscent of the famous pictorial creations of the master from Vinci.

to avoid confusion and to keep the right balance. Thus it is in *Sacra Conversazione* that we find numerous formal relationships that give the picture the necessary cohesion. The clear emphasis on the left side results in turn from a reference to another work within the church: the glances of a total of five figures are directed towards the crucified figure of Christ on the high altar of San Michele Visdomini. Despite the orientation towards the left, it is the fine balance of the picture that determines its impact, and this is due to the position of Mary, over which Pontormo had taken special care. The Madonna, who sits enthroned above everybody, turns her upper body towards the left and draws the focus over to Joseph and St. John the Evangelist. At the same time, her legs lead our gaze to the right and to Jacob and the kneeling Francis. Mary is the central point of the

painting around which everything revolves, a technical feat Pontormo achieves by using the twisted figure to engage with both sides of the picture. In the lower part of the picture the small naked figure of John the Baptist fulfills a similar function of linking together the picture elements. If we compare this altar picture with the strict representation of the *Sacra Conversazione* from the Quattrocento, in which the saints stand in a row next to Mary, it becomes clear that in Pontormo's picture a real conversation is taking place between the saints. By means of gestures, glances, body postures, and color, Pontormo has the figures enter into a lively dialogue. Vasari's judgment of the *Pala Pucci* was particularly positive: "It is the most beautiful painting that this exquisite painter has ever produced."

Joseph and his Brothers in the Bedchamber of the Borgherini

31 *Joseph in Egypt* (detail ill. 32), 1517/18

On the lowest step of the Pharaoh's palace there sits a child, a portrait of Pontormo's beloved pupil, Angelo Bronzino. Its inclusion serves to underline the artist's concept of the sequence of generations which is at the heart of the cycle of the Joseph panels. This is, however, only one of the many aspects which link the representation of the biblical story of Joseph and his brothers with the life of 16th century Florence.

PAINTING AS DECOR FOR PRIVATE ROOMS

The beauty of the young Pontormo's painting must have appeared quite breath-taking to his contemporaries. Vasari at least seems almost lost for words in the attempt to give fitting expression to his deep admiration. So it is that he gives the award of "best picture" not just to one, but to two of Pontormo's youthful works. Particularly remarkable here is the fact that the two paintings honored in this way are quite different, although they originated at approximately the same period.

Pontormo's *Sacra Conversazione* of 1518 (ill. 28), already discussed above, a large altarpiece in the tradition of Leonardo's dark-toned paintings, demonstrates an admirable arrangement of monumental figures. In contrast, the other "best picture" is an incredibly colorful painting of medium size that dates to the years 1517/1518. In a fantastic landscape and on an architectural stage there are numerous little groups of figures acting out scenes from the Old Testament story of *Joseph in Egypt* (ills. 31, 32). Vasari praises the "beauty of the composition", the "arrangement of the figures" and the "liveliness of the heads". Today this picture, with its elaborate composition made up of many centers of activity, is regarded as epitomizing the quintessential anti-classical Mannerist style.

Indeed the contrast between Pontormo's Joseph panels and the altarpiece in San Michele Visdomini could hardly be greater. Nevertheless, the two works can in a way be regarded as related, not only because of Vasari's common evaluation of them and the closeness of their dates of execution, but also because of the insight they give into the importance of the context of art in the early modern period. Painting at that time relied exclusively on commissions, and served above all to decorate and glorify sacred or secular rooms. The artists of the Renaissance therefore primarily responded to the requirements of the particular commission, and in their artistic designs the wishes of the patron played a very significant role. As Michael Baxandall once acutely observed, painting in the Renaissance was too important a subject to be left solely to the painters.

In the case of Pontormo a discussion of the background to his art seems particularly appropriate, since even today his name is associated with the romantic aura of an independently creative genius. His fascinating paintings are all too easily seen as the expression of a very individual artistic sensibility – an assessment that can be traced back to Vasari and his characterization of the aging Pontormo as an eccentric. The 24-year-old's two highly diverse artistic creations, so admired by Vasari, almost defy explanation by the modern criteria of the development of a personal style. They do, however, reveal the highly developed ability of the young painter to realize the wishes of his particular

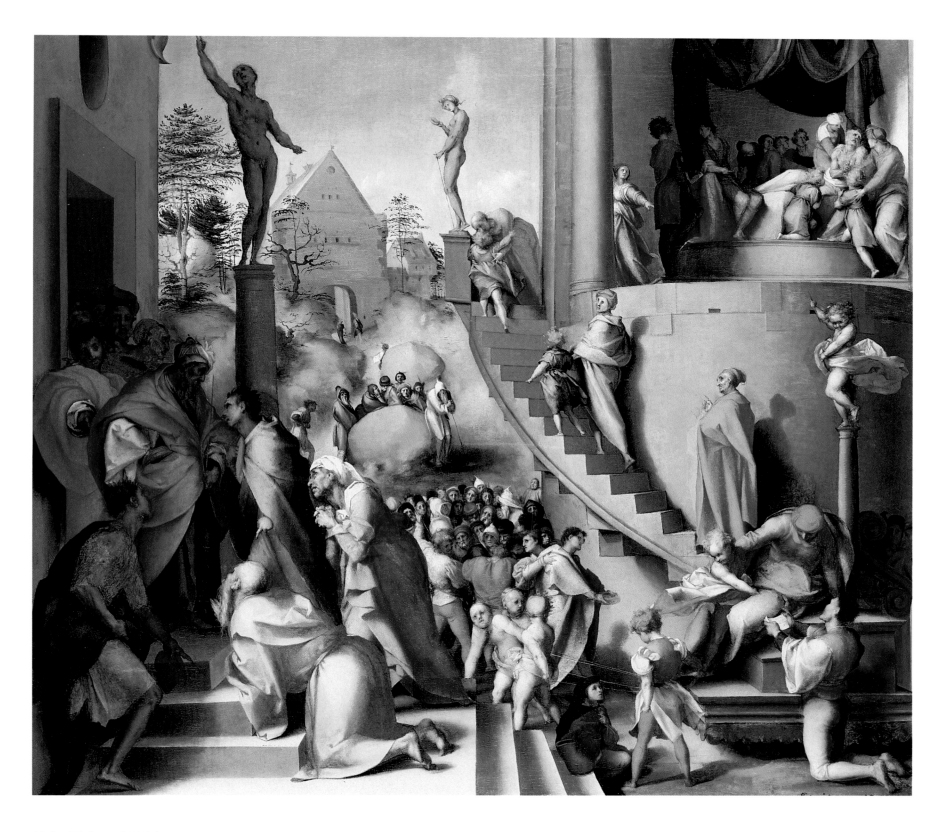

32 Joseph in Egypt, 1517/1518
Oil on wood, 93 x 110 cm
The National Gallery, London

The panels depicting the Old Testament story of Joseph
used to be part of the decoration of a bedroom in the
Florentine palace of the Borgherini family. Here, several
scenes are represented in one picture. The figure of Joseph
can be identified by his bright red cap. In the left
foreground he stands, cap in hand, before the Pharaoh,
and points to the kneeling figure of his father, Jacob. On
the right, Joseph is seen bending towards a petitioner. He
appears again halfway up a curved staircase, holding one
of his two sons by the hand. Finally, Joseph is depicted in
the top right-hand corner beside Jacob's bed.

33, 34 *Joseph Being Sold to Potiphar* (and detail),
1516/1517
Oil on wood, 58 x 50 cm
Salmond Collection, Henfield, Sussex, on permanent
loan to The National Gallery, London

The small figure of Joseph in his yellow cloak is seen
standing before Potiphar, the Pharaoh's highest-ranking
administrator, and Joseph's new master. Joseph was
originally sold by his jealous brothers to the Ishmaelites,
depicted on the left, who then sold him to his new
master in Egypt. A statue of *Caritas* (charity, or brotherly
love) in the background on the right points to the hidden
Christological message of the story: Joseph is able to
survive his long suffering successfully thanks to the
overwhelming love of his father Jacob. The story of
Joseph in the Old Testament was therefore seen as
prefiguring the life of Jesus.

patron in an appropriate and yet innovative way. It is this gift that must have added considerably to Vasari's positive assessment of him.

Contrary to his widespread reputation as a loner, Pontormo participated many times on commissions that depended on close cooperation with other artists, and on a precise agreement with the patron. The almost square panel portraying the story of Joseph resulted from an extensive commission awarded in 1515 by the Florentine burgher Salvi Borgherini to Pontormo, Andrea del Sarto, Francesco Granacci (1477–1543) and Francesco Bacchiacca (1494–1577). Borgherini's requirements included the production of 14 panels that were to decorate the nuptial chamber of his newly married son Pierfrancesco. The theme was to be the representation of the story of Joseph and his brothers according to the version in the First Book of Moses,

Genesis, chap. 37–50. The wooden paneling in the room, the gilding, and the precious wooden carving had been commissioned by Borgherini from the respected architect Baccio d'Agnolo (1462–1543). The paintings would have to fit perfectly into the wooden panelling at the head and foot of the bed as well as on the chests and walls. By means of the costly decoration of the young couple's future bed chamber, the patron Borgherini was acknowledging the high social position of his daughter-in-law, Margherita Acciaiuoli, who belonged to one of the most respected and wealthy families in Florence. Paternal pride at the new family connection and hope for a fruitful future may have moved Borgherini to his generous wedding gift.

According to Vasari, it was not long after its completion in the year 1518, that the decoration of the Stanza Borgherini was being praised throughout

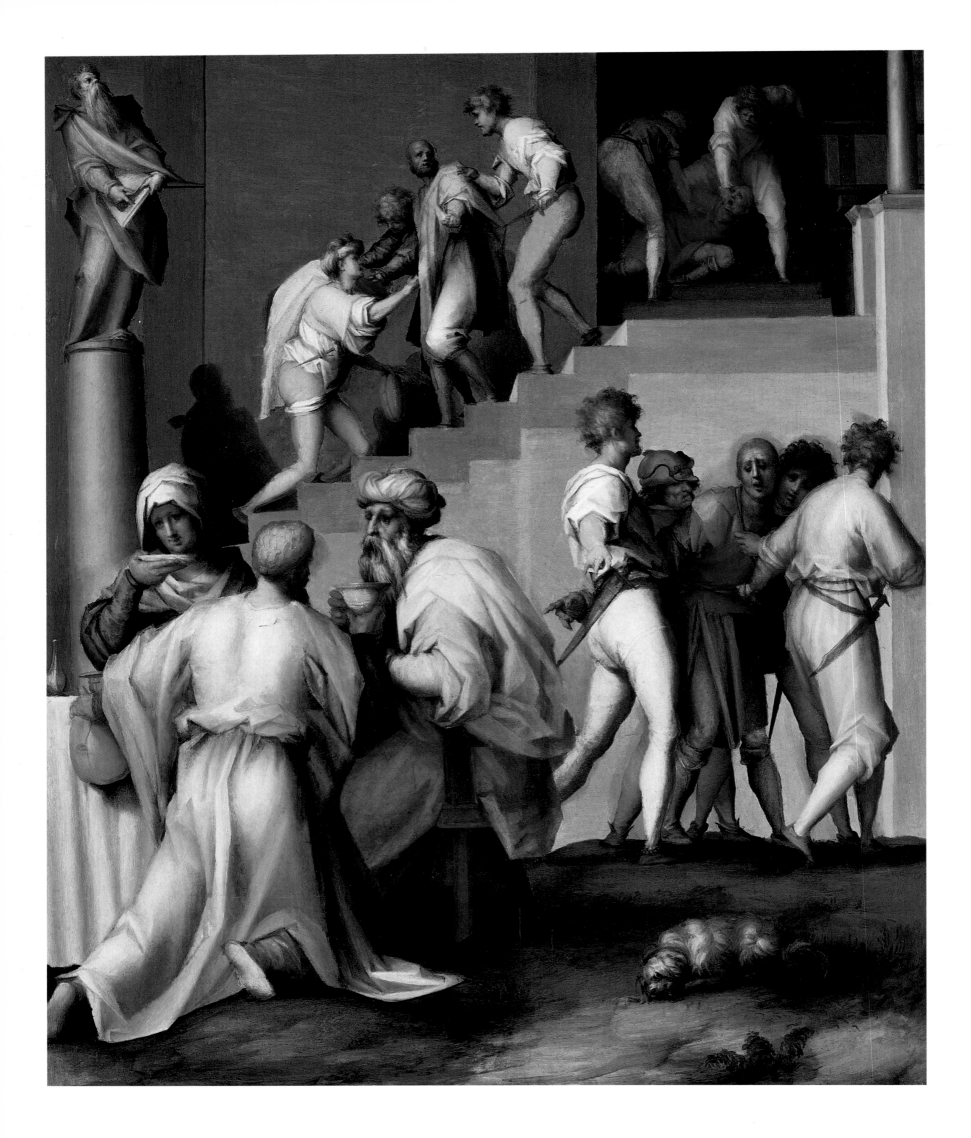

35 (opposite) *The Punishment of the Baker*, 1517
Oil on wood, 58 x 50 cm
Salmond Collection, Henfield, Sussex, on permanent
loan to The National Gallery, London

Joseph's first interpretation of dreams took place while he
was serving his prison sentence, and is represented in this
painting by a number of scenes occurring simultaneously.
In his sleep Joseph had recognized the just destiny of his
two fellow prisoners. This led not only to his own release,
but also to the drastic punishment of the baker, as
illustrated in the painting in three episodes taking place
on and below the staircase. The Pharaoh's treasurer, on
the other hand, was rehabilitated and can be seen on
the left in front of a laid table. Again, a statue in the
background is used to emphasize the significance of the
story: the stone prophet on his pedestal is an allusion to
Joseph's gift of prophecy.

36 (right) *Motion study for Joseph in Egypt*, 1517/1518
Red chalk, 41 x 27 cm
Musée des Beaux-Arts, Cabinet des dessins, Lille

This is a preparatory drawing for one of the figures on
the staircase in the *Punishment of the Baker*. The sequence
of the movement is broken down into several pictures,
similar to the film technique of representing several
sequences of an action. The body is modelled in an
almost naturalistic way and testifies to Pontormo's
ambitious interest in the study of the human body and
motion, an interest that he applied even to figures that
played a marginal role in the story he depicted.

37 Joseph Revealing Himself to his Brothers, 1515/1516
Oil on wood, 35 x 142 cm
Salmond Collection, Henfield, Sussex, on permanent
loan to The National Gallery, London

The long and narrow shape of the panel suggests that it
was used to decorate a clothes chest. Joseph is hailed as
the redeeming savior, as is testified by inscriptions on
Joseph's carriage and on the base of the statue of Ceres
inside the grain store. The words "Ecce Salvus mundi"
(This is the redeemer of the world) inscribed in the
tympanum of Joseph's carriage are an obvious reference
to Christ. They might, however, also be an allusion to
the Christian name of the man who commissioned
the pictures, Salvi Borgherini.

Florence for its "regal splendor". Pontormo's contri-
bution consisted of four paintings. Two smaller square
panels, which may be regarded as pendants, portray
scenes from Joseph's childhood and youth, sorely tested
by suffering: *Joseph Being Sold to Potiphar* (ill. 33)
and the *Punishment of the Baker* (ill. 35). The very
elongated rectangular panel *Joseph Revealing Himself to
his Brothers* (ill. 37) already portrays Joseph after his
promotion by the Pharaoh to be the ruler of Egypt. By
interpreting the dream of the Pharaoh, Joseph
recognized that the land of Egypt would be visited by
seven fat years followed by seven lean years, and that
moderation and thrift alone would save the country
from famine and misery. To the right of the picture
there is a granary that is a reference to the wise storage
policy of the Egyptians – the policy that has driven
Joseph's brothers out of their homeland of Canaan to
seek relief in Egypt from their famine. The scene marks
a dramatic turning point in the story. Sitting on a
triumphal cart, Joseph greets the brothers who once
spurned him. Full of remorse, the treacherous siblings

bow down as they recognize the identity of the
generous ruler. The final picture in the series, the highly
praised *Joseph in Egypt* (ill. 32), is said by Vasari to have
been placed on the wall next to the entrance. The final
chapters of the Old Testament narrative are illustrated
in a concentrated form in this painting. Jacob's move to
Egypt is skillfully portrayed in the same picture as the
scene where, in the left foreground, Joseph introduces
his father Jacob to the Pharaoh. Finally on the right
hand side, there is the almost surreal and fantastical
architecture of the building on whose winding staircase
Joseph's two sons, Manasse and Ephraim, are being led
up to the aged patriarch Jacob. On the stage-like
platform of the building Jacob, lying on a bed, receives
his grandsons and gives them his blessing.

Pontormo's Borgherini panels are part of a decorative
whole that can no longer be seen in its totality. Already
by the end of the 16th century the Stanza Borgherini
had been taken apart, and the 14 individual pictures of
the four participating artists are now to be found in
various museums and collections. Thanks to the

reconstructions of Allan Braham, however, it has now been possible to gain an approximate idea of the appearance of the room. It has been shown that the four participating artists worked together in close cooperation to create a unified cycle that charted the stages of Joseph's life chronologically and that remained true to the Old Testament text. At the head of the marital bed there were scenes portraying Joseph's childhood and youth. The first was a painting by Andrea del Sarto (ill. 40) that showed Joseph's departure from his parents and his murderous and evil-scheming brothers. Pontormo's representation of Joseph before Potiphar must be imagined as directly following on from del Sarto's picture. As in del Sarto's panel, the young Joseph in Pontormo's painting is wearing a yellow coat. Moreover, the proportions of the figures and the similarity of the architecture and landscape motifs in all the Borgherini panels ensure a continuity in the representation. Precise agreement between the participating artists over the continuity of the common pictorial elements would appear to have

been indispensable in the decoration of the Stanza Borgherini. Moreover there is a recognizable unity of style in all the individual pictures that comes before any personal imprint of the particular artist. The many small detailed scenes in each of the compositions and the delicacy of the figures appear to hark back to the late-Gothic style, an impression heightened by the technique of simultaneous narration employed in all the pictures. The subordination of the pictures to the overall character of the Stanza Borgherini is therefore very evident. It is this that explains why Pontormo may have painted such diverse works as the altarpiece for San Michele Visdomini and the Joseph panels for the Stanza Borgherini during the same period. This also highlights another feature that represents a fundamental innovation for Pontormo's generation. At the beginning of the 16th century artists were able to master several styles that they could draw on according to the nature and demands of the commission. An altarpiece demanded a very different artistic idiom from the one required in the decoration of a private bed

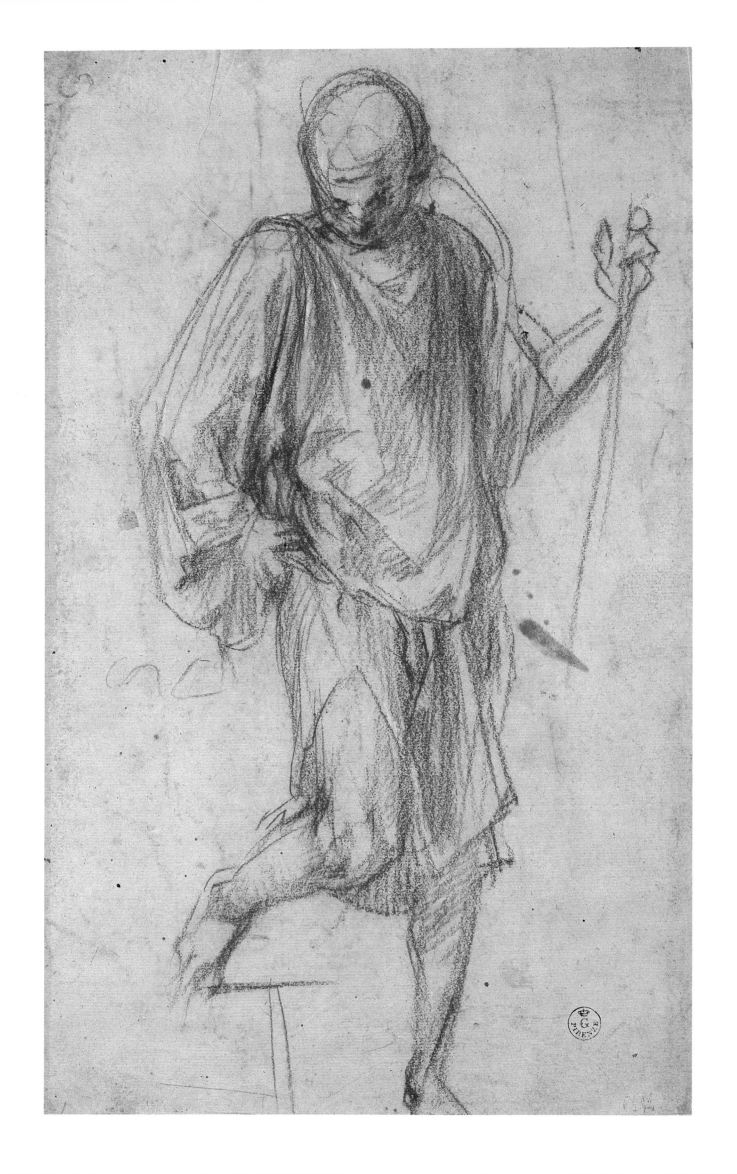

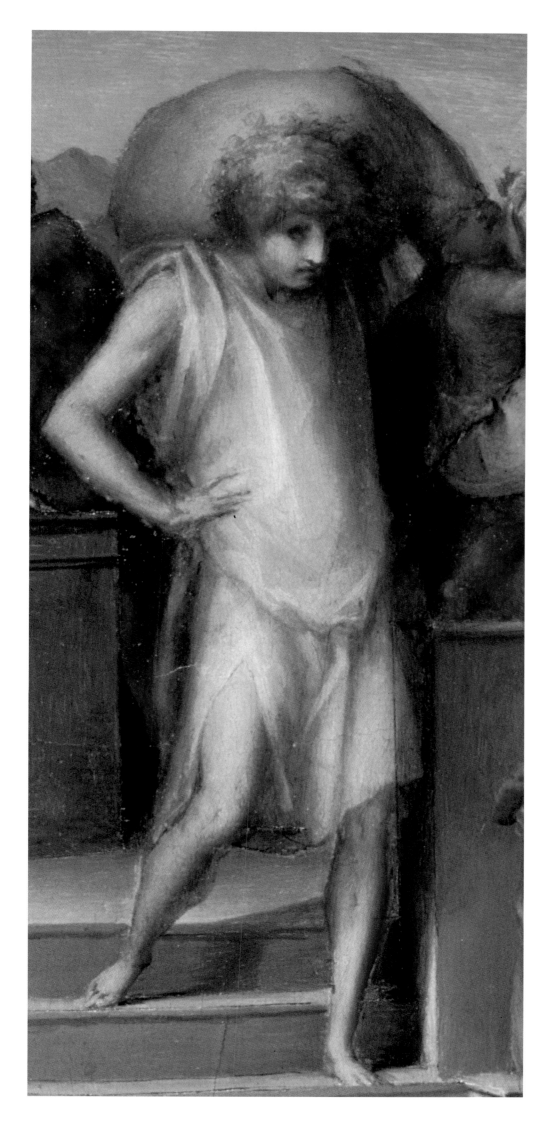

38 (opposite) *Figure study*, 1517/1518
Red chalk, 40.8 x 25.2 cm
Galleria degli Uffizi, Gabinetto dei Disegni e delle
Stampe, Florence

39 (right) *Joseph Revealing Himself to his Brothers*
(detail ill. 37), 1515/1516

This is another study of a figure in motion for the
paintings for the Stanza Borgherini, and shows a draped
figure about to descend a staircase. A figure adopting a
similar posture can be seen on the steps of the grain store
in the panel painting *Joseph Revealing Himself to his
Brothers*. The figure in the preparatory drawing is not
carrying a heavy sack, as in the painting. As usual when
working from the life model, the carrying position of the
arm was established with the aid of a staff.

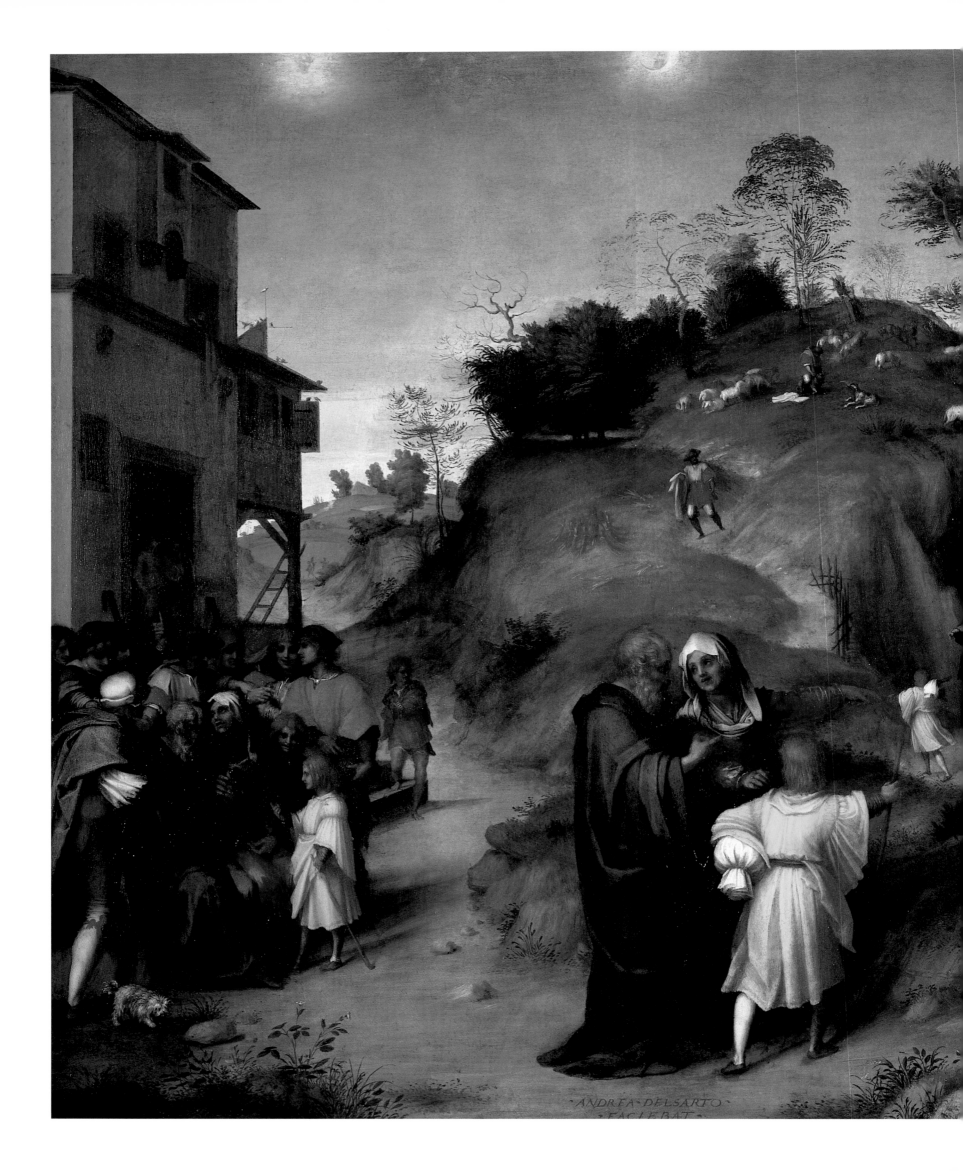

ANDREA·DELSARTO·
·FACIEBAT·

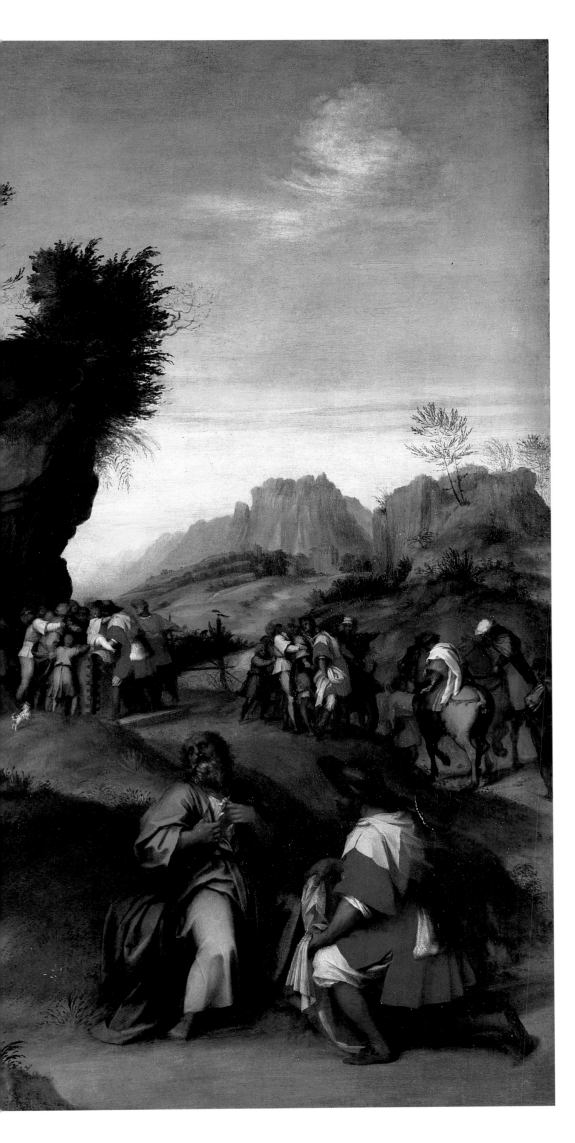

40 Andrea del Sarto
Joseph in Egypt, 1515–1518
Oil on wood, 98 x 135 cm
Galleria Palatina, Florence

Two panel paintings by Andrea del Sarto represent the
artist's contribution to the decoration of the Stanza
Borgherini. Here he relates how the story of Joseph
and his brothers began. Joseph is seen in the center
foreground, taking leave of his parents. As in Pontormo's
paintings, Joseph as a boy can be identified by means of
his yellow cloak. In this picture, Andrea del Sarto also
uses the simultaneous representation of several scenes that
take place in chronological order. The malicious brothers
are seen in the right-hand background of the painting,
looking down into the well into which they had pushed
Joseph in order to rid themselves of him.

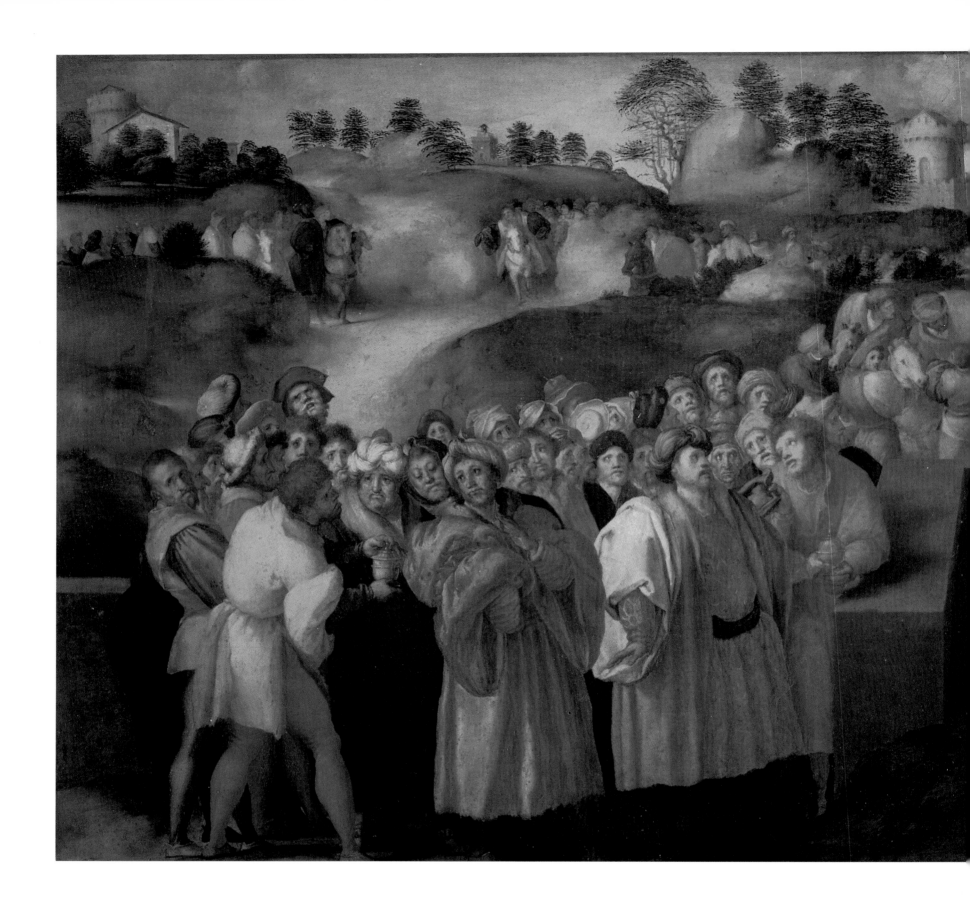

41 *Adoration of the Magi*, 1519/1520
Oil on wood, 85 x 190 cm
Palazzo Pitti, Florence

Epiphany, the feast of God's manifestation in Jesus
Christ, has been celebrated on January 6th ever since the
3rd century. The three Magi paying their tribute to the
Christ Child are representative of the whole of mankind,
and this is exactly what comes across in Pontormo's
crowded painting. The approach of the procession of the
Magi is depicted in a succession of stages and included
figures that can be read as quotes from Dürer, Leonardo,
and other artistic models.

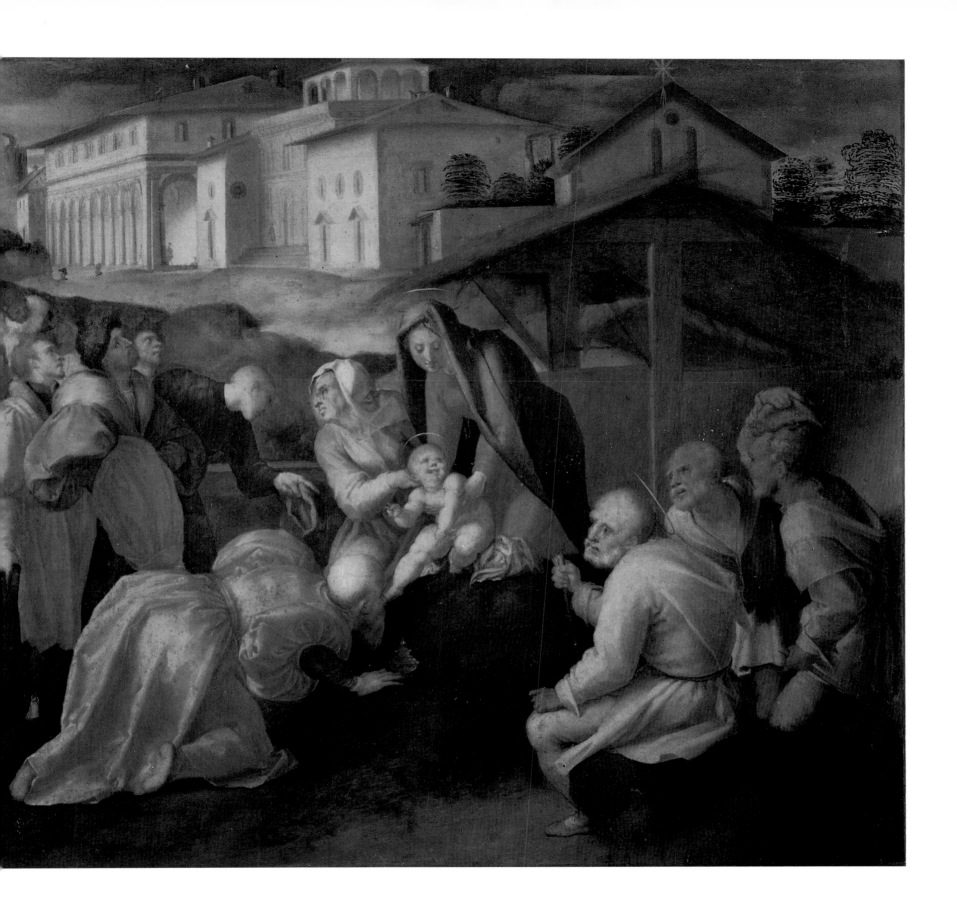

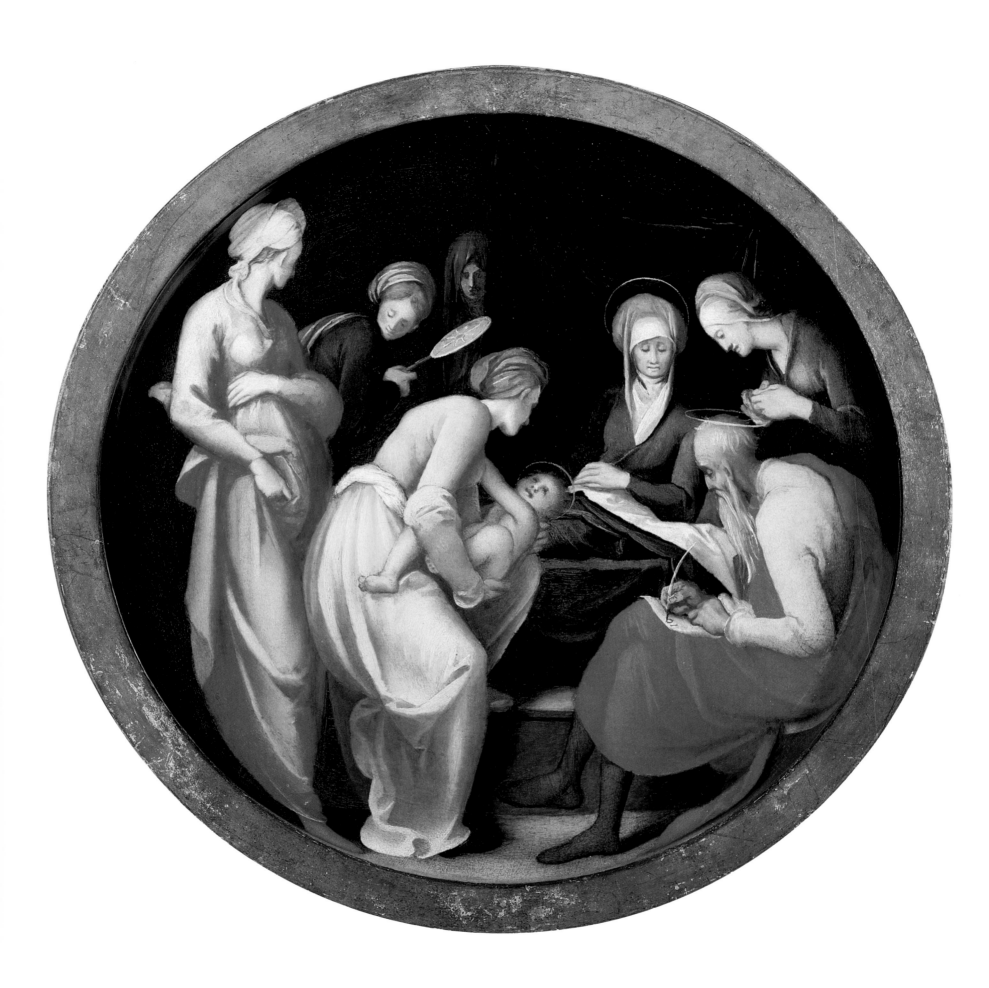

chamber. The style of a pictorial representation, its *maniera*, was closely in harmony with the theme to be portrayed. Although the primary objective was to relate a story clearly and with conviction, it is nevertheless not surprising that the decoration of a private nuptial chamber should be littered with many references to the family of the patron, of whose intentions more will be said below.

The biblical story of Joseph and his brothers enjoyed great popularity in Renaissance Florence, although it was rare as the subject for bedroom décor. However in one respect it was very well suited to the family history of the Borgherini. The story of Joseph is fundamentally about how a young man triumphs in adversity in a foreign place, achieves fame and fortune against all the odds, and how finally the family is happily reunited. There are of course evident parallels to the career of Pierfrancesco Borgherini, who not only had a banking house in Florence, but also in distant Rome. The story of Joseph served as a constant visual reminder to the young banker of exemplary virtues. Included among these are Joseph's chastity in the face of the seduction by Potiphar's wife, as well as his generosity and his readiness to forgive. The First Book of Moses, Genesis deals above all with the descent of races, that is to say, from father to son.

In this respect, too, the theme is a fitting contribution to the marriage and the founding of a new family, to which, after all, a Christological reference is appropriate. Joseph represents the prefiguration of Christ, and the love of his father Jacob is equated with the love of God the Father. When in the First Book of Moses, Genesis it says, "And the Lord was with Joseph…and made all that he did to prosper in his hand", this can be interpreted as a wish of good luck from the Borgherini father to his ambitious son on the occasion of his marriage. Finally, but very significantly, the fact that dreams form one of the central themes of Joseph's story obviously makes the story particularly meaningful in the surroundings of a bedroom. It might well be that in their fantastic and imaginative paintings the four artists thought of just this aspect and told the epic story of Joseph and his brothers in pictorial sequences that are reminiscent of dream narratives.

The success of the Stanza Borgherini brought Pontormo a second commission shortly after 1518 from another art-loving private individual in Florence. Giovanmaria Benintendi had decorated his entrance hall with a fine collection of paintings. Pontormo duly obliged with a painting that Vasari described as "a picture deserving of the highest praise". Pontormo arranged over 80 figures in a landscape format to create an imposing *Adoration of the Magi* (ill. 41) that makes use of the technique of simultaneous representation tried and tested in the Joseph panels. So it is that the approach of the kings' retinue is illustrated at several stages. It is in the foreground on the right that the Three Wise Men from the East are portrayed as having arrived at their destination. Humbly they bow before Mary and the Christ Child. One king has even thrown himself emotionally to the ground, reminiscent in his pose of a figure in Leonardo's famous *Adoration* of 1481/1482. On closer examination of Pontormo's broadly planned narration of the Epiphany, it becomes evident that there is a mixture of very diverse stylistic features. Some of the heads in the kings' retinue appear as though borrowed from the pictures of Albrecht Dürer (1471–1528). Other elements again show evidence of recourse to the Florentine tradition: the palace in the background, for example, cites the architecture of the foundlings home in Florence designed by Filippo Brunelleschi (1377–1446). To the left is the astonishing addition of a typical northern European town fortification. By means of this combination of picture formulas of the most diverse origins, Pontormo creates the impression of a rich narrative that, with its allusions at many levels, will have provided great enjoyment to a patron versed in art history.

One last example of artistic work in the private sphere is provided by the painting of a so-called birth plate (ill. 42). Once again the function of the object fits perfectly with the story portrayed, the birth of St. John the Baptist. It was on the birth plates that women who had just given birth were served. In a very subtle way Pontormo adapted the delicate and slightly lengthened figures to the format. This round picture presumably dates back to 1526, that is to say a few years after the Borgherini panels and the *Adoration of the Magi*. In terms of Pontormo's artistic biography, therefore, we have moved a long away from the early work so highly praised by Vasari, and are now in the phase that the latter described as regrettably straying from the path of high art. Vasari's main reproach was directed at Pontormo's orientation towards models outside Italy, and he was particularly critical of what he saw as the negative influence of the *maniera tedesca*, that is to say of German style, to which, to his great misfortune, the promising Pontormo had fallen prey.

42 *Birth of St. John the Baptist* (birth plate), 1526
Oil on wood, Ø 54 cm
Galleria degli Uffizi, Florence

Birth plates, *deschi da parto*, were given to women after the birth of their child, and have long been a tradition in Florence. The coat-of-arms showing the alliance between two famous families in Florence – the Della Casa and the Tornaquinci families – appears on the back of this plate. It is therefore generally assumed that Pontormo painted this birth plate to mark the birth of Aldighieri Della Casa in 1526.

HE WAS STILL FOND OF THAT GERMAN STYLE

43 *John the Evangelist* (detail ill. 44), ca. 1519

Pontormo's portrait of the Evangelist, part of a two-part picture panel, originates from around 1519. It marks a transition from the early works of the artist to his middle period which is characterized by an intensive dialogue with foreign models. Vasari's polemical critique had suggested that Pontormo was largely distancing himself from the Italian style. Nevertheless, the modelling of the Evangelist's lean face exhibits clear stylistic features of Italian provenance, such as the sculptural work of the Florentine Donatello. Pontormo's extensive interest in art and art history led to a highly productive and sophisticated further development of the models he used.

THE INTERACTION WITH FOREIGN ARTISTS

Whilst the main requirement for the artist in the Quattrocento was to study nature, at the beginning of the 16th century artists began to study the works of other artists intensively. Pontormo's *Adoration of the Magi* of 1519/1520 (ill. 41) already showed the virtuosity with which he was able to distil the most diverse styles to produce an independent and unified work. In the course of his career Pontormo constantly showed a keen interest in the works of other artists, and with its immense store of art treasures Florence offered every opportunity to see a wide variety of paintings. Imitating excellent pictures and possibly surpassing them by using one's own ideas was considered at that time as one of the most effective ways of producing a successful work of art. Drawing inspiration from other art and less and less from nature is an important feature of the phenomenon of Mannerism. Pontormo's work clearly demonstrates this change in thinking.

Around 1519 Pontormo was asked to paint a work for the village church of his birthplace, Pontormo. His fame had reached beyond the city of Florence. The two wood panels *St. John the Evangelist* and *St. Michael the Archangel* (ills. 43, 44) form the framework for a tabernacle of the holy cross in the village church of San Michele in Pontormo, today Pontorme, a suburb of Empoli. The two life-size figures are characterized by intense colors, the daring drapery of the robes, and a marked departure from the imitation of nature. On the left side the Evangelist is writing at an unseen writing desk, his body twisted and his legs crossed. The Archangel Michael, who is defeating evil in the form of a black-winged putto, poses in a kind of contrapposto position within the tall picture format. Swinging a sword in his right hand, he completely fills the available space within the frame as it widens towards the top. Within the narrow picture areas both figures demonstrate a maximum degree of movement. Both the dynamic and the statue-like qualities are skillfully held in balance. The statue-like effect is increased by the crisp draftsmanship within the folds of the robes and the outlines. Pontormo must certainly have used

sculptural models in the production of these panels. Comparisons have been made of Pontormo's figures of John and Michael with a number of others artists' works ranging from Donatello to the German Veit Stoß.

The interaction with the works of other artists can also be observed in a number of sacred works Pontormo painted in the third decade of the 16th century. Although *Madonna and Child with the Young St. John* (ill. 46) is possibly a copy of the lost original, it nevertheless demonstrates Pontormo's intention to create a work that again represents a synthesis of the most diverse elements of style. A grace emanates from the youthful Madonna that one could almost characterize as exaggerated late Gothic. She pointedly holds the infant Jesus standing upright and facing towards the spectator. The garments, worked with acutely angled folds, are reminiscent of the art of an earlier age. The background, again with its typical north European architectural elements, appears to have been borrowed from the pictorial world of the German artist Albrecht Dürer. In a painting in the Hermitage in St. Petersburg, *The Holy Family with the Young St. John* (ill. 47), the Virgin Mary is again dressed in robes, draped in elaborate gothic folds, and wrapped in a voluminous cloak. Behind Mary, Joseph and John look out from the painting as if from another plane of the picture. Pontormo is here experimenting with forms, which emphasize the elaborate, one could almost say artificial, character of the picture.

The increasing abandonment of the imitation of nature in favor of a formal, highly developed and stylized method of representation is clearly noticeable from the third decade of the 16th century onwards. Building on the achievements of the painting of the preceding century, such as perspective, optics, and correct anatomy, a younger generation of artists was turning to a new ideal in art: using art to improve nature and thereby imbue it with gracefulness. That was Pontormo's goal as a painter, as he was to reveal in his letter to the writer Benedetto Varchi in 1548. This new ideal consisted in an intellectualization of the fine arts, giving it equal status with poetry, music, and the all-embracing rhetoric of the time. Painters and

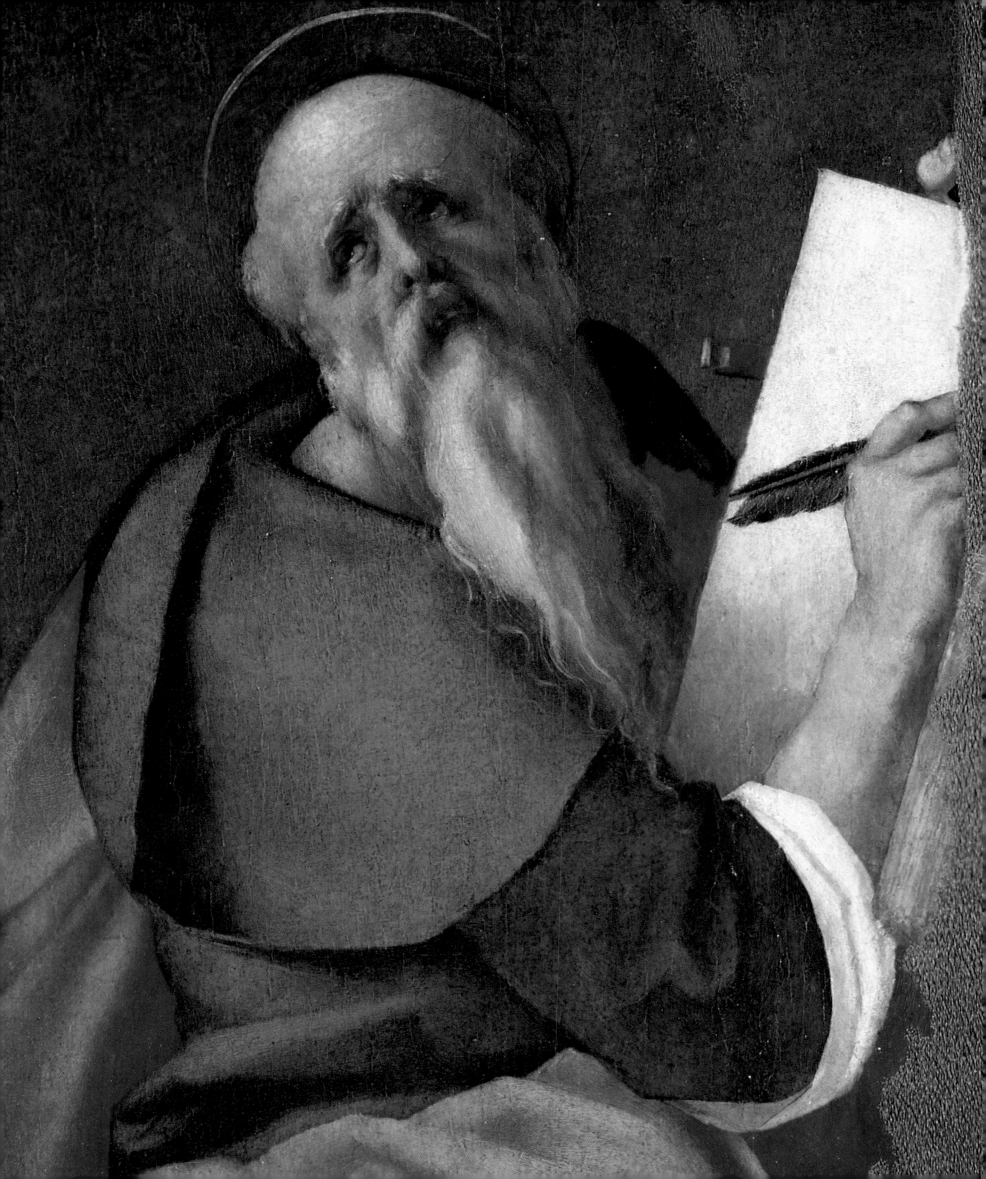

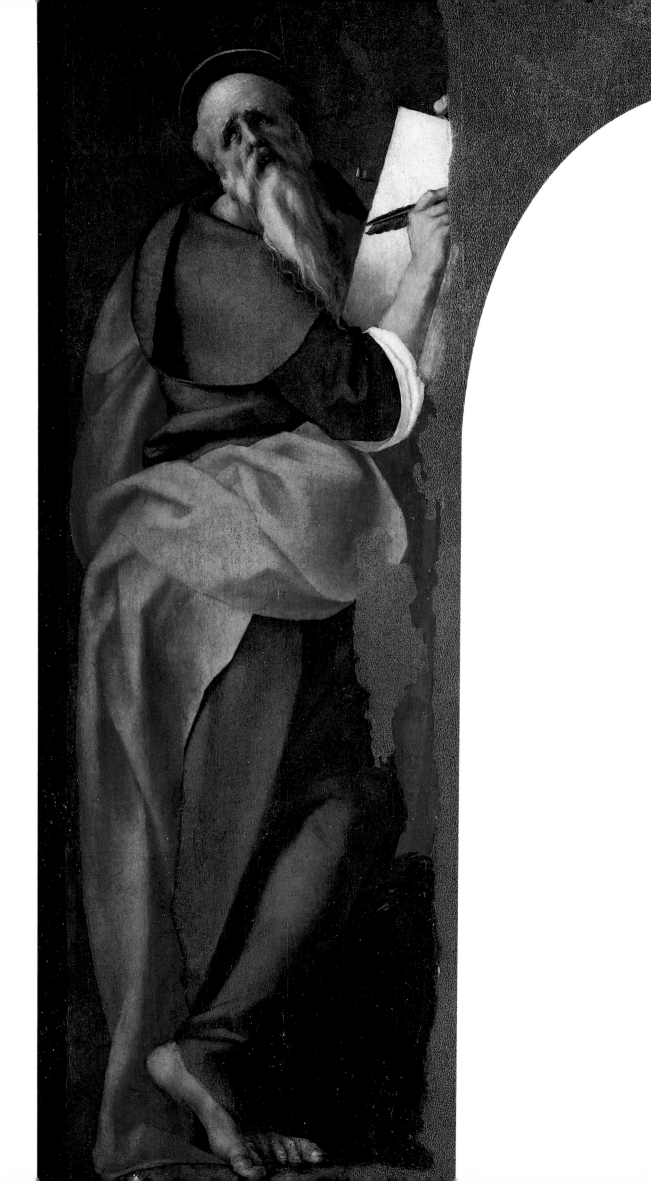

44 *St. John the Evangelist* and *St. Michael the Archangel*, ca. 1519
Oil on wood, 173 x 59 cm each
San Michele, Pontorme

Pontormo painted two panels for the church of Pontormo (today Pontorme), the village where he was born. The church is dedicated to St. Michael, and in Pontormo's panel the archangel is represented as the dragon slayer. In accordance with his function within the iconography of the Last Judgement, St. Michael holds the scales in order to weigh the souls of the resurrected. Depicted on the left-hand panel, St. John the Evangelist, in his role as author of the Apocalypse, provides the logical complement to St. Michael. The complementary effect of the two panels is further enhanced by the eye-catching drapery in glowing red, as well as by the figures' dramatic gestures.

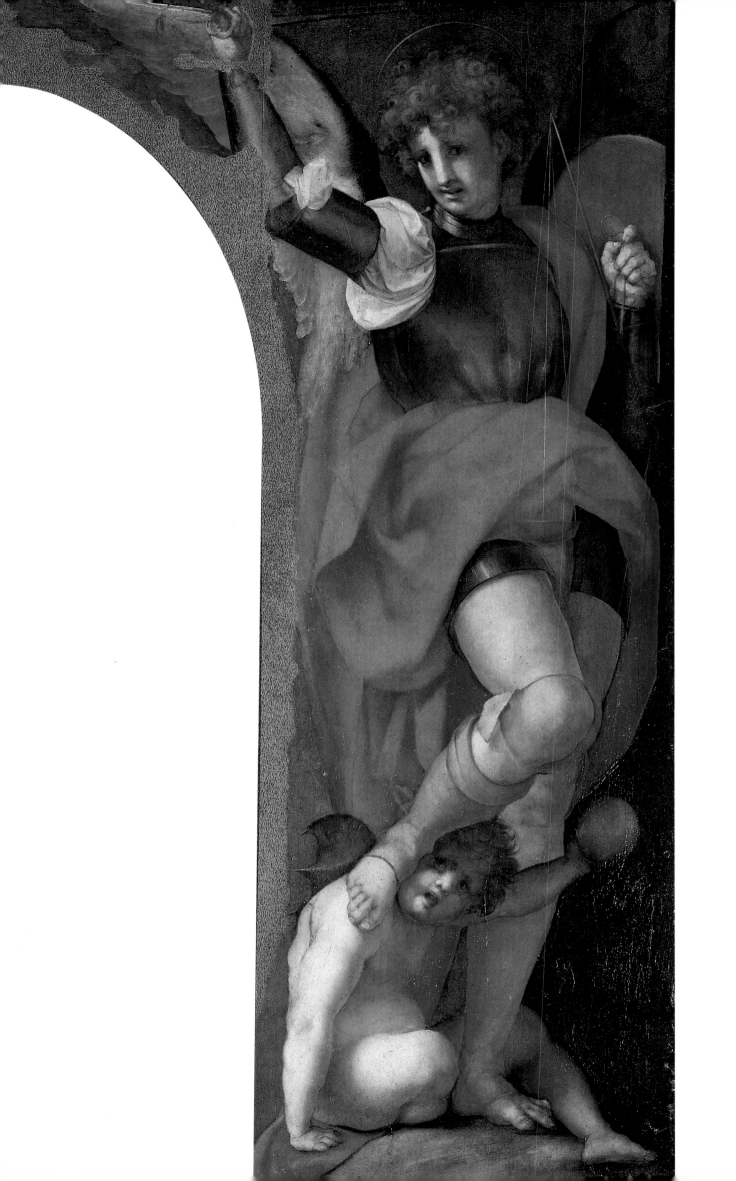

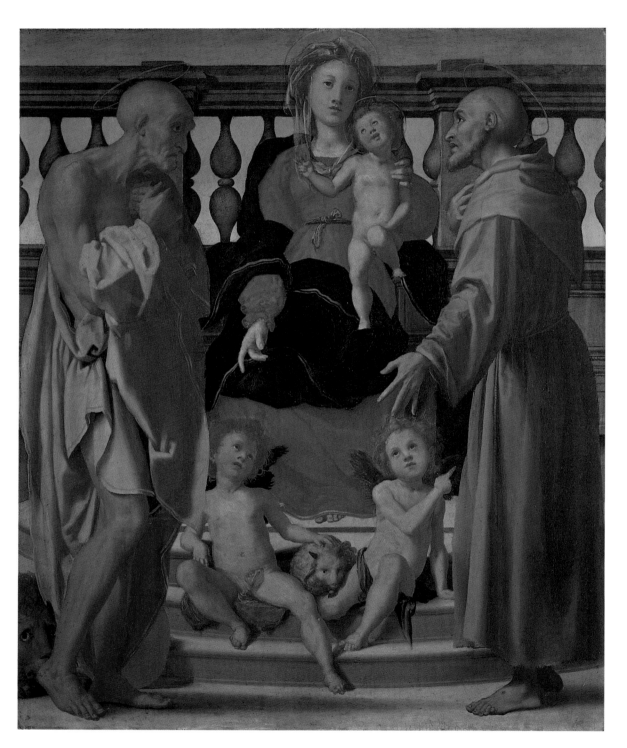

45 (left) *Sacra Conversazione*, ca. 1522
Oil on wood, 72 x 60 cm
Galleria degli Uffizi, Florence

This painting is dominated by violently contrasting colors that serve to increase the tension that seems to emanate from the gaunt figure of St. Jerome. With sheer horror he looks at the Stigmata visible on the left hand of St. Francis. The attribution of this painting to Pontormo is, however, the subject of debate. Like most of his paintings, it is neither signed nor dated. It is possible that this panel was painted by the talented young Angelo Bronzino who was an assistant in Pontormo's workshop.

46 (opposite) *Madonna and Child with the Young St. John*, 1523–1525
Oil on wood, 87 x 67 cm
Galleria Corsini, Florence

Initially this painting was attributed to Rosso Fiorentino, and even today opinions still differ as to whether Pontormo painted this picture himself; it might be a copy of a lost original painting by the artist. The painting must have been very popular, since three other versions are known to exist. The landscape in the background is based on a print by Albrecht Dürer. The painting is therefore thought to date back to the period of Pontormo's intensive study of Dürer's work during his work on the Carthusian frescoes.

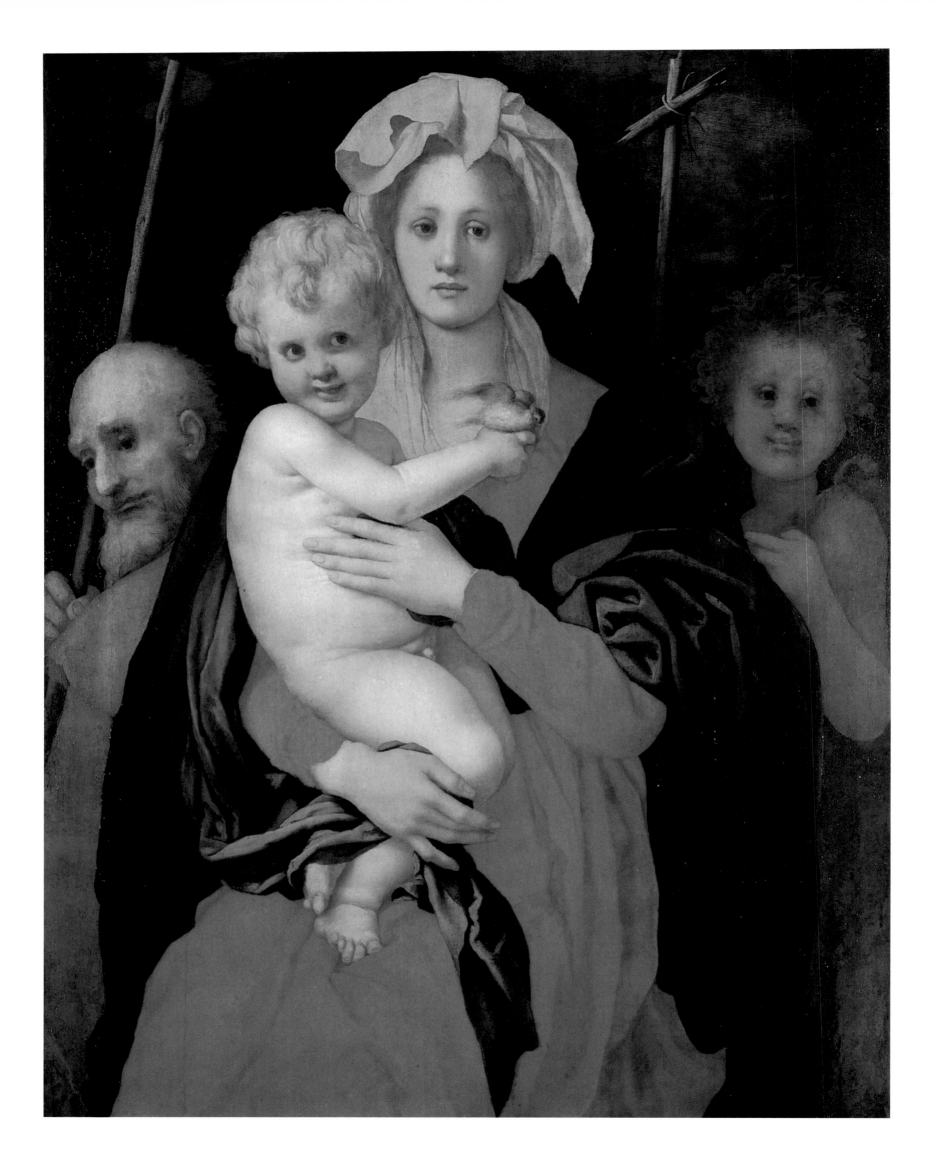

47 (opposite) *The Holy Family with the Young St. John*,
1522–1524
Oil on linen, 120 x 98.5 cm
Hermitage, St. Petersburg

In 1922 the painting was bought by the Hermitage in St.
Petersburg from a Russian private collection. Its original
provenance is not known. Like a number of Madonnas
dating from the 1520s, the picture is characterized by its
experimentalism, employing a wide variety of stylistic
elements. Pontormo's uninhibited references to other
great artistic models have often made attribution based
on style very difficult. However, there is very little doubt
that he did, indeed, paint this St. Petersburg Madonna.

48 (right) *Madonna and Child with the Young Saint John*,
ca. 1526–1528
Oil on wood, 52 x 40 cm
Galleria Corsini, Florence

The delicate Madonna and the two children, who are
caught in poses of extremely graceful movement, have
given rise to serious doubts as to whether Pontormo
painted this picture. It has also been suggested that it
might be one of Bronzino's early works. In Pontormo's
time, however, it was common practice to look to the
work of other artists and incorporate a number of stylistic
influences in one's own work. While there is no certain
evidence as to the origin or provenance of this painting,
the question as to who actually painted it must remain
unresolved.

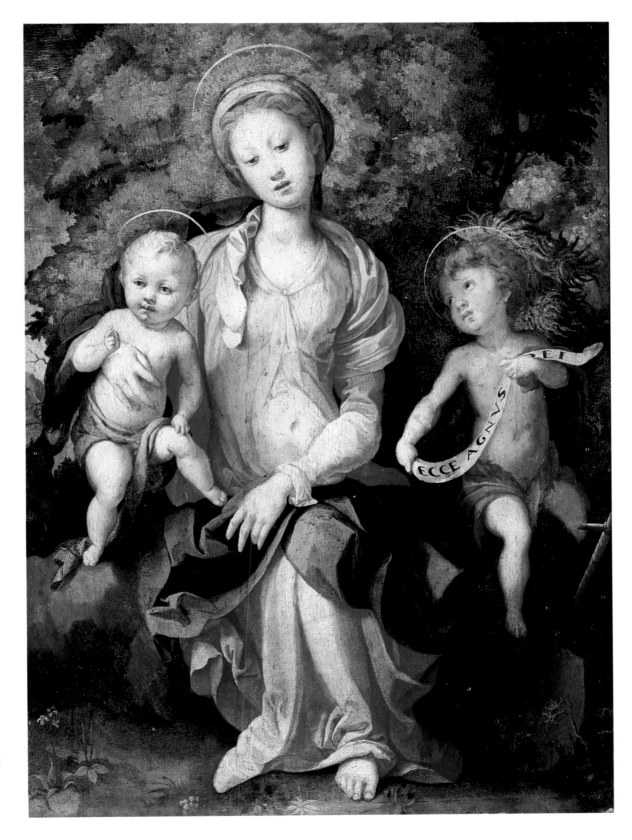

49 *The Agony in the Garden*, 1523–1525
Fresco, 300 x 290 cm
Certosa del Galluzzo, Florence

It took Pontormo three years to paint five lunette frescoes for the cloister of the Carthusian monastery situated to the south of Florence. The frescoes show scenes from the Passion of Christ. Their original impact, in particular their incomparable colorfulness, can only be guessed at today, since the frescoes, particularly the first one, are badly damaged. The fragmentary figure above the sleeping disciples may be identified as Jesus Christ, while Pilate's henchmen can be seen approaching on the right-hand side of the picture.

sculptors thereby elevated themselves above the status of mere artisans. Pontormo, like many of his fellow artists, was regarded as extremely well read, and educated in philosophy and theology. He would cultivate the company of scientists and scholars. In 1525 he was accepted as a member of the Florentine Academy, where intellectual interests were wide ranging and questions of art were treated with high seriousness.

In 1523, when the plague began to rage in Florence, Pontormo lodged in a Carthusian monastery just south of the city. In the cloister of Certosa del Galluzzo he painted five lunette frescoes with scenes from the passion of Christ (ills. 49–52, 54), which bear out

his artistic inventiveness and his claim regarding the intellectual status of art. Despite numerous restorations, the paintings are in a ruinous state; nevertheless, it is still possible to recognize the extraordinary design of the cycle and the almost disconcerting effect that must have emanated from them. The brilliant coloring of the frescoes alone must have put all previous paintings in the shade. With their bright red, lemon yellow, ochre, blue, violet, and pale green tones, the pictures must once have glowed like watercolor. The alienating stylization of the colors indicates the intellectual orientation of the frescoes. As Petra Beckers has demonstrated in her doctoral thesis,

Pontormo's passion cycle is closely linked with the spiritual practice of the Carthusian monks. They acted as devotional pictures as the monks passed through the monastery cloister on the way from their cells to prayers in the chapel. The function of the individual fresco pictures is therefore most decidedly meditative. In harmony with the beliefs of the Carthusian monks, the pictures emphasize the godliness of Christ rather than his incarnation. The uniqueness of the Son of God is given pictorial expression by not allowing any of the figures to obscure the figure of Christ. Even if Italian painting of the Quattrocento increasingly tried to present the biblical stories in as vivid a way as possible,

Pontormo's Carthusian frescoes have largely ignored images of this world.

Vasari in his detailed commentary on the Carthusian frescoes particularly stressed the fact that Pontormo was largely, indeed excessively, inspired by Albrecht Dürer's prints. This was emphasized again and again even by later commentators. It is indeed the case that the inspiration of many figures in Pontormo's pictures can be easily recognized as coming from Dürer's woodcuts; for example, the sleeping night watchmen in the resurrection scene (ill. 54). However, it is by no means merely a question of straight quotations or even copies. Nevertheless the art historian Erwin Panofsky has

50 *Christ Standing before Pilate*, 1523–1525
Fresco, 300 x 292 cm
Certosa del Galluzzo, Florence

Following the theological principles of the Carthusians, Pontormo developed a unique pictorial program for which he made use of new artistic sources, including the prints of Albrecht Dürer. This meant that he referred to non-Italian models – models, moreover, from a region where worrying news was spreading across the Alps about growing demands for reform of the Church. For Vasari, Pontormo's use of such models gave rise to harsh criticism: "Some of the soldiers around Pilate are so German in their facial expression and their garments that anyone who does not know who painted this picture, would surely think it was a work executed by a Northerner."

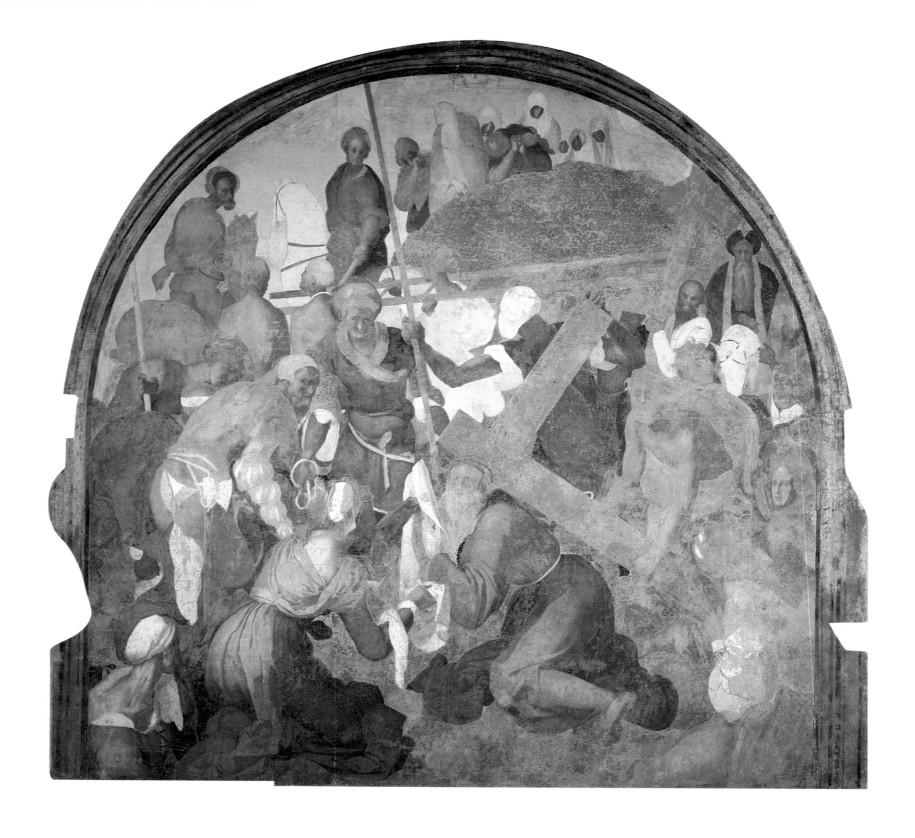

51 *The Ascent to Calvary*, 1523–1525
Fresco, 300 x 292 cm
Certosa del Galluzzo, Florence

In the Carthusian frescoes, Christ's Passion was portrayed
in a new light. Until then it was customary in Italian art
to depict Christ standing upright on his way to Calvary.
In this painting, however, he has sunk to the ground in a
state of exhaustion. The human sympathy thus aroused is
embodied in the figure of Veronica handing her veil to
Christ. A figure only partially visible from the back at the
left-hand bottom of the picture draws us into the
complex and crowded picture and invites us to decipher
its innovative contents.

spoken of an "ultra-Gothic Christ" in the Pilate scene,
"more Dürer than Dürer … like a column of smoke
stretching into the sky". Seen from today's perspective,
the Galluzzo frescoes owe their . visionary-spiritual
quality primarily to the changed understanding of
the functions of a religious picture. The influence
of Reformation thinking, which attributed a more
symbolic than representational function to a picture,
had also taken root south of the Alps. Dürer may
have been seen as a particularly good exemplar to
illustrate these new ideas. Nevertheless, as Petra Beckers
writes, Pontormo's Carthusian frescoes are equally
clearly based on Italian models, the sculptor Donatello

being the prime inspiration. With respect to the
choice of theme, on the other hand, Pontormo has
plainly been influenced by Dürer (ill. 53). Monumental
fresco cycles with scenes of the Passion were a rarity in
Italy, and they remained so even after Pontormo's
Carthusian murals at Galluzzo.

As has already been mentioned, Vasari was of the
opinion that Pontormo's work had deteriorated after his
astonishing early masterpieces. By borrowing from
Dürer in his Galluzzo frescoes, however, he had really
gone too far. In his "Lives" Vasari claims again and
again that from about 1520 Pontormo had abandoned
the good style (*buona maniera*) with which natural

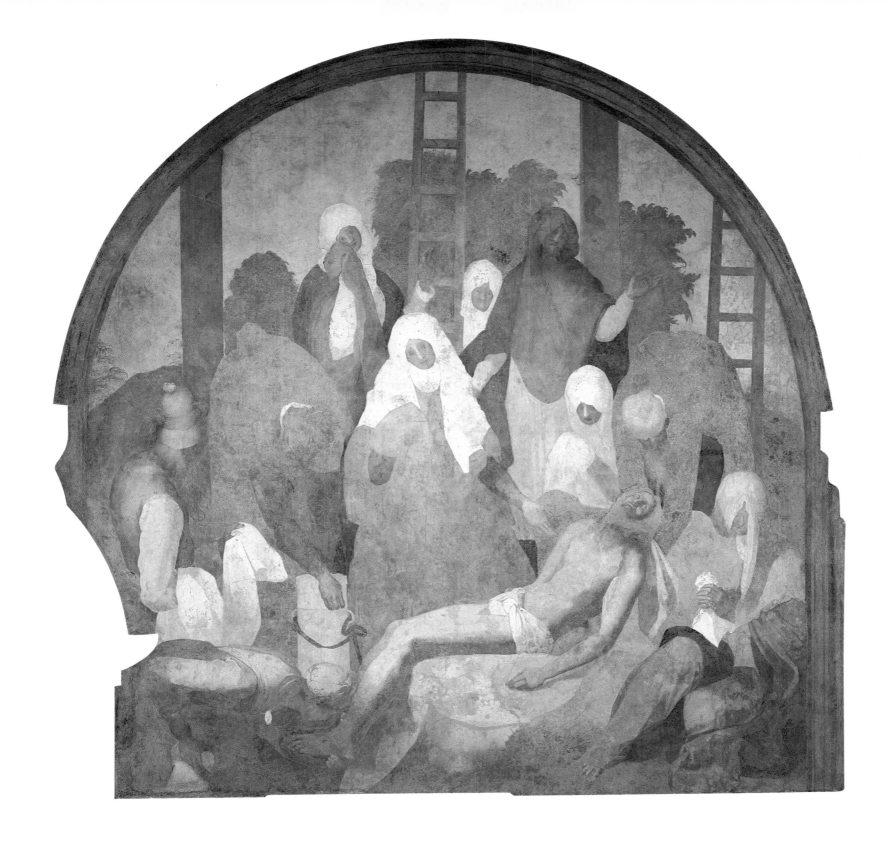

talent and diligent practice had endowed him. The reason for this was the excessive study of the prints of Albrecht Dürer, which had reached Italy in large quantities at this time. Vasari is here unmistakably arguing in a highly patriotic way. His priority was above all to assert the unbroken pre-eminence of Italian art. Extremely worried about Pontormo's powers of judgment, he thus posed the rhetorical question, "Or did not Pontormo know that German and Flemings came to these parts to learn the Italian style, which he made such great efforts to abandon?" Vasari's polemic against the *maniera tedesca* has a long tradition in Italy going back to the building of Milan cathedral in the

14th century in Gothic style. Even Raphael a hundred years later wrote a letter to Pope Leo X fulminating against the barbaric ugliness of the Gothic pointed arch. In Vasari's time, moreover, the Italians felt particularly superior to the north Europeans because of the many classical works of art that had been discovered in archaeological excavations. In Pontormo's biography Vasari at any rate wastes no opportunity to attack the "German style". Pontormo's triptych *Tabernacle of Boldrone* (ills. 55 – 57), which he executed either during or after his work on the Carthusian frescoes, was described briefly and pointedly by Vasari in these words: "and all these figures, as his earlier whim had not

52 *Lamentation*, 1523 – 1525
Fresco, 300 x 292 cm
Certosa del Galluzzo, Florence

The structure of this group of figures corresponds to the semicircular shape of the lunette and has as its dominant theme the mourning of the dead Christ. An interesting contrast is achieved by the vertical thrust of the ladders and the shafts of the crosses. Separated from the main group, the dead body of Christ is lying on the anointing stone. Placed in the center of the picture is the Mother of God in her purple gown, so that the color of the Passion becomes a focal point in the painting. In the chronology of Christ's Passion, the Lamentation is preceded by the nailing of Christ to the cross. Although Pontormo made a preparatory drawing for the latter, he did not execute it as a fresco.

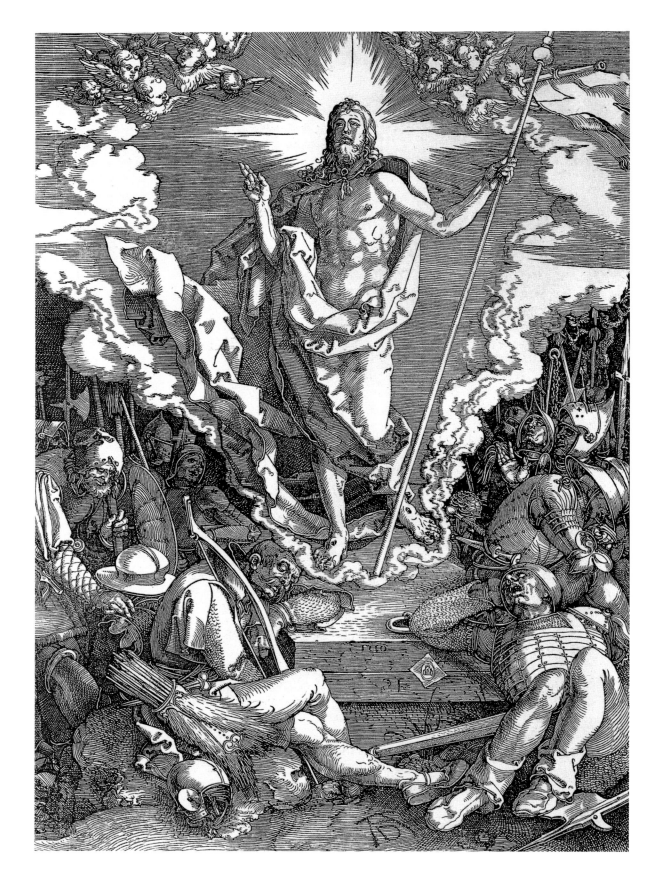

53 Albrecht Dürer
The Resurrection of Christ, 1510
Woodcut from the Great Passion, 39.1 x 27.7 cm
Staatliche Museen Preußischer Kulturbesitz,
Kupferstichkabinett, Berlin

Compared with Pontormo's *Resurrection*, Dürer's woodcut
appears compellingly three-dimensional and detailed. The
spatial depth is emphasized not only by the staggered
arrangement of the figures, but also by the tomb which is
depicted as a square hewn stone in foreshortened

perspective. Vasari claims that Pontormo drew inspiration
from Dürer's *Great Passion* when working on the frescoes
for the Carthusian monastery. Vasari stated that
Pontormo did so "in the firm belief that he would give
satisfaction not only to himself but also to the majority of
the craftsmen of Florence, who were all, with one voice
and by general agreement and consent, proclaiming the
beauty of those prints and the excellence of Dürer."
Although Pontormo was obviously inspired by Dürer's
printed work, he certainly did not copy it.

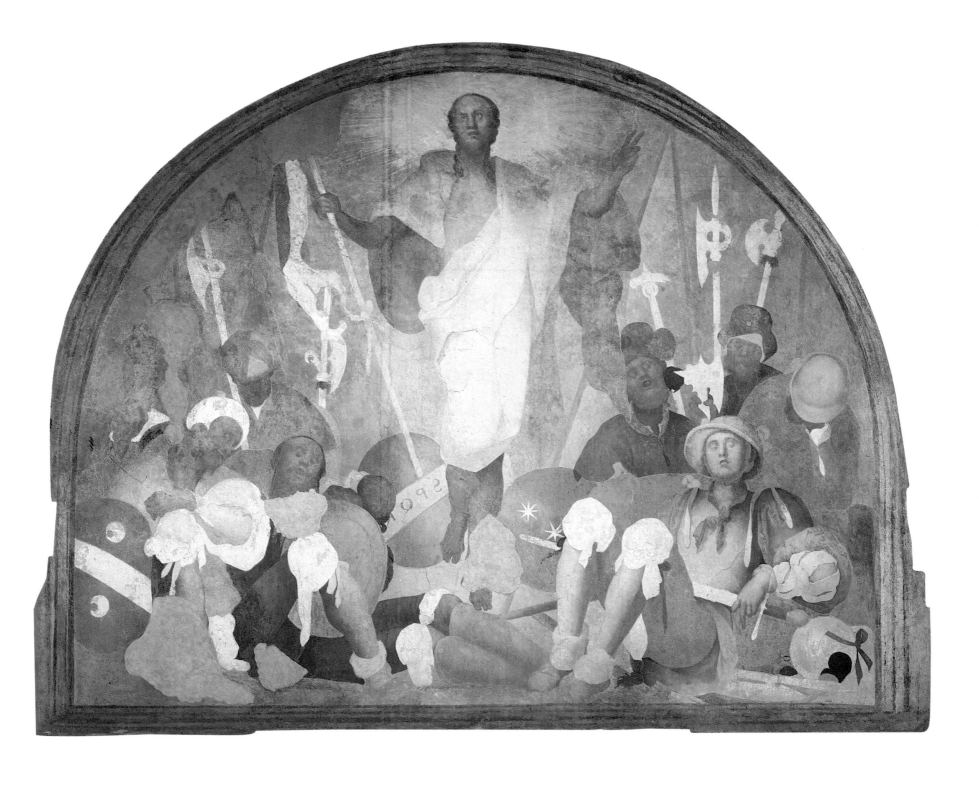

yet been given full rein and he was still fond of that German style, were not very dissimilar from those he had painted at the Certosa."

In fairness it must be said that Vasari's vehement criticism was not directed at Dürer himself, for whom he had the greatest admiration. However, he found it highly inappropriate that an Italian should make use of such artistic idioms, which were alien to his nature. For Vasari it was simply unnatural for Pontormo to distance himself so far from his own traditions. Underlying this is the notion that *maniera* or style reaches into the very personality of the artist and his behavior. This attitude found expression in Vasari's commentary on another work that Pontormo carried out for the Carthusian monks. *Supper at Emmaus* (ill. 58), a large canvas, was once again inspired by a Dürer engraving in terms of motif and iconography. This time however Vasari's judgement was thoroughly positive: Pontormo had painted that work "without tormenting or forcing his nature ... and because he followed his true genius in this picture, it came out as truly wonderful". Vasari particularly praises the lifelike portraits of the monks, who are standing next to Christ and serving him. Liveliness and naturalness are the qualities of a picture most appreciated by Vasari in a painting. In the *Supper at Emmaus* he may have liked the realistic portrayal of the glasses, plates and loaves, which are arranged on the table in the manner of a still life. The painting

54 *The Resurrection of Christ*, 1523 – 1525
Fresco, 232 x 291 cm
Certosa del Galluzzo, Florence

The final episode of this Passion sequence depicts the risen Christ and the soldiers who have fallen asleep while guarding the tomb. Pontormo's style in this fresco is marked by his emphasis on the two-dimensional. There is no information concerning the location or spatial relationships; we do not even see Christ's tomb. The removal of any sense of reality in this picture corresponds to the remoteness of the Carthusian monks from the real world. Furthermore, the sense of unreality characterizes the Resurrection of Christ as a spiritual event. The shape of Christ as he ascends to heaven with his outstretched arms is reminiscent to the shape of the cross. That which is visible in this devotional picture serves as a reminder of that which is invisible, namely Faith.

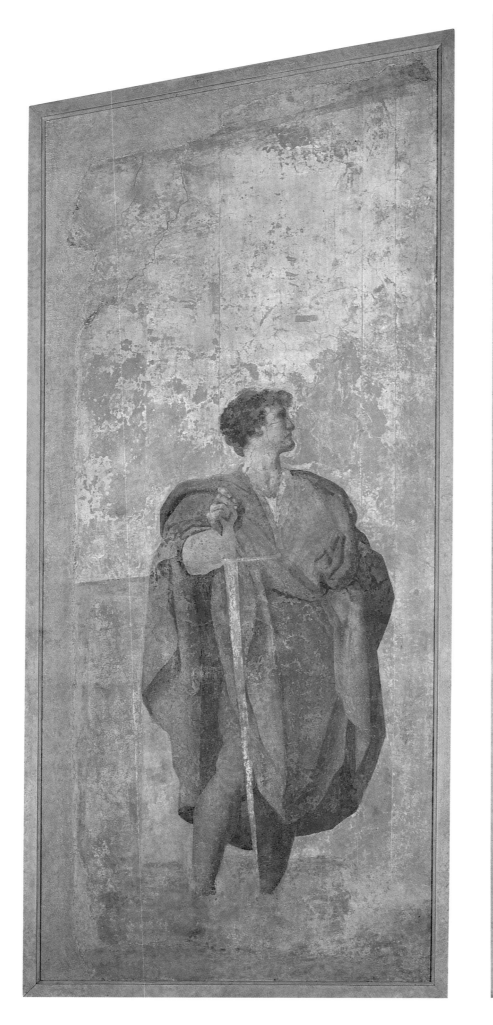

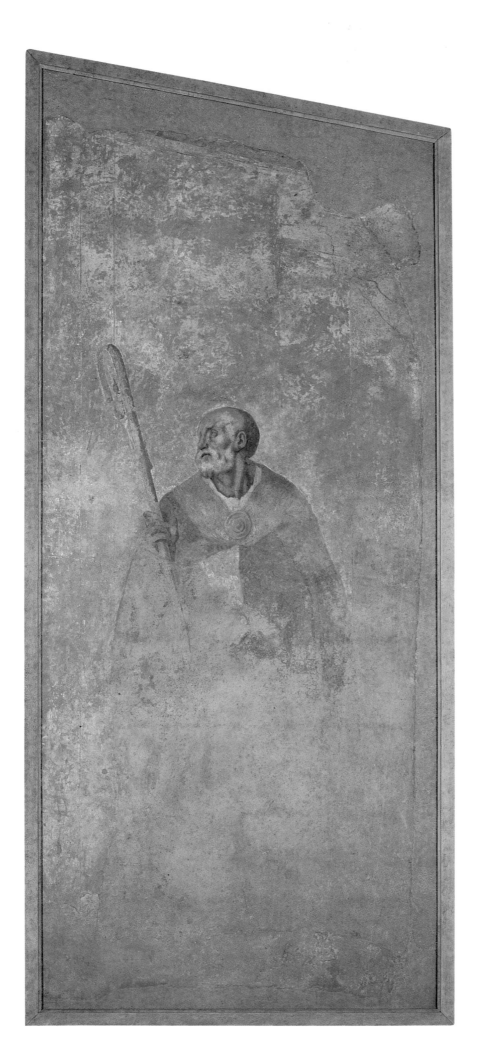

55–57 *The Tabernacle of Boldrone*, 1522/1523 or
1525/1526
Saint Julian, 275 x 127 cm
Crucifixion with the Virgin and St. John, 307 x 175 cm
Saint Augustine, 275 x 127 cm
Removed frescoes
Accademia dei Disegni, Florence

"(…) he was still fond of that German style", was Vasari's
terse comment about the figures of the tabernacle which
was originally housed in a roadside chapel near Boldrone.
In 1955 the badly damaged fresco was taken down,
transferred to plastic panels, and carefully restored.
Despite this, only a small part of Pontormo's painting
has survived, particularly in the right-hand part of the
picture.

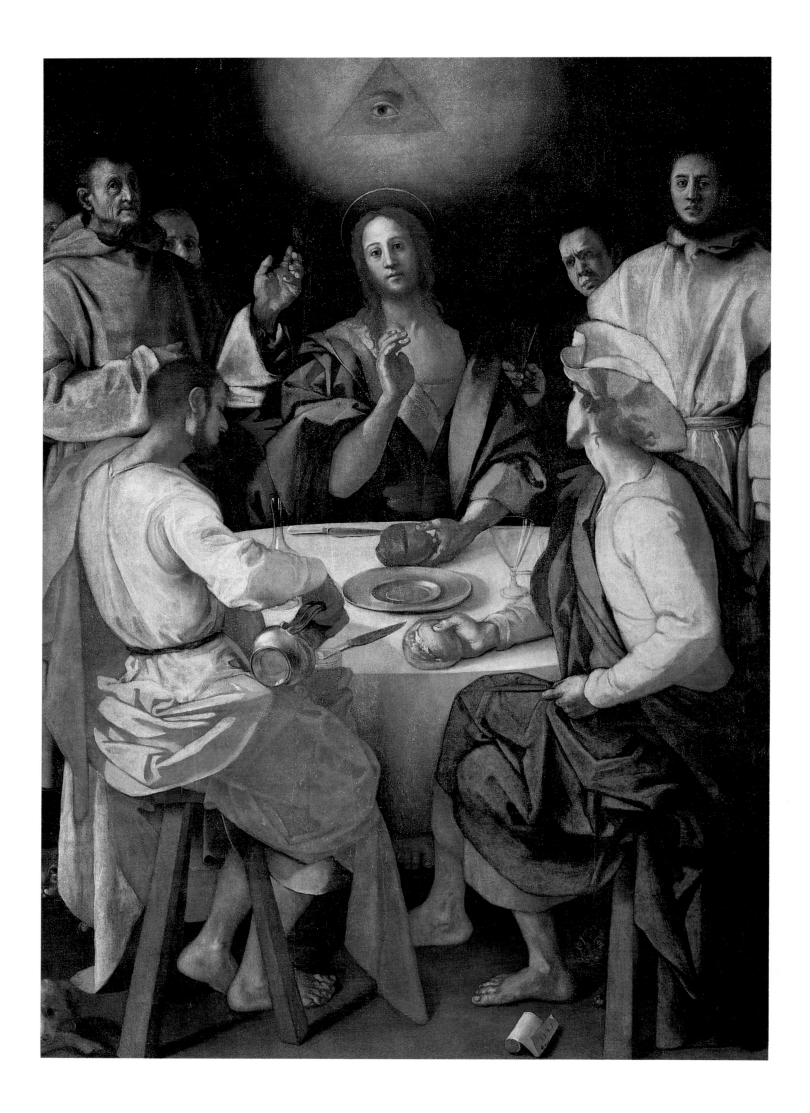

58, 59 *Supper at Emmaus* (and detail), 1525
Oil on linen, 230 x 173 cm
Galleria degli Uffizi, Florence

According to Luke (24, 13–33), two disciples on their
way to Emmaus met Jesus of Nazareth; but they did not
recognize him as the risen Christ until he broke and
blessed the bread during their meal together. In
Pontormo's painting, five Carthusian monks are included
in the scene. Vasari knew the depicted monks personally
and expressed his admiration of their successful portraits.
One of the remarkable features of the still-life-like
arrangement on the table is its realistic portrayal. The eye
of God above Christ was added at a later stage by another
artist. The date of the painting is inscribed on the small
paper scroll in the foreground.

was originally in the guesthouse of the Carthusian
monastery. It was fitted in a stone frame in such a way
that the spectator seemed to be observing the scene
through a doorway and being invited to participate in
the supper with Christ.

The altar panel *Madonna and Child with St. Anne and
the Saints Sebastian, Peter, Benedict, and Philip* (ill. 61),
which Pontormo painted for the Florentine Signoria
around 1528/1529, demonstrated once again how on
the one hand German and Italian, and on the other
hand medieval and contemporary style elements could
be synthesized in one picture. Saints in resplendent
colors stand on dark clouds. The trinity of Mary, her
mother Anne, and the baby Jesus occupy the center.
The complex sitting arrangement echoes Leonardo's

bold picture of St. Anne dating back to the beginning
of the century. In the two figures standing at the front
we can once again see the influence of Dürer. On the
left is St. Peter in an orange robe, and, on the right, in
his "emotional fragility" as Adolfo Venturi describes it,
is the abbot Benedict. By including a medallion, which
honors the patrons of the altarpiece, Pontormo was
borrowing from medieval panel painting. The actual
impact of this painting is achieved through Pontormo's
ability to adapt these influences, concentrate and
condense them, and bring them into harmony with one
another. Even the graceful play of the hands in this
picture, which underlines the devotional conversations
of the saints, is a mark of the excellence of the quality
and independence of the artist. Pontormo's *Madonna*

and Child with St. Anne and the Saints Sebastian, Peter, Benedict, and Philip was a present from the republican city council of Florence to the nuns of Santa Anna in Verzaia. It was there that a large procession began each year celebrating the expulsion of the Medici. It was between 1527 and 1530, when the city of Florence had rid itself for the second time of the hated Medici rule, that Pontormo received the commission for the picture.

In the medallion on the lower edge of the picture he portrays part of that very anti-Medici procession. One should by no means conclude however that Pontormo was also an opponent of the powerful Medici family. On the contrary, the ties between Pontormo and the great art collectors and patrons of the Renaissance are so extensive that a special section is devoted to them in the following chapter.

60, 61 *Madonna and Child with St. Anne and the Saints Sebastian, Peter, Benedict, and Philip* (and detail), 1528/1529
Oil on wood, 228 x 176 cm
Musée du Louvre, Paris

From the late Middle Ages, the veneration of the Virgin Mary was extended to include her mother, Saint Anne. The traditional portrayal of St. Anne shows Anne, Mary and the baby Jesus in a harmonious group. Following ideas derived from Leonardo, Pontormo translates this grouping into an immensely complicated seated subject. Placing the three heads next to one another emphasizes the succession of the generations, grandmother – mother – child. The surrounding saints once again bring to mind the subject of the "Sacra Conversazione". Napoleon arranged for the painting to be brought from the Hospital Sant' Eusebio in Prato to Paris in 1813.

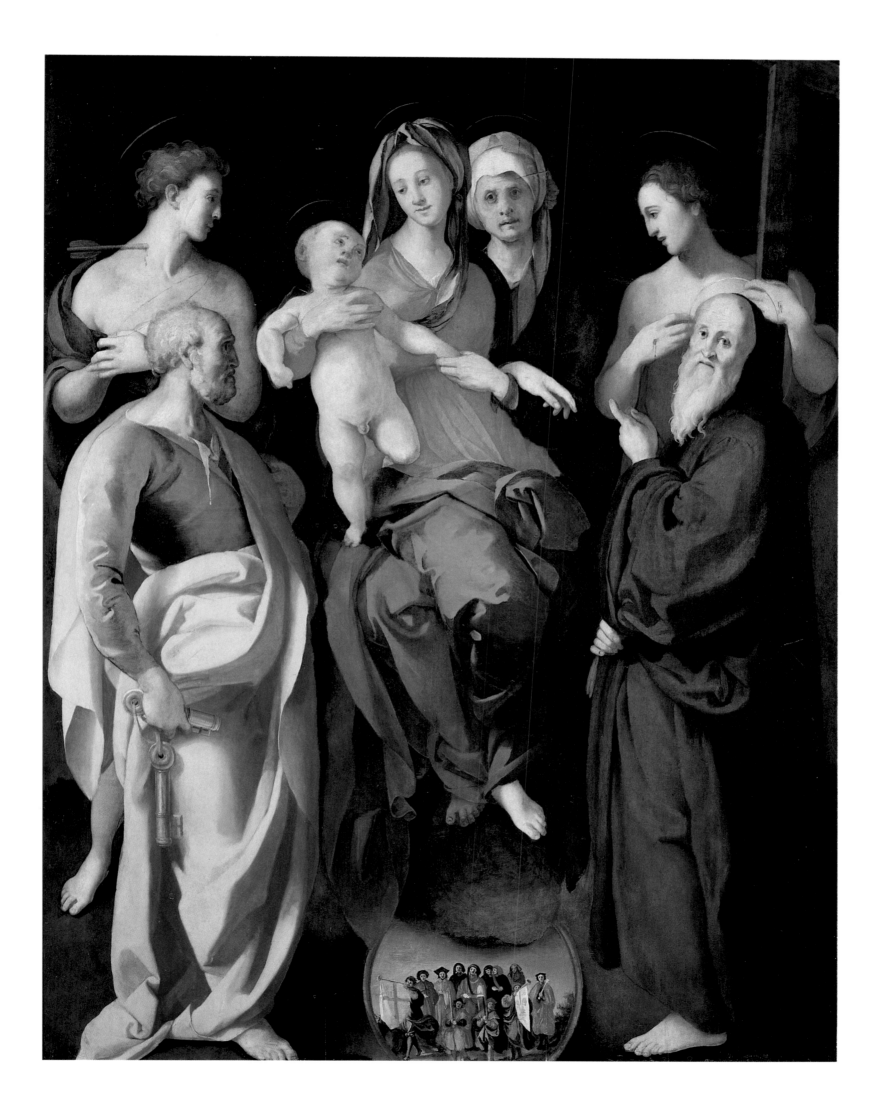

The graphical reproduction techniques of woodcut and copperplate engraving were invented at about the same time as book printing, around the middle of the 15th century. The prerequisite was the introduction of paper production in Europe in the second half of the 14th century. The increasing religious requirement for private prayer was met by the development of the printed book: the illustrations of biblical stories or saints produced in limited editions were relatively affordable, easily transportable and could be viewed at home. The earliest

62 Albrecht Dürer
Four Naked Women (*The Four Witches*), 1497
Copperplate engraving, 19 x 13.1 cm
Staatliche Museen Preußischer Kulturbesitz,
Kupferstichkabinett, Berlin

Thanks to the new medium of printing, it was possible in the Renaissance to create pictorial subjects and motifs that would have been unthinkable in the era of panel painting. Prints not only encouraged experimentation, they also, through reproductions of paintings and sculptures, contributed to a greater awareness of artistic innovations. This can be seen in the example of Dürer's *Four Naked Women* in which the study of the female nude is translated into a genre-like motif. This small copperplate engraving must obviously have inspired Pontormo, for this is borne out in the composition of the four female figures in his famous painting of the *Visitation* in Carmignano (ill. 3).

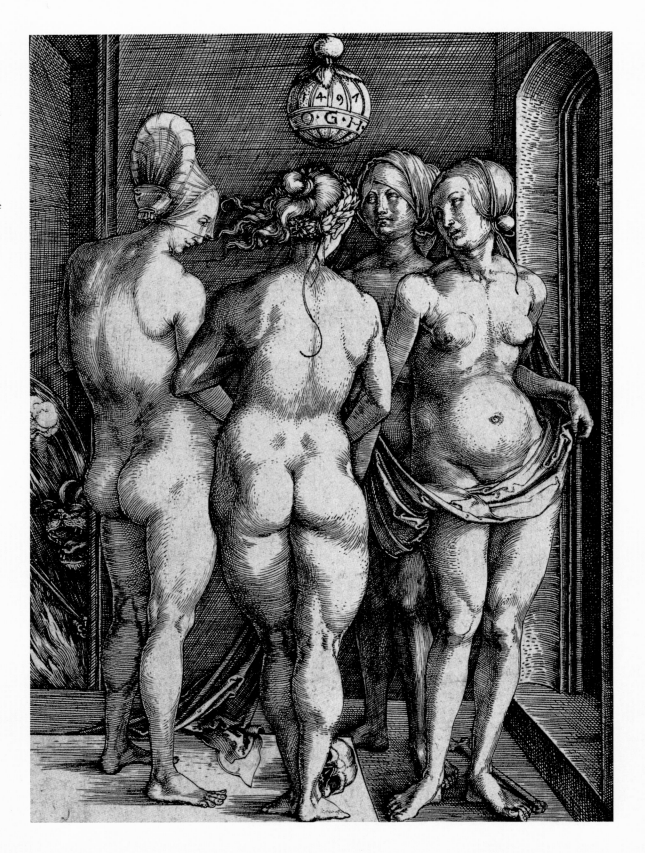

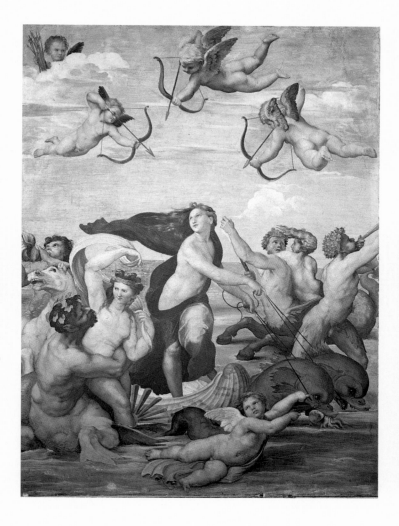

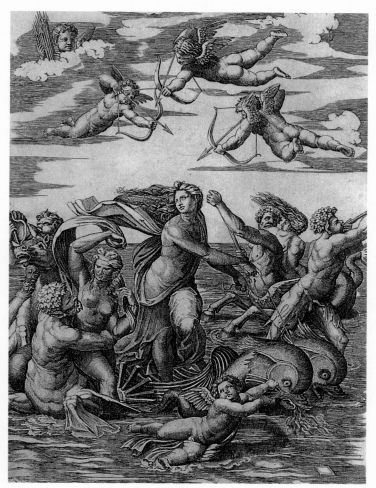

printed products come from south German workshops and are not associated with the names of any particular artists. Not until the end of the 15th century did famous painters such as Martin Schongauer (ca. 1450–1491), Lucas van Leyden (1494–1533) and above all Albrecht Dürer (1472–1528) use woodcut and copperplate engraving as artistic techniques and raise the new medium to a level on a par with painting (ill. 62). Dürer's achievements in graphic art were judged by his contemporary Erasmus of Rotterdam (ca. 1469–1536) as proof of an artistic advance over classical antiquity: with the aid of just black lines alone on white paper, Dürer had imbued his pictures with light, shade, brilliance, height and depth.

Printed pictures developed independently of patrons and so were characterized by much greater experimentation in the themes portrayed. Picture motifs were developed that were inconceivable in contemporary painting. In the case of Dürer, this led to an extended depiction of the world around him and the first autonomous representations of landscape. On the other hand, printing acquired a tendency towards the conceptual and the allegorical, as in Dürer's masterpiece *Melancholia I*. Due to its origin and nature, graphic art occupies an intermediate position between words and pictures. This idea is inherent in the term itself, which goes back to the Greek verb *graphein* (to write). Moreover, the "written pictures" of graphic art

were rarely created to be hung on walls, but rather to be stored in folders so that they could be taken out and perused at length, like a book. It can be safely assumed that Pontormo had a large number of prints in his possession.

The development of printing at the beginning of the modern age represented a new branch of the fine arts, which for the first time allowed a wide distribution of pictures. Publishers tried to achieve a European-wide marketing of the printed picture. In the course of the 16th century the first large factory-like enterprises were founded that organized the production of pictures on the basis of the division of labor. As well as graphical sheets, which were based on the artist's imaginative creations, engraved reproductions of paintings and sculptures were also available from the beginning of the 16th century. The influence of innovative pictorial concepts and styles therefore spread considerably faster. Artistically, this resulted in the reception of new foreign influences, as was the case with Pontormo. Without the medium of printing the immense influence of Raphael would be inconceivable, for his works were reproduced by Marcantonio Raimondi shortly after their creation and then widely distributed (ills. 63, 64). Since the Renaissance the development of art has been intimately bound up with the history of its reproduction and distribution.

63 (above left) Raphael
The Triumph of Galatea, 1511
Fresco, 295 x 225 cm
Villa della Farnesina, Rome

The banker and businessman Agostino Chigi, who had a particular penchant for splendor and magnificence, commissioned a fresco from Raphael for his Roman garden villa. Raphael created a mythological fresco *all' antica* that was extremely modern for its time. The beautiful nereid Galatea rushes across the waves in a scallop carriage pulled by dolphins. Tritons, nymphs and cupids accompany her as she makes her way to her lover.

64 (above right) Marcantonio Raimondi
The Triumph of Galatea, ca. 1515/1516
Copperplate engraving, 39.5 x 28.2 cm
Staatliche Museen Preußischer Kulturbesitz,
Kupferstichkabinett, Berlin

Marcantonio Raimondi (ca. 1480–1530) developed his graphic style under the influence of Dürer. From 1510 he was active in Rome and devoted his art to the promotion of Raphael's work. His engravings after paintings by Raphael helped to make a large audience acquainted even with works that were originally created for private chambers.

Not Only Masters, But Also Servants

65 *Portrait of Cosimo de' Medici Il Vecchio*, ca. 1518/1519
Oil on wood, 86 x 65 cm
Galleria degli Uffizi, Florence

The picture is an evocation of a prominent ancestor of the Medici family, Cosimo de' Medici Il Vecchio ("the Elder"), whose rule in Florence was the subject of great debate in Pontormo's time. Cosimo Il Vecchio (1389–1464) led his dynasty to the heights of its political and economic power. After a brief banishment in 1433/1434, he dominated the Florentine State, supported by the Popular Party. Cosimo Il Vecchio founded the Platonic Academy and admired and promoted Donatello, Brunelleschi, Fra Angelico and many other artists, thus establishing firmly the reputation of the Medici family as the patrons of Renaissance art in Florence.

PONTORMO AND THE MEDICI

The artists of the Renaissance had to solve problems that arose from the continuing religious function of art in their society. "They were not only masters, but also servants", was how the renowned art historian Sir Ernst H. Gombrich once succinctly expressed it. Two aspects of the Renaissance artist's role as servant can be distinguished: the pictures firstly had to express the theme to be portrayed in an appropriate and plausible way; and secondly they had to satisfy the interests of the particular patrons.

During Pontormo's generation, and for the first time in history, the role of artist as servant was, to some extent, curtailed. The demand for artistic freedom was heard. However, this awakening freedom of the artist in the Renaissance still represented only a small step on the way to the autonomy. Vasari, certainly, concentrated on that artistic freedom when he states that Pontormo was not concerned about the social position of his patrons, and was even prepared to accept the less well-paid commission of an insignificant patron than a large commission from a duke or potentate. If we look at all Pontormo's work, however, it becomes clear that the patronage of a powerful family is a thread that runs through his whole career. From the very beginning right up to the frescoes of San Lorenzo, Pontormo's creativity was intimately bound up with the Medici. Some of his best works such as the *Portrait of Cosimo de' Medici Il Vecchio* (ill. 65) and the *Vertumnus and Pomona*, a fresco in Poggio a Caiano (ill. 66), were executed under their patronage. That Vasari should play down Pontormo's dependency on the Medici and emphasize his free-spirited nature, may owe something to Vasari's own involvement with this family and its generous, albeit at times tyrannical, patronage.

In 1494 the Medici had been driven out of the republic of Florence. Their return and renewed domination of the town followed in the year 1512, when the diplomatically skillful Giovanni de' Medici (1475–1521) had rescued Florence from attacks and plundering by negotiating between the warring parties. When in the following year Giovanni was elected Pope Leo X, Florence celebrated in style with sumptuous processions. The city's best artists contributed to their design. Even Pontormo was familiar with the iconography of the Medici. The painting of the three procession wagons represented his first independent artistic work. When the Pope paid a visit to Florence in 1515, Pontormo was again involved in the celebratory decorations. Also very pro-Medici were the Servite monks of Santissima Annunziata, for whom Pontormo executed his first major works. When around 1518/1519 Ottaviano de' Medici gave him the commission to paint a picture in memory of the long-dead founder of the house of Medici, the resulting *Portrait of Cosimo de' Medici Il Vecchio* (ill. 65) was not only a magnificent picture, but it defined a style of portrait which found many imitators.

Pontormo's posthumous portrait showed the venerated Cosimo (1389–1464) as "Pater Patriae", father of the homeland, sitting in a dignified pose on his throne of stone. The glowing red of the coat and cap lend a radiant appearance to the half-figure portrait. Pontormo used a 15th century coin as the pattern for the head that was portrayed in a stylized profile view. The laurel branch on the left side of the picture is part of the iconography of the Medici. Lorenzo Il Magnifico (1449–1492), a grandson of Cosimo and as famous a patron of the arts as his illustrious grandfather, appropriated the laurel, the attribute of the God Apollo, for himself as a reference to his name, laura being the Italian for laurel. The laurel leaf is moreover well-known for the ability of its branches, even apparently dead ones, to burst into leaf again, a quality which during the time of the portrait could be very aptly applied to the current family. In the painting it is illustrated by the juxtaposition of one cut and one growing shoot. The ribbon around the laurel branch with the Virgil quotation emphasizes the desire for the continuity of the Medici family: UNO AVULSO NON DEFICIT ALTER (if one is cut down, then the other remains). In fact before 1519 it had looked for some years as if there would be no male heir to ensure the continuity of the family. Pontormo's painting evokes a happier era from the past. It may have originated in the year 1519 on the occasion of the birth of the son of Maria Salvati (1499–1543) and Giovanni

66 *Vertumnus and Pomona*, 1519–1521
Fresco, 461 x 990 cm
Villa Medicea, Poggio a Caiano

The Villa Medicea in Poggio a Caiano was built for
Lorenzo Il Magnifico in 1480–1485 by Giuliano da
Sangallo. It is surrounded by a magnificent garden and
affords views to the gently undulating hills of Tuscany.
The rural character of the villa's surroundings are
continued inside in Pontormo's frescoes. Framed by
laurel branches, four figures are sitting on a garden
wall: they simultaneously personify the seasons as well
as deities from classical antiquity. The title of the
fresco, bestowed upon it by Vasari, invites us to read it
as an interpretation of a story from Ovid's
"Metamorphosis". This, however, does not do
justice to the complexity of the fresco. In
accordance with the wishes of his patron
who commissioned the work, the
fresco in the main salon of the villa
is full of references to classical
antiquity and glorifies the
Medici dynasty.

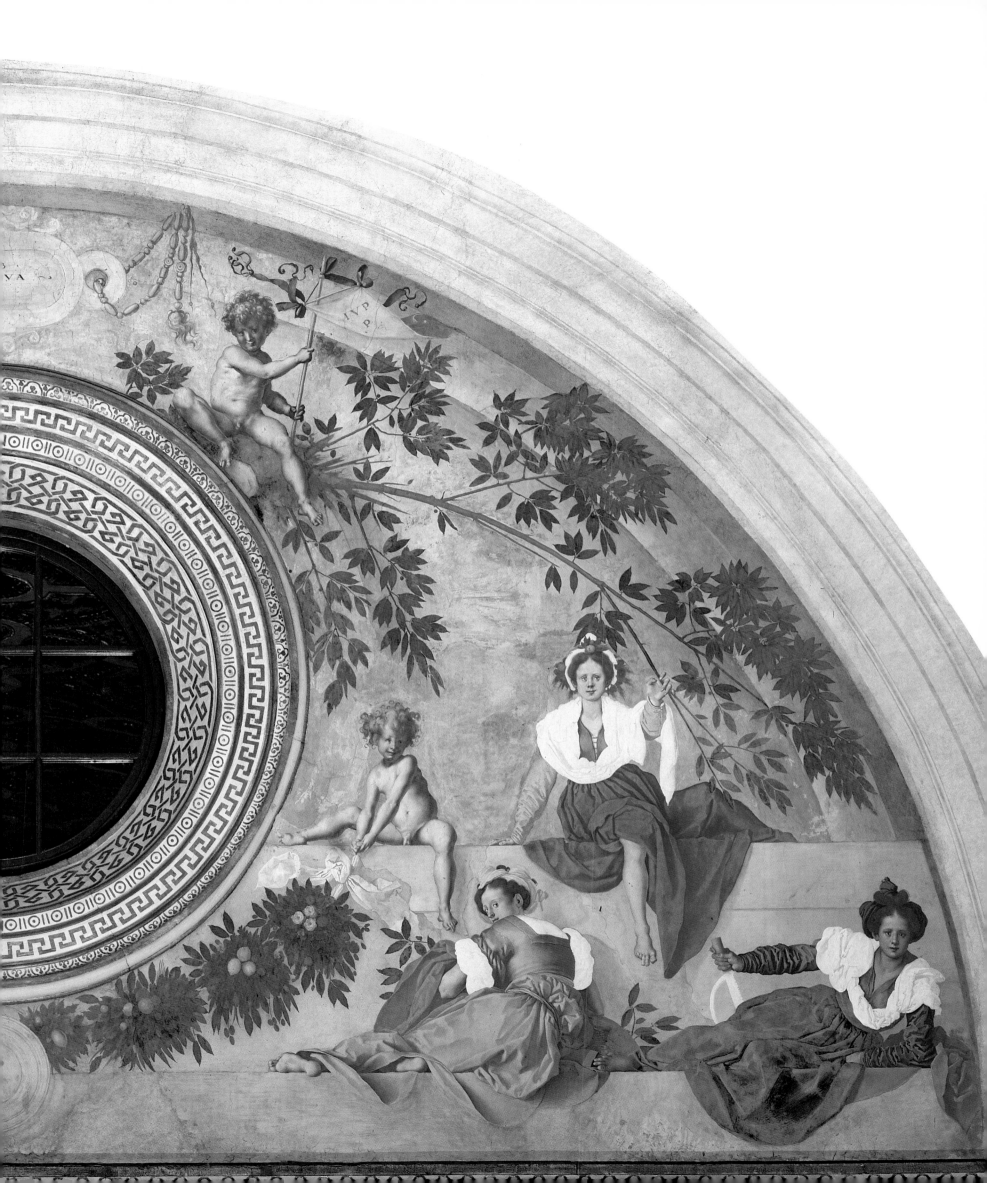

GLO
VIS

67 *Vertumnus and Pomona* (detail ill. 66), 1519–1521

Pontormo's fresco *Vertumnus and Pomona* symbolizes the continuation of the Medici rule through the ages. The composition is therefore extensively built up of circular forms and turns, and Pontormo has very skillfully integrated into the picture design both the semi-circle of the wall space and the round window in the middle. The inscription GLOVIS expresses the underlying concept of the picture in a particularly subtle way, for it is only when one reads it backwards that it reveals its meaning: SI VOLG(E), which means, "it revolves".

68 *Figure study for the fresco in Poggio a Caiano*, ca. 1520
Black chalk, 40.3 x 26.5 cm
Galleria degli Uffizi, Gabinetto dei Disegni e delle Stampe, Florence

Numerous preparatory studies for the fresco in Poggio a Caiano show Pontormo's preoccupation with depicting different ways in which figures could sit, stretch, and lie or lounge in a casual and relaxed manner. This drawing is one of several versions of a motif that the artist seems to have considered but that he did not include in the final fresco. It shows a boy sitting with his legs drawn up and holding his hand over his eyes to protect them from the glare of the sun.

dalle Bande Nere (1498–1526), who was named after the very Cosimo portrayed in the portrait. All the hopes lay on this boy, even if he did come from a collateral branch of the family. In 1537 he became the first true Medici duke and later still the Grand duke of the city of Florence and all Tuscany. His long period of rule until his death in 1574 laid the foundations for a hold on power by the Medici that would last uninterrupted for two hundred years.

The themes of renewal and return also feature in Pontormo's fresco *Vertumnus and Pomona* (ill. 66), on which he worked between 1519 and 1521 at the Villa Medicea in Poggio a Caiano, and which must rate amongst his best works. The patron was Giulio de' Medici (1478–1534), then the ruler of Florence and later to become Pope Clement VII. Behind the idea of renovating the somewhat neglected family estate to the west of Florence was none other than Pope Leo X himself, whose pontificate was characterized by an immense relish for pomp and splendor. In addition to Pontormo, Andrea del Sarto and Franciabigio were also involved in the decoration of the great hall on the first floor of the building. Pontormo's fresco is located in the eastern front side of the room at some height just below the barrel vaulted ceiling. There was a problem caused by a round window which was situated exactly in the middle of the lunette area, but, as we shall see, Pontormo was able to use this architectural feature, and indeed make it to the starting point of his composition.

The program for the decoration had been conceived by a learned humanist, Cardinal Paolo Giovio (1483–1552). Lorenzo Il Magnifico and the fame of the Medici family were to be celebrated with references to classical antiquity. Pontormo's fresco, at first glance a simple country scene, is to be understood as a highly

complex allegory full of literary references, as research by Jürgen Kliemann and by Matthias Winner has shown. As is indicated by the inscription under the round window, the fresco, prepared by numerous preliminary studies (ills. 68, 69), illustrates the constant rule of the Medici over the course of time. The motto is GLOVIS, which is SI VOLG(E) read backwards, meaning: it revolves. Indeed revolving represents a main formal element in Pontormo's fresco. Initially everything revolves around the round window in the middle. On its upper side two thick laurel branches, bursting into leaf, are following the semi-circle of the picture field downwards. There they are seized by the two figures sitting on the wall, the ancient gods Bacchus and Ceres, and pulled down even further. Next to them two putti are sitting holding a garland between them. In this way the round window is not only framed in the lower half, but by means of the tugging motion of the putto on the right hand side that is echoed by a complementary motion on the part of the putto on the left, a circular dynamic is set up. There is clearly reciprocation with the laurel branches in the upper half of the picture. On a platform parallel to the lower edge of the picture there is a row of sitting figures, two male and two female, that also embody the themes of change and transformation. These are the four seasons dressed in the garb of ancient gods. The old man sitting in the left corner represents winter and is at the same time the Roman God Vertumnus, famous for his ability to change his appearance, and after whom Vasari named the work. Pontormo's composition however extends considerably beyond a portrayal of the story of Vertumnus and Pomona as told by Ovid. Sitting next to winter is Saturn as the personification of autumn, then in third position is spring, represented by the

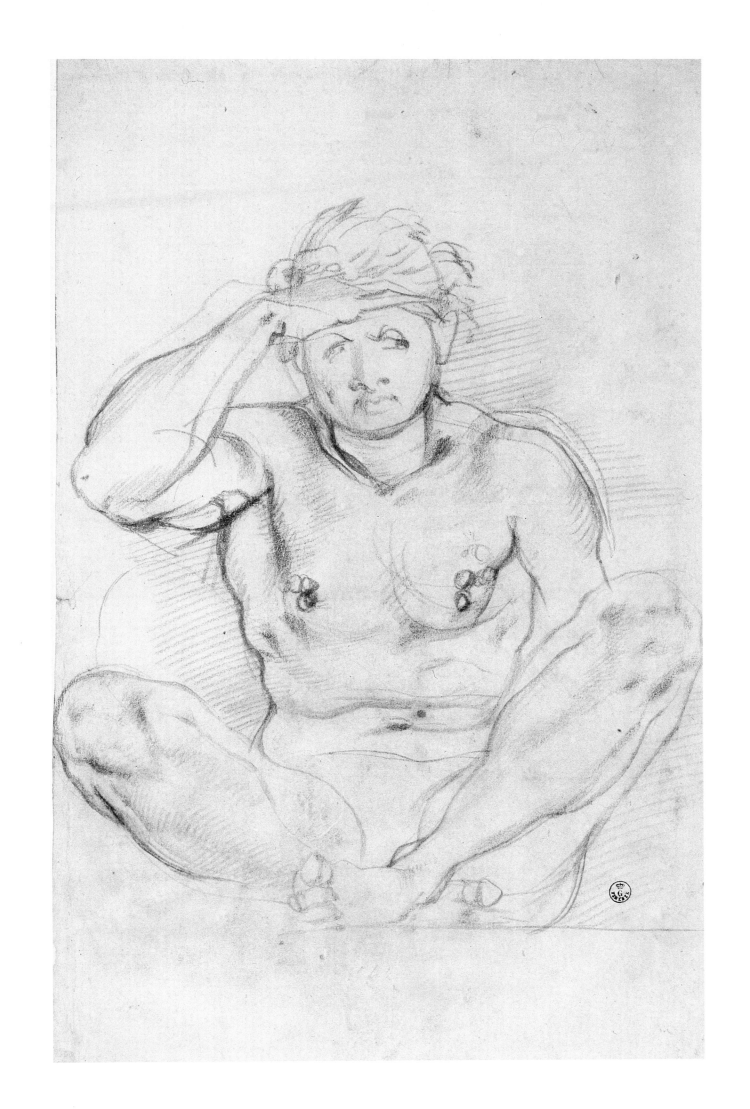

69 *Study for the lunette fresco in Poggio a Caiano*,
1519–1521
Bister and ink, traces of black crayon, 18.5 x 38.1 cm
Galleria degli Uffizi, Gabinetto dei Disegni e delle
Stampe, Florence

This study represents either an alternative to the final
fresco of *Vertumnus and Pomona*, or an idea for the
opposite lunette in the main salon of the Villa Medici.
That second lunette remained unpainted owing to the
abrupt abandonment of the work at Poggio after the
death of Leo X. The Medici family asked Pontormo
about ten years later to paint the lunette, but the work
was never executed.

70, 71 *Vertumnus and Pomona* (details ill. 66),
1519–1521

Four figures have settled on the lower area of the
plinth in the rural garden scene. With reference to the
continuing rule of the Medici, they also represent the
themes of change and renewal. Portrayed here are the
personifications of the four seasons which appear in the
garb of mythological deities. The old man on the left
embodies winter and Vertumnus, and next to him sits the
autumn as Saturn. Spring is represented as the Roman
goddess Diana, and the row is completed on the right by
summer disguised as Venus. The row of four figures
expresses the changing course of the seasons by the rich
variety of their sitting positions and the directions of their
gaze.

Goddess Diana, and finally Venus follows in the garb of
summer. As in the portrait of Cosimo Il Vecchio, there
is a quotation from the Roman poet Virgil in the
cartouche over the window which gives the motto of
the iconographical program "[Diique deaeque omnes]
studium arva tueri" which roughly means: "all the gods
and goddesses have hastened themselves here in order
to care for and protect the sprouting branches of the
Medici family." The message of the fresco is thus clear:
time may pass, the seasons may change, but the laurel
of the Medici remains forever green.

When on 1 December 1521 Pope Leo X un-
expectedly died, the works at the Villa in Poggio a
Caiano stopped. Otherwise Pontormo would certainly
have filled the opposite lunette with a fresco, an idea
supported by the existence of a drawing with an
alternative design (ill. 69). *The Vertumnus and Pomona*
fresco is one of the very few mythological themes
ever executed by Pontormo. As a highly allegorical
iconographical program, it has been linked with
another picture glorifying the Medici. Whilst
Pontormo was painting the fresco in Poggio a Caiano,
Michelangelo was working in the Medici funeral chapel
in the old sacristy of San Lorenzo in Florence on a
equally complex iconographical program on the same
theme – the continuation of the Medici over the course
of time. A comparison of the preliminary drawings of
the two artists strongly suggests that there was an

exchange of ideas. This is borne out by the symmetrical
arrangement of the figures in Pontormo's fresco as well
as the execution of elaborately changing sitting
positions. By strictly avoiding any overlapping of the
figures Pontormo gives the lower half of the picture a
frieze-like character. The ingenious arrangement of the
figures creates an impressive effect because it is based on
a symmetrical principle, although this is varied and
broken in many ways. The calm idyll of the scene is
contained within a formal pattern. It is above all from
this tension between informality and rigor that the
fresco draws its strength and dynamism.

The frescoes Pontormo created for the Medici villas
in Careggi and Castello in the 1530s and 1540s have
not, unfortunately, survived. Nevertheless, some of the
preliminary drawings (ills. 72–74) allow us to guess at
the extravagance of the painting. Personifications of
fortune, justice, victory, peace and fame, figures from
classical mythology, planetary gods and star signs
must have been combined in the two loggias of the
two villas to create a fantastic program of decoration.
Furthermore, Pontormo had, according to Vasari,
portrayed philosophy, astrology, geometry, music and
arithmetic "in the shape of some colossal, almost
completely naked women". An impression of their
extraordinary effect can be glimpsed in the drawings.
Pontormo had worked with his close friend Angelo
Bronzino (1503–1572) on the frescoes in the loggia of

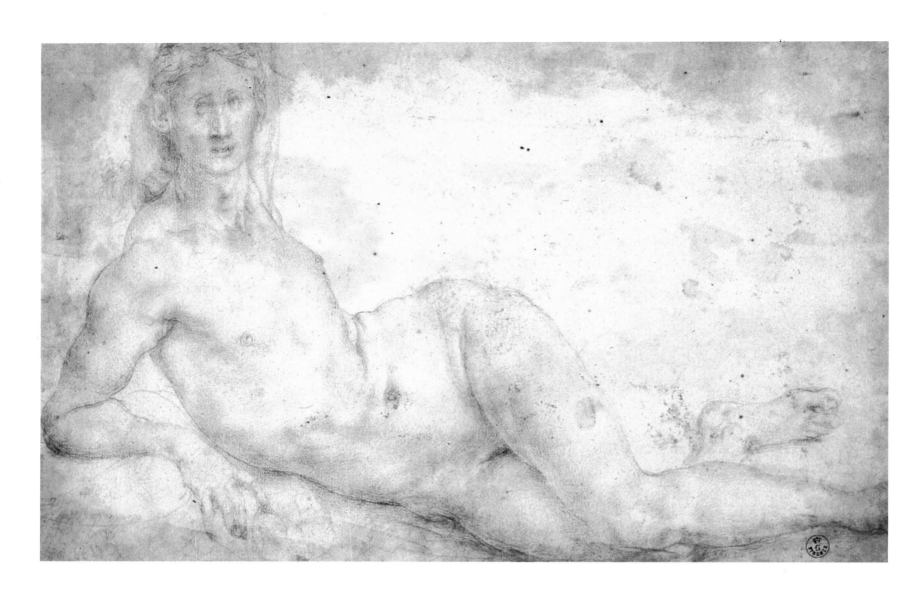

72 (opposite, top) *Female Nude*, figure study for the loggia frescoes in Careggi or Castello, 1535–1543
Black chalk, 19.9 x 31.8 cm
Galleria degli Uffizi, Gabinetto dei Disegni e delle Stampe, Florence

In the 1530s, the members of the Medici family began with the restoration of their two oldest country seats. Pontormo was commissioned to decorate the loggias of the two villas in Careggi and Castello respectively. Neither of the two fresco cycles, produced in succession over an eight year period, have survived. There are, however, a number of drawings in the Prints and Drawings Collection of the Uffizi Gallery that can be related to the loggia frescoes. The studies prove that the projects for the decoration of the two loggias must have been extravagant.

73 (opposite, bottom) *Female Nude*, figure study for the loggia frescoes in Careggi or Castello, 1535–1543
Red chalk, 21.2 x 28.9 cm
Galleria degli Uffizi, Gabinetto dei Disegni e delle Stampe, Florence

The figure lying on its side and turning towards the viewer with a strong twisting movement has hermaphrodite characteristics. It cannot be established with certainty whether this drawing was a preparatory study for the fresco in Careggi or that in Castello.

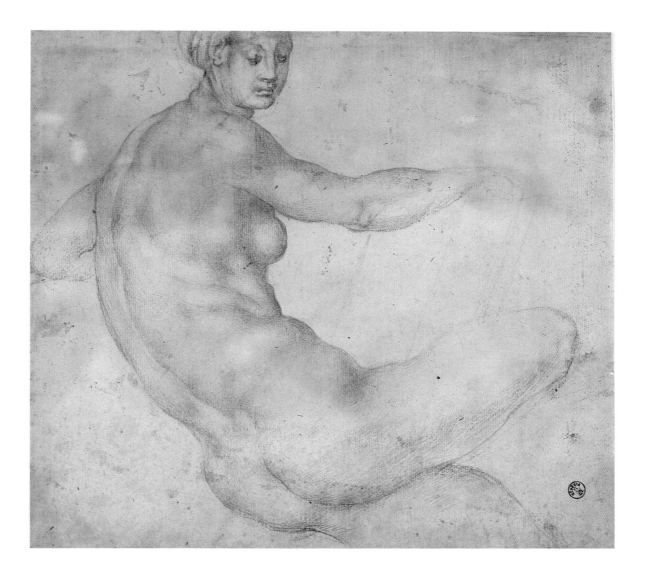

74 (right) *Female Nude*, figure study for the loggia frescoes in Careggi or Castello, 1535–1543
Black chalk, 26.9 x 29.5 cm
Galleria degli Uffizi, Gabinetto dei Disegni e delle Stampe, Florence

The anatomical distortion of this female nude is reminiscent of Michelangelo's allegorical figures guarding the tombs of Lorenzo and Giuliano de' Medici in the mortuary chapel of the Medici family in the church of San Lorenzo in Florence. The androgynous characteristics of the muscular female figure also take Michelangelo's stylized figures as their point of reference.

the Careggi Villa. In December 1536 the murals were completed. Shortly afterwards Duke Cosimo I and his mother Maria Salviati engaged Pontormo again. Because of his ambition to finish the frescoes at the Villa of Castello all by himself, the artist allegedly shut himself in with his work behind walls for five years. According to Vasari, this gradually angered his patrons, and when the work was finally unveiled after long delays, they were apparently not especially satisfied: "For although many parts of the work are good," commented Vasari, "the overall proportion of the figures seems very ugly, and certain of the contorted attitudes to be seen there seem to lack proper rule and measure and to be very strange."

Such critical tones were just a foretaste of the thoroughly damning review of the choir frescoes of San Lorenzo, a gigantic undertaking that occupied the last ten years of Pontormo's life, but which have also not survived. Since this commission was also granted by the Medici, and since he painted portraits for them, it must be assumed that the artist enjoyed their continued support. *The Portrait of Alessandro de' Medici* (ill. 76) dates to around 1534 and shows the unpopular ruler, who was murdered by a relative, occupied in drawing. Another portrait, *Portrait of a Young Man* (ill. 75), dating to the mid-1520's, and painted in glowing colors, might be a portrait of the same Alessandro in his youth, but this is a matter of much disagreement. It is

fairly certain that the subject of *Portrait of Maria Salviati* (ill. 77) is the mother of Duke Cosimo I. This portrait was executed shortly before or after her death in 1543 and is thus one of the Pontormo's few surviving late works. There are also severe problems with the identification and dating of the splendidly dressed half-length figure *Halberdier* (ill. 78) who gazes out at the spectator with that impenetrable gaze that Pontormo frequently gives to his subjects. This young hero could be the idealized portrait of the young Cosimo I, and thus explain the lack of similarity with other portraits of the duke. The young warrior is resting his left hand on his hip in the manner of David. A medallion on his beret, which shows Hercules in his battle with Antaeus, emphasizes courage and strength as the virtues of the subject. Nevertheless, it must remain uncertain whether this young man is Cosimo I, who succeeded to the dukedom after the murder of Alessandro, and who in 1546 commissioned Pontormo to decorate the choir of San Lorenzo.

The church of San Lorenzo in Florence, which was built in the 15th century by Brunelleschi under Cosimo Il Vecchio, was the patronage church of the Medici. The decoration of the choir was the largest commission Pontormo had yet undertaken. At his death at the beginning of 1557 the frescoes were not yet finished, and his assistant Agnolo Bronzino (1503–1572) took over the work, which was duly completed in 1558. In

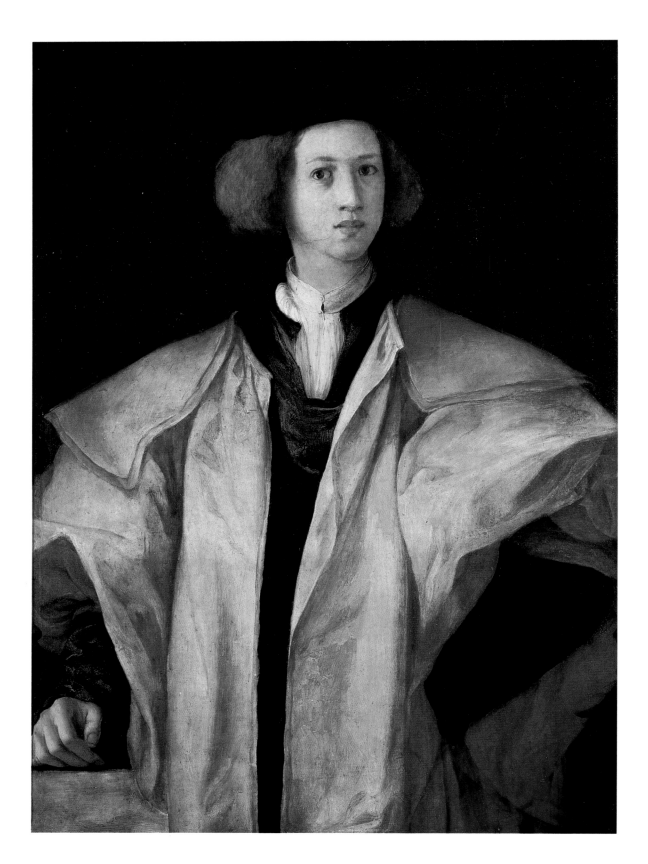

75 *Portrait of a Young Man (Alessandro de' Medici?)*,
ca. 1525/1526
Oil on wood, 85 x 61 cm
Pinacoteca Comunale, Lucca

The color of the young man's hair has given rise to a
continuous dispute amongst art historians. Could this
painting really be a portrait of the young Alessandro de'
Medici (1515–1537), who in contemporary sources is
always described as a man with jet-black hair? Further
doubts as to the identity of the sitter might rest on the
fact that the historical Alessandro has been described as
rather disagreeable in appearance and therefore seems to
have little in common with the beautiful youth depicted
by Pontormo.

the 17th century, however, they were painted over, and
after building work in the church in 1742 to support
the crossing, they were irretrievably lost. All that
remains today is a total of 27 drawings with
composition and detail studies as well as some
descriptions, including those of Vasari and of
Pontormo himself, who wrote notes on the progress
of the work from 1554 to 1556. The frescoes in San
Lorenzo must have made an impression as
overwhelming as Michelangelo's *Last Judgment* in the
Sistine Chapel. As is well illustrated in the study for a
group of figures for the *Deluge* (ill. 81), figure upon
figure, many showing highly complicated movements
and postures, populated the walls. As a preparation for
the painting, Vasari reported that Pontormo had
modelled small clay figures in order to study the
appropriate expression of movement. In the
compositional study for *Christ the Judge with the
Creation of Eve* (ill. 79) a host of naked angels, circling
around Christ as though forming a wreath, announce
the coming of the Day of Judgment. Under them God
the Father is kneeling and in the act of creating Adam

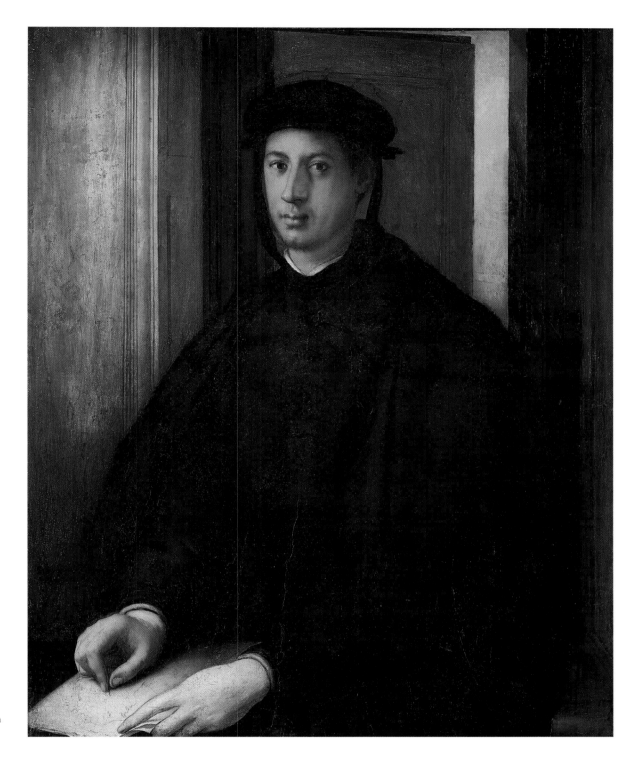

76 Portrait of Alessandro de' Medici, ca. 1534/1535
Oil on wood, 97 x 79 cm
Collection John G. Johnson, Philadelphia

Thanks to Vasari's detailed description there can be no
doubt that the sitter for this painting was the unpopular
first Medici Duke, here portrayed as an art-loving
draftsman. Vasari furthermore explains the reason why
Alessandro is wearing black: he is in mourning for Pope
Clement VII who died on 25 September 1534, and who
was possibly his father. This information allows for a
fairly accurate dating of the portrait, a copy of which is in
the National Museum in Lisbon.

and Eve, a highly unusual and puzzling juxtaposition
from an iconographical point of view. Vasari remarked,
"I have never been able to understand the didactic
concept of this picture, although I know that Jacopo
had intellect and frequented circles of learned and
scholarly people". The didactic concept Vasari is
referring to is possibly based on ideas for religious
reform Pontormo came into contact with in Florence.
Christ is not portrayed here as the judgmental God, but
as a gracious one. Moreover there were certain circles
around the Duke Cosimo within the Florentine

Academy who took Etruscan myths and interpreted
them in a Christian sense in order to strengthen the
predominance of the Medici in Florence. Such
humanistic studies apparently found an echo in
Pontormo's design of the frescoes. The explosive nature
of Pontormo's mature works may thus have involved a
politically motivated deviation from theological
doctrine. At a time when the Council of Trent
(1545–1563) was bringing in the Counter-
reformation and giving an enormous impetus to
Catholicism, this must have seemed extremely daring

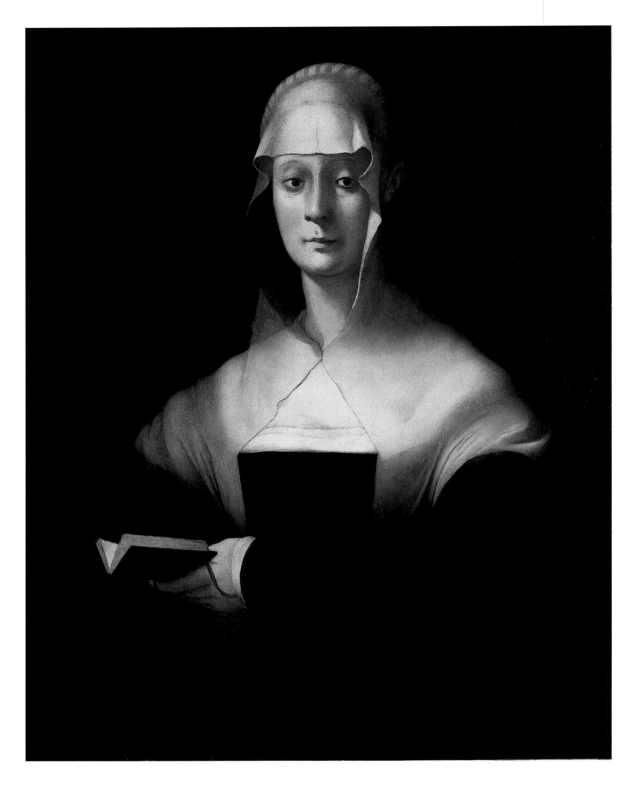

77 *Portrait of Maria Salviati*, 1543–1545
Oil on wood, 87 x 71 cm
Galleria degli Uffizi, Florence

According to Vasari, Pontormo painted a picture of Maria
Salviati (1499–1543), the mother of Duke Cosimo I,
while working on the loggia frescoes of the villa in
Castello. The youthful appearance of the sitter, and the
inadequacy of some stylistic features have, however, given
rise to doubt as to whether the painting in the Galleria
degli Uffizi is the one mentioned by Vasari. It is
nevertheless true that idealization and stylization are
essential characteristics of Pontormo's painting. It is
therefore revealing that the sitter, dressed in a singularly
simple and almost demure manner, and holding a book
in her hand, embodies the spirit of Maria Salviati, who
was widely regarded as an intelligent and educated
woman.

and possibly explains Vasari's incomprehension. Vasari
shed light on another aspect regarding the choir
frescoes in San Lorenzo. He believed that Pontormo
wanted to "to excel all other painters with this work,
maybe even, dare one say it, Michelangelo". In order to

explain the extremely important relationship between
Pontormo's art and Michelangelo we must once again
go right back to the time before the San Lorenzo
frescoes, to be precise, to the third decade of the
sixteenth century.

78 *The Halberdier (Cosimo I de' Medici?)*, date disputed
Oil on canvas, 52 x 40 cm
Paul Getty Museum, Malibu

The young fighter takes up the traditional theme of
David that had been particularly evident in Florence,
developed in sculptures by Donatello, Verrocchio and
Michelangelo. His left hand resting on his hip, and his
right hand holding a halberd, the young man faces the
viewer with a provocative gaze. So far no agreement has
been reached about the actual identity of the subject;
therefore the date of its execution is also uncertain. If the
suggestion were to be proved that this superb picture was
an idealized portrait of the young Duke Cosimo I
(1519–1574), the date of its origin could justly be put at
the year 1537. In that case, the painting might well have
been connected with Cosimo's elevation to the position
of Duke of Florence in the same year.

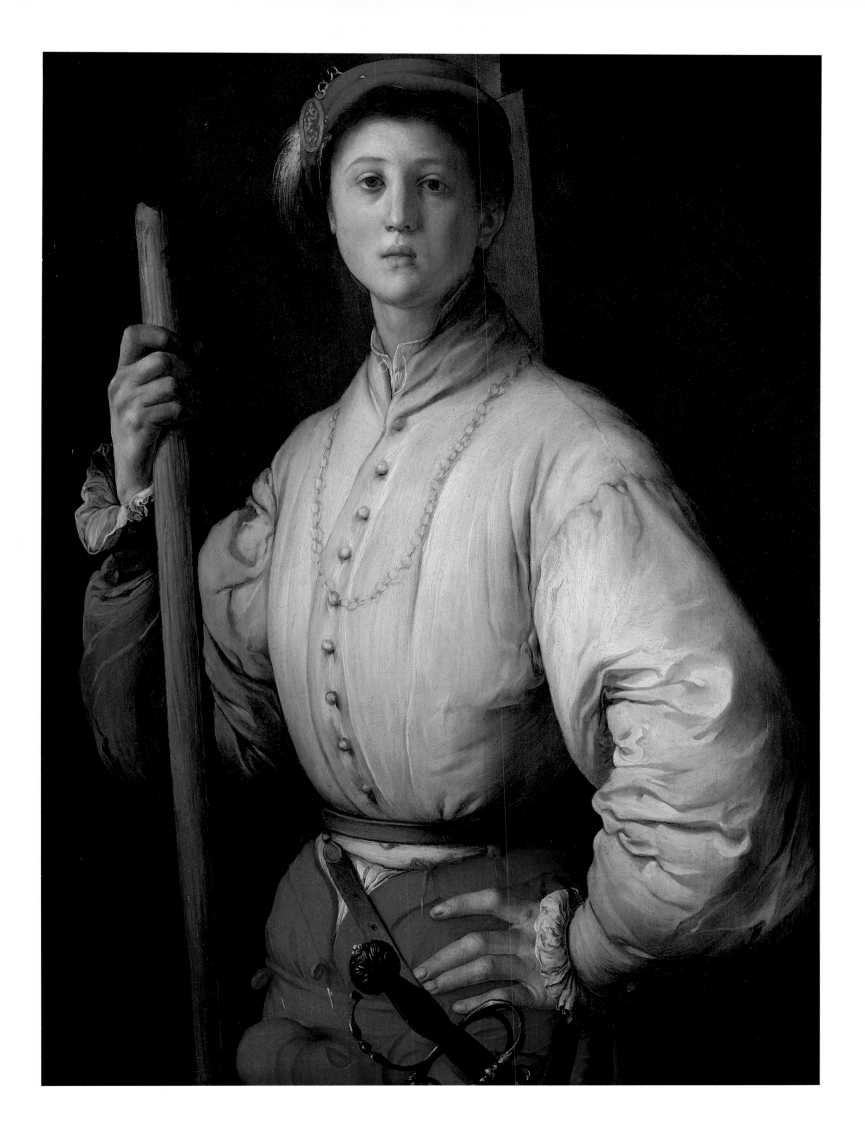

79 (above) *Compositional study for Christ the Judge with the Creation of Eve,* preparatory drawing for the choir frescoes of San Lorenzo, 1546–1556
Black chalk, 32.6 x 18 cm
Galleria degli Uffizi, Gabinetto dei Disegni e delle Stampe, Florence

The frescoes Pontormo painted for the choir of San Lorenzo were the major work of his old age. They were destroyed in the 18th century, but a number of preparatory studies have been preserved. The motif prepared in this particular study represents the central painting of the fresco cycle, which is regarded as somewhat cryptic. Placed below Christ awakening the dead, God the Father is depicted in the act of creating Eve from one of Adam's ribs. The painting is unusual in that it depicts both the Last Judgement and the Creation together.

80 (left) *Compositional study for Moses Receiving the Tables of the Law,* preparatory drawing for the choir frescoes of San Lorenzo, 1546–1556
Black chalk, 38.5 x 14.8 cm
Galleria degli Uffizi, Gabinetto dei Disegni e delle Stampe, Florence

This drawing, badly faded, shows in its lower half the muscular back of Moses, who is looking up to God the Father with his arms raised aloft. Like Moses, God is depicted as a nude figure. Following Michelangelo's *Last Judgement* in the Sistine Chapel, completed in 1541, Pontormo had the courage to disregard theological doctrines. This was Vasari's comment: "…the work is full of nude figures .…it does not seem to me that in any place at all did he pay heed to any order of composition, or measurement, or time."

81 (above) *Study for a group of figures for the Deluge,* preparatory drawing for the choir frescoes of San Lorenzo, 1546–1556
Black chalk, 26.6 x 40.2 cm
Galleria degli Uffizi, Gabinetto dei Disegni e delle Stampe, Florence

In the lower right-hand part of the choir Pontormo depicted what Vasari describes as "the inundation of the Flood, in which there are a mass of dead and drowned bodies, and Noah talking with God". Presumably the unusual theological program of the frescoes of San Lorenzo was inspired by reforming circles at the Florence Academy. Cosimo I de' Medici, who commissioned the frescoes, had a close relationship with these circles.

82 *Portrait of Pontormo*
Woodcut illustration in the second edition of Vasari's
"Lives of the Most Eminent Italian Painters, Sculptors
and Architects", Florence 1568

It was not until the second edition of Vasari's "Lives",
which appeared in 1568, that artists such as Pontormo,
namely Vasari's contemporaries, were included. The first
page of each biography is now decorated with a woodcut
showing a portrait of the artist in question that embodies
his most essential characteristics. Vasari's biography of
Pontormo describes the life and the career of the artist in
great detail. It is the only contemporary document about
Pontormo's life and has created a lasting image of the
artist as a melancholy outsider.

Giorgio Vasari, who was born in the city of Arezzo in
Tuscany, was a painter and architect (ill. 83). His reputation
as the father of art history, however, rests on his work as a
writer on art. His "Lives of the Most Eminent Italian
Painters, Sculptors and Architects" (Le vite de' più
eccellenti pittori, scultori e architetti italiani) was published
in 1550 in two volumes. By 1568 a second revised edition
had appeared, which in its third volume covered Vasari's
contemporaries, including Pontormo (ill. 82). The theme of
the book is the history of Italian art from the Middle Ages
up to the 16th century. The chronologically arranged
biographies describe a continuous line of development
that represents, for Vasari, a progress towards perfection.
His outstanding achievement consists, firstly, in having
compiled of a series of detailed reports on the lives of artists
of previous ages; and, secondly, in having incorporated
these biographies into a historical model based on the
classical pattern of a golden age, followed by decay, and
then renewal. Vasari defines the "dark" Middle Ages as a
period of decay. Thereafter Giotto (ca. 1267–1337) in the
14th century is the first artist to provide a more lively
representation of movement and space in his painting. The
Florentine Masaccio (1401– ca. 1428), with his mastery of
perspective and use of light, was a pioneer of the style of
the 15th century. With Leonardo and Raphael the last
vestiges of stiffness in painting were softened. A high
degree of perfection was achieved. Around 1500 the art of
Italy could undoubtedly be measured against the
achievements of Antiquity. It is the "divine" Michelangelo,
however, who was the crowning glory of this development.
It is he alone who deserves the credit for a remarkable
imitation of the classical world, and one that brilliantly
surpassed it in beauty, grace, and inventiveness.
Michelangelo, an older contemporary of Vasari, must
therefore be considered as the real protagonist of his
"Lives". His art and personality serve as a yardstick for
Vasari to evaluate the past. The "Lives" consequently
pursue a very specific objective: by means of an historical
model and the ideal of Michelangelo it seeks to provide an
example of how contemporary artists should work.

The history of art that developed in the 19th century
above all saw a rich source of biographical material in the
"Lives" and thereby lost sight of the real character of
Vasari's book. Even today most of our knowledge of
Renaissance works rests on Vasari. Above all, however, it is
the lively, sometimes witty, narrations that have shaped our
image of these various artistic personalities. Raphael's
courtly grace or Leonardo's puzzling eccentricity are
described here in detail. We should not however take
everything Vasari says at face value. The "Lives" is very
much shaped by inventions and literary references. That is
even the case when Vasari writes about a contemporary
such as Pontormo, whose life has been told to him by a
reliable witness, namely Angelo Bronzino. Vasari's book
corresponds to a humanistic literary ideal, which did not
see its task as one of drily recounting known facts, but of
turning those facts into literature, into a biography that
gains exemplary character by references and allusions.
Raphael's facial traits and behavior are thus described as
graceful, because grace and beauty are the outstanding
features of his painting. In Vasari's life of Pontormo, the
themes of withdrawal and isolation assume the function of
a leitmotif to explain the extraordinary singularity of his
artistic invention. The moral message is clear: by remaining
aloof, and even rejecting the advice of friends the artist is
moving outside the norms of society. He thereby runs the
risk that his art will not be understood, and, according to
Vasari, this is precisely the case with the choir frescoes in
San Lorenzo. Pontormo's biography comes to represent an
example of an artist's unwillingness to communicate and to

83 Giorgio Vasari
Self Portrait
Oil on wood, 100.5 x 80 cm
Galleria degli Uffizi, Florence

Giorgio Vasari has portrayed himself in a dignified pose, wearing a chain and elegant dark clothes. Drawing implements are the attributes that testify to his artistic genius; after all, he regarded drawing, or *disegno*, as the intellectual basis of all art. Appearing as a courtier of universal education, Vasari confidently represents the new type of artist of his era. Equipped with a comprehensive humanist education, Vasari was actively working as an architect, a painter, and a writer about art. His main work, the "Lives of the Most Eminent Italian Painters, Sculptors and Architects", was first published in 1550 and earned him the reputation of being the "father of art history".

interact with society. Clearly brought out by his unreserved admiration for the artist's early works, Vasari's portrayal of Pontormo's failure is intended as a warning to all young painters. The factual truth of the related events is relative to Vasari's didactic intention. Whether Pontormo really did erect a wall and barricade himself in the choir of San Lorenzo, in order to work undisturbed on his frescoes, or whether the strange tower room without steps really did exist in his house can never be known. The literary power of such images, however, makes the question as to their authenticity a secondary one. In his "Lives", Vasari uses poetic skill to mix fiction and reality. According to the English historian Paul Barolsky, they are to be regarded as "a masterpiece of literature and not merely a vehicle of art historic information".

THE CAPPONI CHAPEL, MOVEMENT AND DIVINE GRACE

84, 85 *Deposition of Christ* (and detail),
1525/1526 – 1528
Oil on wood, 313 x 192 cm
Santa Felicità, Capella Capponi, Florence

For the mortuary chapel of the Capponi family in Santa Felicità Pontormo painted one of his most outstanding works. The composition consists of ten figures interlinked in animated movement and seemingly revolving around an empty central space. They are lamenting the loss of Jesus Christ, who is being carried to his grave held by two angels. In the right-hand corner, another figure (bringing the total to eleven) gazes out of the painting with a face marked by grief: this is Pontormo, who has placed himself amongst the group of the mourners.

THE DIALOGUE WITH MICHELANGELO

As we have seen, the contacts between Pontormo and Michelangelo reach right back to the early days of Pontormo's career, when Michelangelo, twenty years his senior, predicted a great future for the rising talent. Pontormo had begun to react to the art of the creator of *David* and the ceiling of the Sistine Chapel by 1520 at the latest.

The *Vertumnus and Pomona* fresco is strong evidence of this, but at the same time makes clear Pontormo's artistic independence from his model, Michelangelo. According to Kurt W. Forster there existed a "disabling Michelangelismo" in Florence during the first half of the 16th century; but there can be no question of this in Pontormo's case. Quite the contrary, for the "divine Michelangelo", as Vasari was later to call him, was for Pontormo an inspirational and motivating figure and an important point of reference. If the late works of Pontormo had survived in a more complete state, we would have seen the special relationship between Pontormo and Michelangelo much more clearly. It is above all the loss of the choir frescoes in San Lorenzo that is particularly regrettable. We would then perhaps have had the best example of Pontormo's further development of Michelangelo's influences and could then have corrected Vasari's one-sided view of Pontormo's dependence on Michelangelo.

As Vasari emphasized, Pontormo decided to follow the art of Michelangelo around 1530. In a clear imitation of his biography of Michelangelo, Vasari painted a picture of Pontormo as someone who carried out this decision even down to the way of life he led. Vasari's description of the artist's struggle working in isolation on his ceiling frescoes in San Lorenzo demonstrates clear parallels to the privations Michelangelo submitted himself to during the painting of the ceiling frescoes of the Sistine Chapel. An inclination towards brooding and self-doubt, to loneliness and melancholy are, according to Vasari, further traits shared by the two artists.

Today Vasari's "Lives" is interpreted not so much as a psychological analysis, but rather as a characterization of the artists according to their works, a characterization that emphasizes the uniqueness and special status of the works of both Pontormo and Michelangelo. Pontormo's interaction with Michelangelo operated on many levels and occurred in diverse phases with diverse intentions. We can analyze his reaction to Michelangelo if we turn once again to the 1520s and to a high point in Pontormo's art, the altarpiece with the *Deposition of Christ* in the Capponi Chapel in Santa Felicità (ill. 85) – the very picture, indeed, that prompted Pontormo's rediscovery in our century and that is now regarded as a singular masterpiece of Florentine Mannerism.

Pontormo's lavish decoration of the Capponi Chapel coincided with the work on the Carthusian frescoes in Galluzzo (ills. 49 – 52, 54), whose unusual iconography and colorfulness have already been discussed. In the autumn of 1525 Pontormo returned to Florence from his three-year stay in the monastery outside the city. There he received the commission to paint the chapel just acquired by Lodovico Capponi, and built in 1410 by Brunelleschi into the southwestern corner of the nave of the church of Santa Felicità. Pontormo's paintings in the ceiling rotunda had to make way in 1565 for the conversion of the church to the Medici court chapel. The famous Vasari corridor, a secret passage built for the Medici, linking the Palazzo Vecchio with the Palazzo Pitti, led through the church at upper floor level and necessitated the flattening of the chapel's cupola. Pontormo's decoration fell victim to this. Some of the works survived, namely the fresco the *Annunciation* on the west wall of the chapel (ills. 88, 89), the tondos with the portraits of the four Evangelists in the vault spandrels (ills. 92 – 95), as well as the outstanding altarpiece with the *Deposition of Christ* (ill. 85).

If an increasingly spiritual, almost symbolic pictorial idiom can be said to be coming to fruition in Pontormo's frescoes of the Passion, then in the visionary representation of the *Deposition of Christ* we have a picture in which a complex subject is captured in a correspondingly complex composition. Here Pontormo demonstrates that he is a very important iconographer. He portrays a scene from the Passion of Christ, in which the deposition from the cross, the

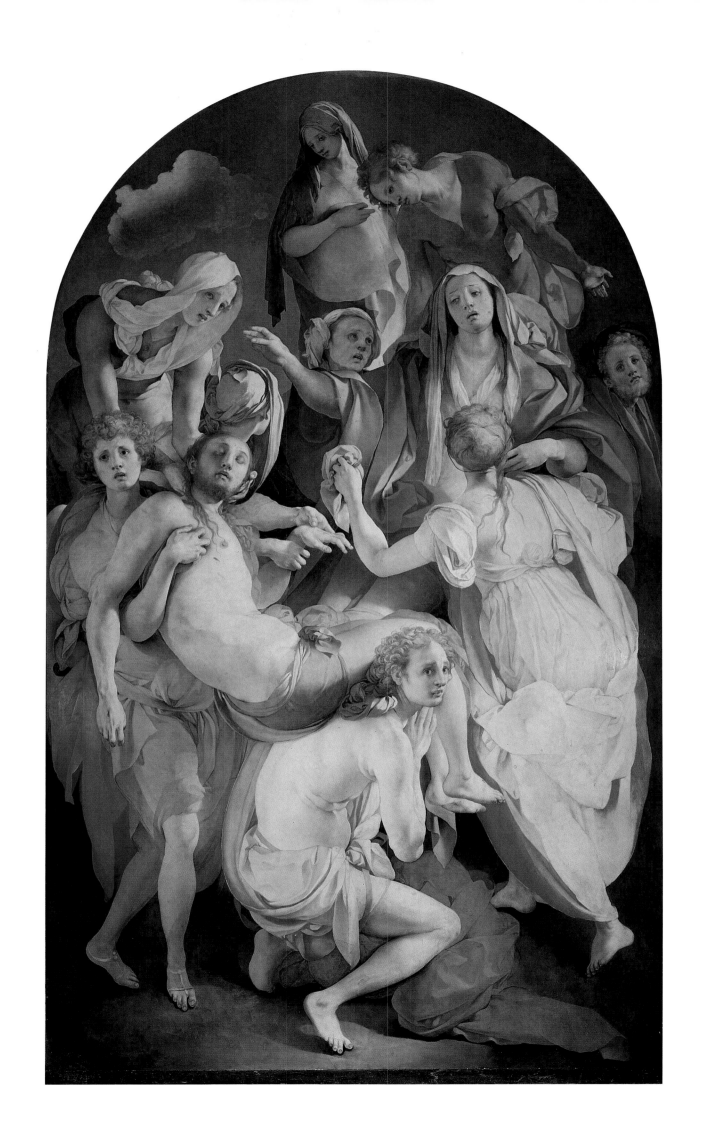

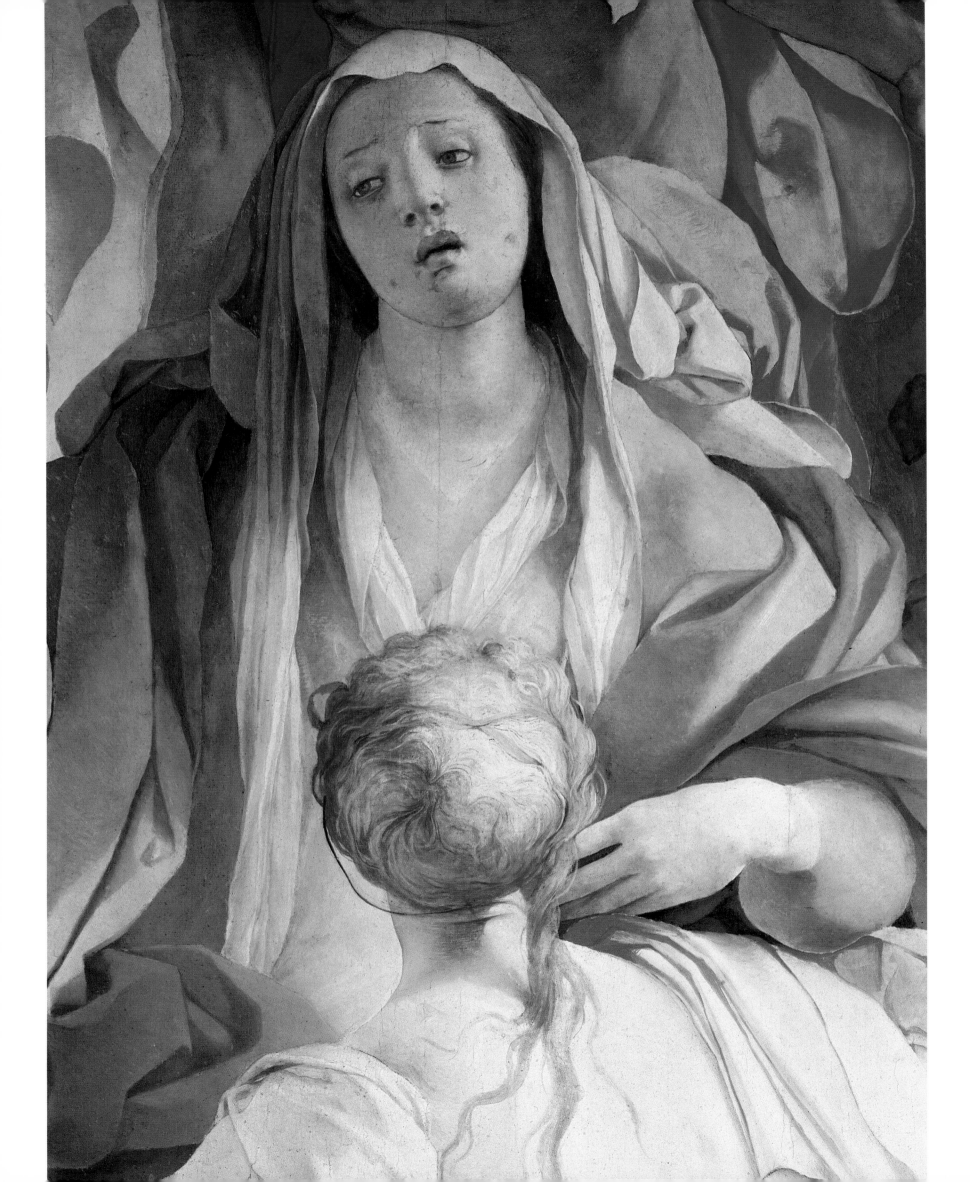

87 (right) Michelangelo Buonarotti
Holy Family with the Young St. John (Tondo Doni),
1503/1504
Tempera on wood, Ø 120 cm
Galleria degli Uffizi, Florence

This tondo, one of the few panel paintings by
Michelangelo to have survived, was painted more than
twenty years before Pontormo's altarpiece in the Capponi
Chapel. It expresses a completely new concept of painting
that served as an inspiration for the early Mannerists. A
new ideal of movement is embodied in the subtly
interlinked group of Mary, Joseph and the baby Jesus.
The impression of three-dimensional volume is enhanced
by the use of light, almost transparent colors.

86 (opposite) *Deposition of Christ* (detail ill. 85),
1525/1526–1528

The Virgin reacts to the death of her son with a dramatic
gesture. Her half-closed eyes and the slightly opened
mouth express the physical pain she experiences. The use
of unreal colors marks the scene as a stage between this
world and the hereafter. Pontormo's painting is concerned
with the transition of Christ, the Son of Man, into the
Son of God. Mary's pain therefore occupies a central
position: while her outstretched arms signify her
motherly grief, they assume at the same time the shape
of the Cross, reminding the viewer of the salvation
brought about by Christ's death.

entombment and mourning of Christ all merge into
one picture.

The stylized method of representation corresponds to
an artistic interpretation of the biblical story, and this is
developed without any reference to the location, but
solely through the portrayal of the figures in the group
around the dead Christ and the swooning Mary.
Pontormo's *Deposition of Christ* is full of both motion
and emotion. The way in which the body of Christ is
presented and held aloft strongly invites the spectator
to participate in the events of the Passion. It is not until
Caravaggio (1572–1610) and Rembrandt
(1606–1669) in the 17th century that we see this
again. The spectator is drawn into the work by the
female figure, seen from the back, hurrying to comfort
Mary. Mourning is presented through various pathetic
gestures, the dismay at the death of Christ finding its
expression in the whirl of movement. The graceful
lightness of this movement however hints at the
merciful redemption at the heart of Christ's sacrificial
death. The almost dance-like movements in Pontormo's
Deposition of Christ encapsulate to a high degree what
was described in the contemporary literature as *gracia*,
the same expression that describes God's grace towards

human beings. Pontormo's inventive picture acts as a
visual metaphor for the salvation promised by the
transition of Jesus, the son of mankind, into the realm
of the divine and spiritual. For this reason Salvatore
Nigro suggests that the title of the picture be changed
to the *Transposition of Christ*.

Pontormo's pictorial concept of the *Deposition of
Christ* is vitally supported by the extraordinary color
scheme. Bright tones – pink and blue – predominate.
To these are added green and orange in various nuances.
All the colors appear to shine as though illuminated by
a supernatural light. This unusual color scheme invites
comparison with Michelangelo's tondo from 1503/04
the *Holy Family with the Young St. John* (ill. 87), which,
because it was commissioned by Angelo Doni, went
into history as the *Tondo Doni*. The emphasis which
both Michelangelo and Pontormo put on the linearity
of their compositions is also comparable. Both artists
developed their representation substantially from the
line that not only outlines the figures, but also acts as
an delineation for the precise working of the folds of the
garments, strands of hair, or muscular parts of the body.
With the emphasis on draftsmanship in the *Deposition
of Christ* Pontormo acknowledges the pre-eminence of

88, 89 *Annunciation*, 1527–1528
Fresco, 368 x 168 cm
Santa Felicità, Cappella Capponi, Florence

The meeting between Mary and the Angel of the
Annunciation is depicted on the western wall of the
Capponi Chapel. The two figures are separated from one
another by a window. There are almost Baroque
characteristics in the figure of the angel in flight, his
garments billowing out as if from a breeze. The young
Mary responds to the angel's prophecy with amazement,
almost disbelief, as she gracefully turns to the left towards
the source of the glad tidings.

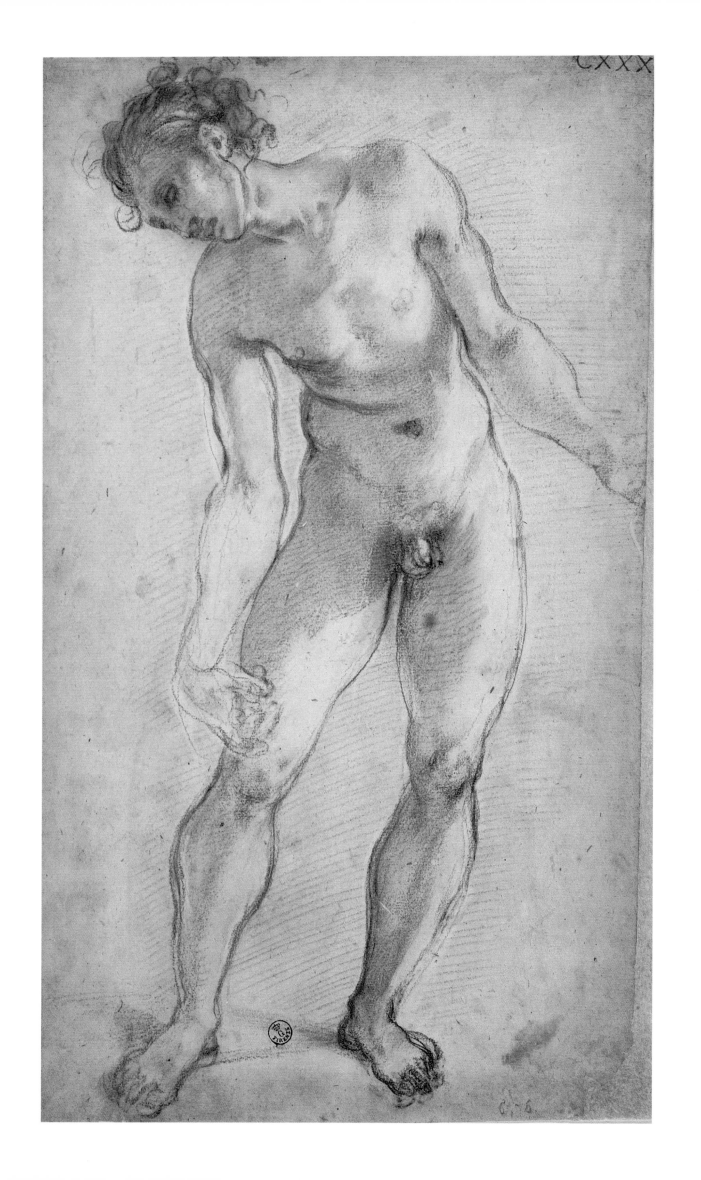

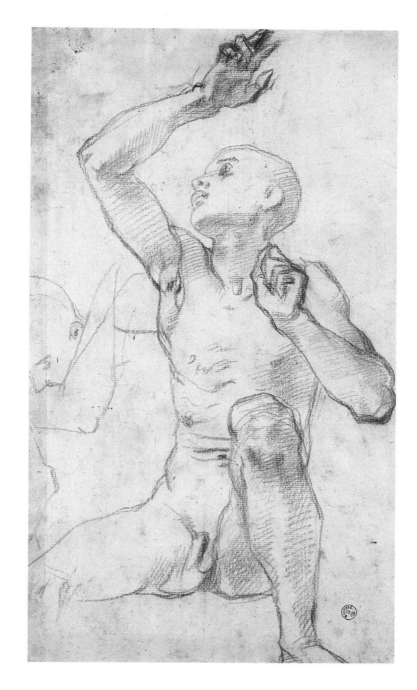

91 (right) *Seated Male Nude*, detail study for the *Four Patriarchs* in the Cappella Capponi, Santa Felicità, Florence, ca. 1526
Red chalk, 36.3 x 22.2 cm
Galleria degli Uffizi, Gabinetto dei Disegni e delle Stampe, Florence

This drawing of this seated nude male figure, seen from below and greatly foreshortened, was part of the preparatory studies for the ceiling decoration of the Cappella Capponi. The painted ceiling has, however, not survived. The contours of the figure in the study are outlined succinctly and economically with strong pencil strokes. This drawing could indeed be a quick sketch of a pose observed from life. The same quick sketchiness characterizes the hatching that indicates the light and the dark areas.

90 (opposite) *Male nude*, figure study for the *Deposition of Christ* in the Capella Capponi, Santa Felicità, Florence, ca. 1525/1526–1528
Black chalk and white lead, 39 x 21.5 cm
Galleria degli Uffizi, Gabinetto dei Disegni e delle Stampe, Florence

This drawing, showing a male figure bending forwards, was a study for the figure seen above the Virgin, reaching down towards the dead body of Christ. The figure study of a male nude when seen with the *Deposition of Christ* makes it clear that Pontormo's composition is based solely on movement and physical expression.

the *disegno* as proclaimed by Michelangelo. In the vocabulary of the time, this meant not only drawing but also the artist's related activity of "designing" conceptual content.

The pictures in the Capponi Chapel are entirely devoted to Christ, a rarity, since private chapels in Italy are mostly dedicated to a saint or are placed under the patronage of the benefactor. On the wall to the right, next to the *Deposition of Christ* is the fresco of the *Annunciation* (ills. 88, 89). The movements of the Archangel and Mary have a dance-like air to them similar to that of the figures in the adjoining altarpiece. In the powerful figure of the angel and its dynamically billowing robes there are echoes of Michelangelo. Pontormo, however, transforms them by his own, finer and softer modelling of the body. Christ is also referred to in the four portraits in the pendentives of the Evangelists, who, quills in hand, act as the purveyors of the glad tidings of Jesus. Within this row of four figures, Pontormo has laid great store by the portrayal of individual heads and the correspondence of gestures

and glances. The Capponi Chapel in Santa Felicità has rightly been described as Pontormo's masterpiece. It did not, however, win Vasari's approval. He bemoaned the lack of shadow in the *Deposition of Christ*, and the twisting characters of the Annunciation fresco made it clear to him that Pontormo's "bizarre and fantastic brain never rested content with anything ... and was continually investigating new concepts and strange ways of doing things". Nevertheless, with regard to Pontormo's work in the Capponi Chapel, Vasari had to concede that "when it was finally uncovered and seen, all Florence marvelled".

The overcoming of the static nature of picture designs by the heightening of movements, so admirably exemplified in the Capponi chapel, represents one of the most significant artistic achievements in Pontormo's generation. The study of human movement was considered part of the basic requirements demanded of every painter. The observations of the most important art theoretician of the Quattrocento, Leon Battista Alberti (1404–1472), had provided the painters of the

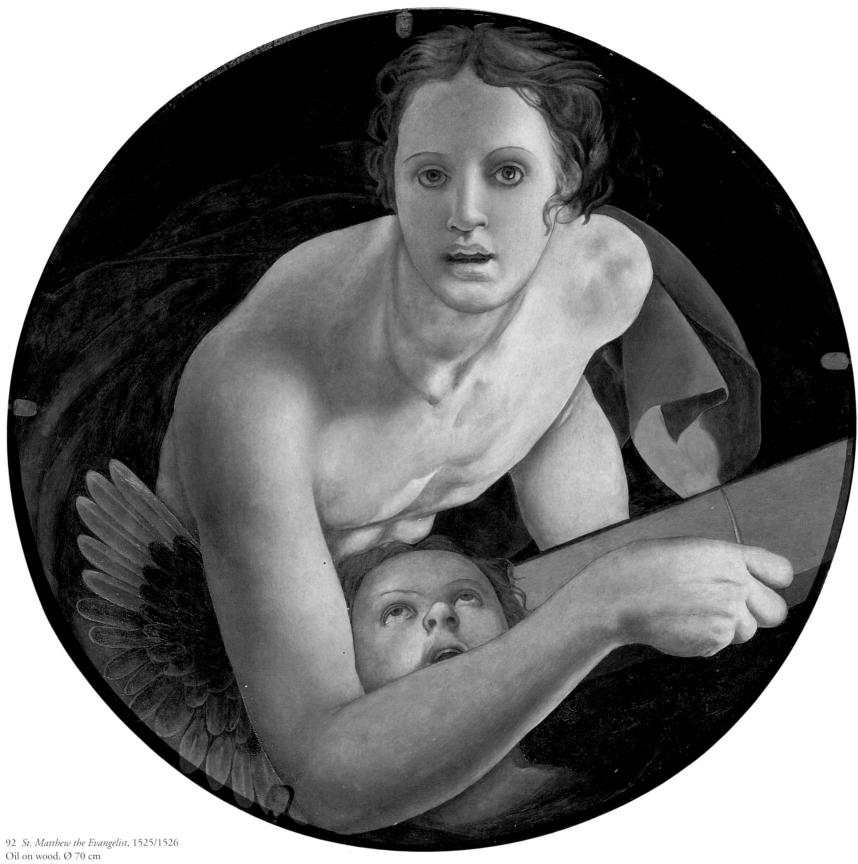

92 *St. Matthew the Evangelist*, 1525/1526
Oil on wood, Ø 70 cm
Santa Felicità, Cappella Capponi, Florence

Four tondos showing half-length portraits of the four
Evangelists adorn the pendentives that connected the
round cupola with the rectangular chapel interior. The
central theme of the portraits is the variation of the
intense gazes and hand gestures. Defying all tradition,
the youthful looking Matthew is portrayed without a
beard. The four Evangelists could therefore also be
representative of four different ages of man.

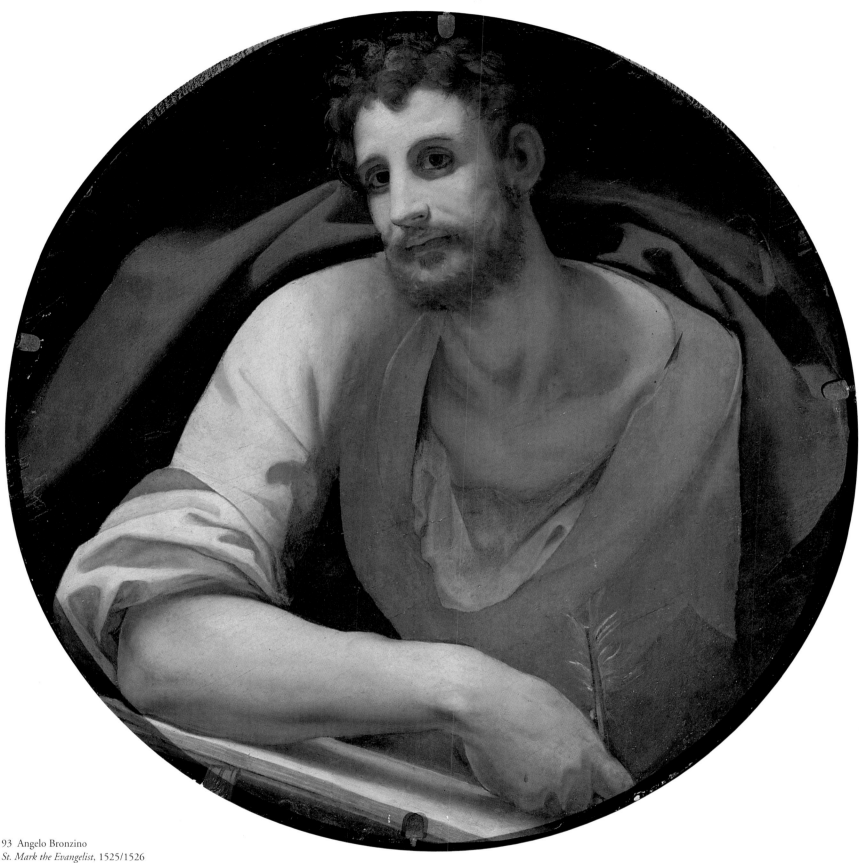

93 Angelo Bronzino
St. Mark the Evangelist, 1525/1526
Oil on wood, Ø 70 cm
Santa Felicità, Cappella Capponi, Florence

The medallion showing St. Mark the Evangelist was
probably executed by Bronzino, a pupil of Pontormo's. It
nevertheless fits perfectly into the overall pictorial design.
The dark-haired St. Mark gazes out of the picture with
his head tilted slightly to the left. Like the other
Evangelists, he is holding a writing quill that identifies
him as the author of one of the Gospels. The attribute of
St. Mark, the lion, is absent, in contrast to the tondo of
St. Matthew who is depicted with his symbol, the angel.

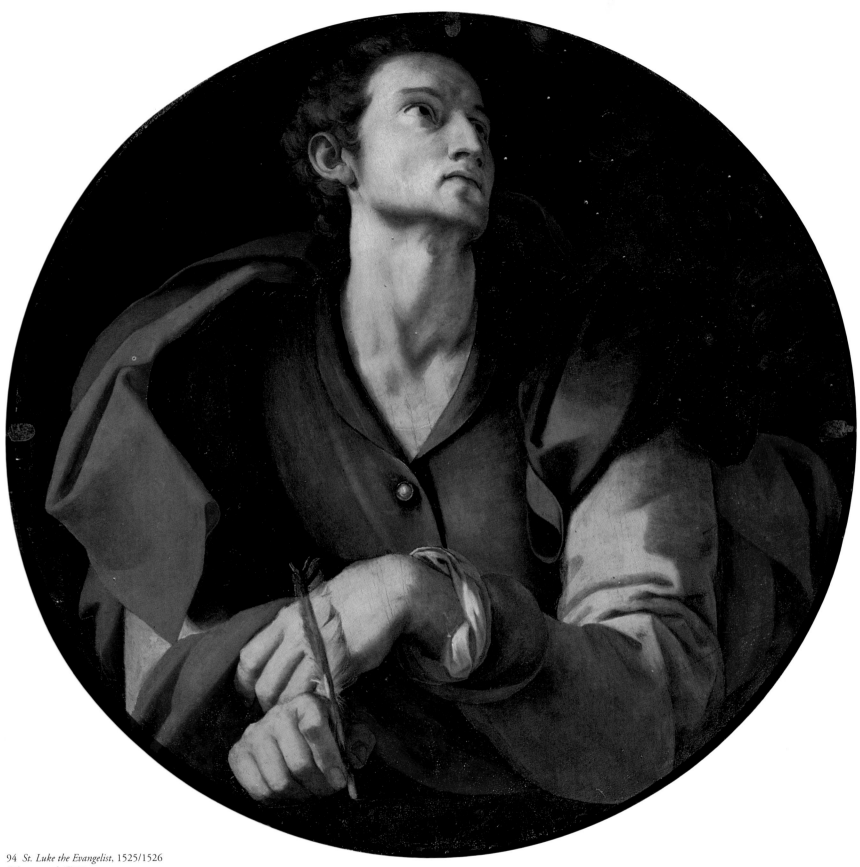

94 *St. Luke the Evangelist*, 1525/1526
Oil on wood, Ø 70 cm
Santa Felicità, Cappella Capponi, Florence

His head tilted upwards towards the right, St. Luke is
seen depicted from below. To his right side can be seen
the head of his symbol, the bull. The emphatic gazes of
the four Evangelists were originally directed towards the
Four Patriarchs represented in the chapel's cupola fresco,
which has not survived.

95 *St. John the Evangelist*, 1525/1526
Oil on wood, Ø 70 cm
Santa Felicità, Cappella Capponi, Florence

It is traditionally believed that St. John reached a great
age, and here he is depicted as an old man. Pontormo has
dispensed with John's attribute, the eagle. The body of
the Evangelist is twisted forward and appears to lean out
of the picture. His face is rendered in profile and turned
towards the right. Nowadays, the four tondos are
arranged in such a way that St. John is turning towards
St. Matthew. The original arrangement of the picture is,
however, likely to have been different from today's.

96 *The Penitence of St. Jerome*, ca. 1526/1527
Oil on wood, 105 x 80 cm
Niedersächsisches Landesmuseum, Städtische Galerie,
Hanover

The life of St. Jerome was distinguished by the
combination of strict asceticism and a deep and wide-
ranging scholarship. He is said to have retreated around
the year 370 into the desert of Chalcis near Antioch
where he lived as a hermit. Later he lived in Rome as an
adviser to the Pope. He is one of the four Fathers of the
Church of Rome. During the Renaissance, St. Jerome
gained great popularity as the epitome of the humanist
scholar. This painting, which focuses on the physical
expression of St. Jerome's readiness for penance, was once
owned by the collector August Kestner (1777–1853)
from Hanover who lived in Italy for several years around
1800.

Renaissance with the insight that, in a "silent" picture, emotions could be expressed only by means of movements of the body. Only through a clearly developed body language would the spectator be convinced by the event represented and drawn into the picture. In Pontormo's paintings there are many examples of body language exaggerated for the purposes of pathos and later combined with an increasing absence of narrative accessories, traditional attributes, or, as in the case of the Deposition of Christ, references to time or location. The concentration on the physical expressiveness of the body, gestures and

mimicry, as was already to be found in Michelangelo's *David*, is well exemplified in Pontormo's *The Penitence of St. Jerome* (ill. 96), which is dated to the same period as the Capponi Chapel. The unfinished work shows the kneeling saint seen from above in steep perspective. His figure, bent in penitence, fills almost the whole picture, so that, even completed, there would have hardly been space to show the traditional surroundings of his hermitic existence. Only the lion, the attribute of the saint, looks out from the right edge of the picture from behind the blood-red cloth. Otherwise the whole narrative is concentrated on the kneeling man who is

97 *Madonna and Child with the Young St. John (Caritas)*,
1527/1528
Oil on wood, 89 x 73 cm
Galleria degli Uffizi, Florence

The deep affection between Mary, Jesus and St. John is
expressed in a compact and unified composition. The
children embrace one another while Mary holds them.
Pontormo can develop one single gesture into a whole
story. The gaze of the young baby Jesus, lost in thought,
is directed into the distance. The tender melancholy with
which the faces of St. John and Mary touch already
foreshadows their mourning of the crucified Christ. The
strong plasticity of the figures, achieved through the
emphasis on the outlines, is reminiscent of Michelangelo.

leaning forward, writhing and painfully beating a stone against his breast. The bare skull corresponds to the raised knee, and both are touched by a shaft of light. The knee and head are therefore accentuated, as it were, as the main parts of the body representing penitence. Pontormo translated a portrayal of *Madonna and Child with the Young St. John* (ill. 97) into an equally impressive pose. Because of the lack of attributes, such as the cross of St. John, the picture was long considered to be an allegory of charity. Mary holds the two children on her lap and bends down lovingly to

listen to St. John, a gesture which appears all the more powerful because the picture only just fits in the group of three with the stooping Mary. In the austere figure of the Madonna we once again find clear references to Michelangelo, just as the works which succeeded this one are characterized by Pontormo's particularly intense interest in the art of Michelangelo during the 1530s. Around 1530 Pontormo painted a picture for the nuns of the Florentine foundling home, a picture that Vasari gave the title *The Eleven Thousand Martyrs* (ill. 98). In order to tell the story of the Roman

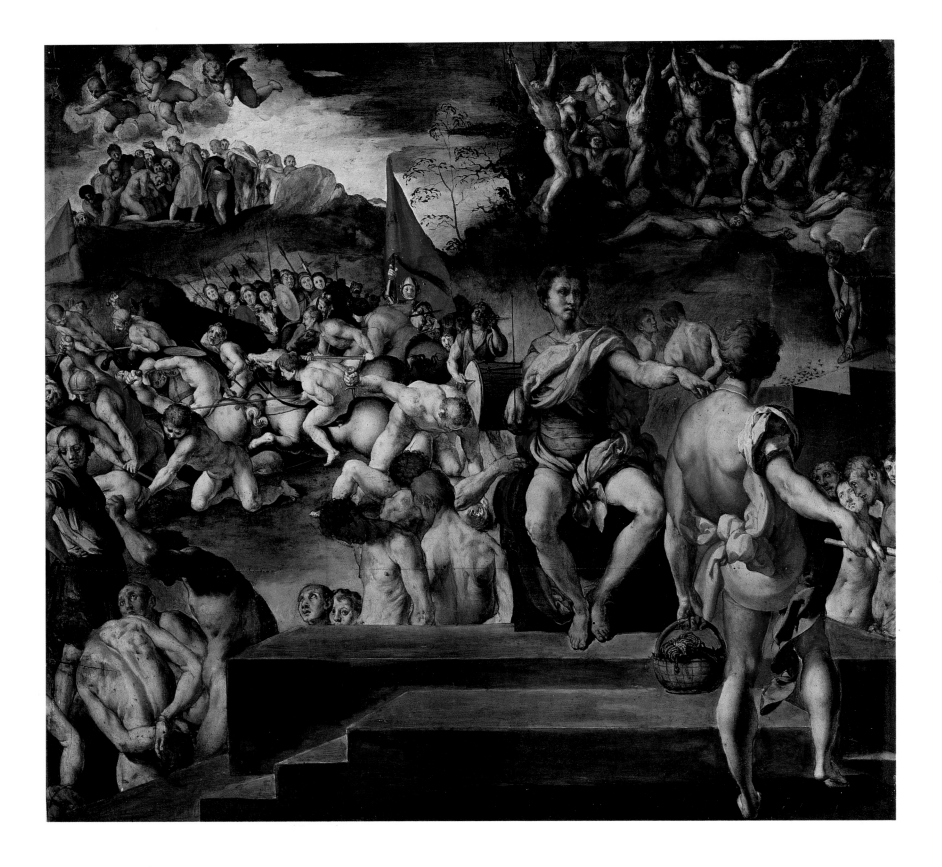

98, 99 *The Eleven Thousand Martyrs* (and detail),
ca. 1529/1530
Oil on wood, 65 x 73 cm
Palazzo Pitti, Florence

The peremptory gesture of a Roman governor is the
command for the persecution and torture of the soldiers
of the Theban legion who had Christian sympathies.
Under the leadership of a soldier called Mauritius, they
had refused to make sacrifices to pagan deities and to
participate in the persecution of the Christians, as the
Emperor had demanded. Using a staggered picture space,
Pontormo develops the narrative in several episodes. The
scenes of baptism and crucifixion in the background also
mark the beginning and the end of the narrative. The
middle ground of the painting is occupied by scenes of
persecution and martyrdom that allowed the artist to
invent a variety of complex body postures. The martyrs
are depicted naked, while their persecutors are shown in
garments reminiscent of classical antiquity.

persecution of the Christians, a story handed down
in the "Legenda Aurea", Pontormo resorted to the
technique of simultaneous representation which
he had developed in the Joseph panels in the
Stanza Borgherini. The picture is characterized by the
imaginative use of a great number of different
portrayals of the body. Some figures individually quote
Michelangelo's pictorial idiom, whilst the Romans
standing in the foreground hark back to Michelangelo's
sculptures in the Medici Chapel in the church of San
Lorenzo. At the beginning of the 1530s there was
genuine cooperation between Pontormo and
Michelangelo. The elder man asked the younger to
carry out the painting of some of his drawing sketches,
for example the *Venus and Cupid* (ill. 100) destined for
a private collector. The androgynous forms of the figure
and the typically Michelangelesque body forms can be
observed in many works of Pontormo (ills. 101, 102).
A chronological account of Pontormo's relationship
with Michelangelo cannot be deduced from this,
however, because of a lack of dates. From the few
surviving works from his later period it may be
concluded that Pontormo's reception of Michelangelo's
art involved a range of different aspects and fluctuated
in intensity over the years. The *Portrait of a Lady with
Dog* (ill. 104), which originated in the 1530s, or the
Portrait of Niccolò Ardinghelli (ill. 107) represent a very
different pictorial style from Michelangelo's. The
portrait of the lady with her cool elegance, which dates
from the supposed period of intensive study of
Michelangelo, is therefore excluded from Pontormo's
list of works by some researchers and attributed to
Bronzino.

The lack of sources makes it difficult to clarify
definitively the relationship between Pontormo and
Michelangelo. With his very diverse and ambitious
talent and an unparalleled openness for artistic
innovations, Pontormo could be measured against one
of the best of his era. The feeling of a certain spiritual
affinity may have influenced his choice of a model. Like
Michelangelo he was an intellectual painter, as
interested in theoretical questions of art as in its
practice. He was therefore able to lift his art onto a new
plane. In 1548 Pontormo answered the question posed
by the writer Benedetto Varchi, whether sculpture or
painting should be given preference, with a letter which
may be regarded as his artistic credo. Pontormo
naturally defended the primacy of painting over

100 *Venus and Cupid*, 1532–1534
Oil on wood, 128 x 197 cm
Galleria dell'Accademia, Florence

This painting is an expression of the high esteem in which Michelangelo and Pontormo held one another. The composition, showing the goddess of love exchanging a tender kiss with Cupid, together with an allegorical still life, can be traced back to a preparatory drawing executed by Michelangelo. It was at Michelangelo's request that Pontormo carried out the final painting. The panel was originally destined to decorate the room of a citizen of Florence, who had dedicated the whole interior design to the subject of love and love-poetry. After the painting was completed, however, it became part of the collection of Alessandro de' Medici.

101 (above) *Figure study* (the *Kicking Player*),1530–1545
Black chalk, 26.7 x 40.3 cm
Galleria degli Uffizi, Gabinetto dei Disegni e delle
Stampe, Florence

The powerfully built body with its legs and its arms
spread far apart seems to represent the antithesis of the
figure of Venus. In this figure study, the close relationship
between Pontormo's and Michelangelo's style of drawing
and the sculptural volume of their draftsmanship can be
observed. The figure is referred to as the *Kicking Player*
since it forms part of a series of drawings depicting figures
engaged in ball games.

102 (above) *Figure study*, 1530–1545
Red chalk, 11.2 x 25.5 cm
Galleria degli Uffizi, Gabinetto dei Disegni e delle
Stampe, Florence

The drawing shows two male nudes kneeling opposite
one another and pressing their heads together while
supporting themselves on their forearms. Again, the
origin of this unusual figure motif is not known. The two
bodies are bent as if they had no bones. The delicate
modelling of the muscles deserves particular attention.

103 (opposite) *The Three Graces*, 1540–1549
Red chalk, 29.5 x 21.2 cm
Galleria degli Uffizi, Gabinetto dei Disegni e delle Stampe,
Florence

The Three Graces are the goddesses of charity and grace.
The symmetrical arrangement of the figures, who are
holding hands, helps to express the three aspects of
charity: giving, receiving, and reciprocating. Moreover, the
stylistic ideal of representing Grace through showing
bodies in motion, is captured in the dance-like movements
of the figures portrayed. This idea is the exemplary basis of
many of Pontormo's pictorial compositions.

Jacopo da Pontormo.

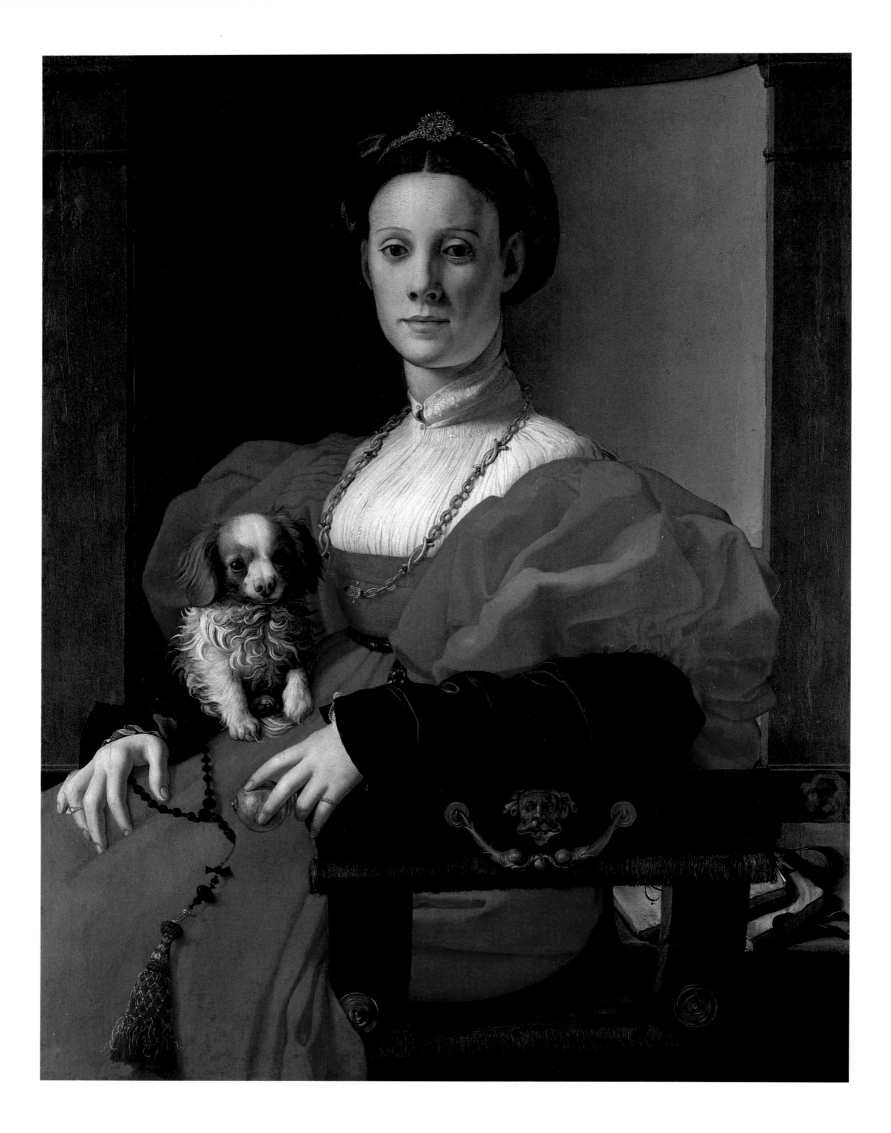

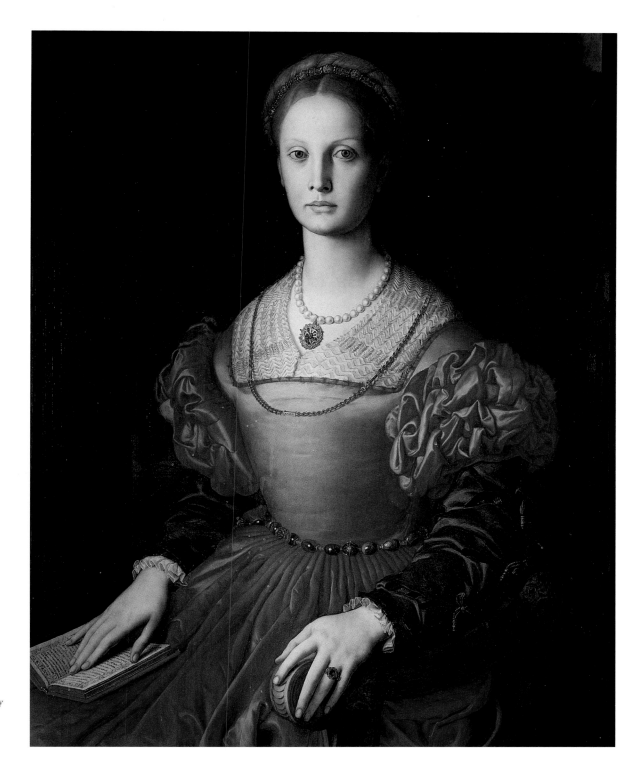

104 (opposite) *Portrait of a Lady with Dog*,
ca. 1532–1533
Oil on wood, 89 x 70 cm
Städelsches Kunstinstitut, Frankfurt am Main

An elegant lady in a bright red dress is shown seated in
front of a niche bathed in bright green light and framed
by two pilasters. This clash of complementary colors
imparts a touch of flamboyance to the representative
portrait of the beautiful unknown sitter. The lady's
clothes, her jewelry and accessories, as well as the
grotesque mask decoration of the chair's armrest, all
combine to express what at that time must have been a
highly modern idiom. *Portrait of a Lady with Dog* is
further distinguished from Pontormo's early portraits by
the artist's use of light. In the former, the sitter is perfectly
illuminated. The enamel-like quality of the brushwork is
reminiscent of the works of Bronzino, to whom the
painting is occasionally attributed.

105 (right) Angelo Bronzino
Portrait of Lucrezia Panciatichi, ca. 1528
Oil on wood, 102 x 85 cm
Galleria degli Uffizi, Florence

The stylistic affinity between Pontormo and Bronzino is
obvious. A former pupil and life-long friend of
Pontormo, Bronzino was engaged in a close exchange
and mutual development of artistic ideas with his former
teacher. Some works by the two painters are so close in
style that the authorship can hardly be distinguished.

sculpture, since painting demands higher spiritual
powers from the artist and above all does not require
physical effort like sculpture. Michelangelo, he wrote,
had shown the "depth of his *disegno* and the greatness
of his divine spirit", not in the "wonderful sculptures",
but in the "miraculous works of his painting". Here
Pontormo makes very clear his high claims for the value
of art. For there is one thing that raises painting, he
wrote, to the level of the heavenly spheres: the will of

the painter to "surpass nature by breathing the spirit of
life into his figure, giving it the appearance of life, and
yet painting it in two dimensions". Pontormo added
that God, when he created man, had made him not flat,
but in three dimensions, since in this way he was so
much easier to bring to life. If the painter had not
considered this the case, "then the painter would not
have sought out an object that demands so much art
and miracles and is quite divine".

106 Angelo Bronzino
Portrait of Pontormo, undated
Drawing
Galleria degli Uffizi, Gabinetto dei Disegni e delle
Stampe, Florence

Bronzino's drawing is one of the few pictures recording
Pontormo's appearance. The latter's shyness and reserve
comes across in this portrait, which has captured his
serious and thoughtful gaze. The bearded artist is wearing
a beret and a simple high-necked doublet. Vasari states
that modesty and a tendency to brood as the main
characteristics of this eminent Florentine mannerist
painter.

107 *Portrait of Niccolò Ardinghelli*, ca. 1540–1543
Oil on wood, 102 x 97 cm
National Gallery of Art, Kress Collection, Washington

Niccolò Ardinghelli (1503–1547) was canon of the
church of Santa Maria del Fiore in Florence. Like
Pontormo, he belonged to the circle of friends of the
neoplatonic writer Benedetto Varchi (1503–1565). The
bearded man of ascetic appearance is shown standing in
the dark church interior. The white sleeve appearing from
the canon's dark gown draws the viewer's attention to the
book which Ardinghelli is holding pressed against his
heart, with his fingers placed between the pages. If
Vasari's dating and identification is correct, this portrait
of the clergyman is the last still-existing painting by
Pontormo. Apart from drawings, no other works have
survived from the two decades before Pontormo's death
in 1557.